Production Design in the Contemporary American Film

Production Design in the Contemporary American Film

A Critical Study of 23 Movies
and Their Designers

BEVERLY HEISNER

McFarland & Company, Inc., Publishers
Jefferson, North Carolina, and London

The present work is a reprint of the library bound edition of Production Design in the Contemporary American Film: A Critical Study of 23 Movies and Their Designers, *first published in 1997 by McFarland.*

LIBRARY OF CONGRESS CATALOGUING-IN-PUBLICATION DATA

Heisner, Beverly.
 Production design in the contemporary American film : a critical study of 23 movies and their designers / Beverly Heisner.
 p. cm.
 Includes bibliographical references, filmographies, and index.

 ISBN 0-7864-1865-6 (softcover: 50# alkaline paper)

 1. Motion pictures — United States — Art direction. 2. Motion picture art directors — United States. I. Title.
 PN1995.9.A74H46 2004
 791.43'0233 — dc20 96-45719
 CIP

British Library cataloguing data are available

Cover photograph: A scene from the 1991 film *Silence of the Lambs* (Photofest)

Manufactured in the United States of America

McFarland & Company, Inc., Publishers
 Box 611, Jefferson, North Carolina 28640
 www.mcfarlandpub.com

For Rudi Feld, Art Director

Table of Contents

II. The Production Designers
(with Filmographies)

Preface

I would like to acknowledge the help of all of the many production design-ers who have allowed me insight into their craft over the years. Especially the inspiration of my longtime friend Rudi Feld, whose humanity and artistry filled his work as an art director first at UFA in Berlin in the days of silent film and beyond, and then in America after he fled totalitarianism in his native land, has kept me at the task.

My friends Virginia Strazdins and Jerry Campfield must also be thanked for their unfailing encouragement.

The University of South Carolina assisted my research with a summer released time grant.

Introduction

This is a book about the way films look.

It focuses upon the way the elements within each frame, other than the actor, help to tell the story and underscore its meaning. Most of these elements are put there by the production designer, who is in charge of the visual design of the film. The film's director decides how the elements provided by the production designer are to be used, while the cinematographer is in charge of their lighting.

In films the *mise-en-scène* takes on a great importance for a variety of reasons, among them because it can be seen so intimately. Through the camera's eye the elements can be focused upon to advance the film story with great precision (*The Silence of the Lambs*) or to isolate its most intimate moments. It can act with the players almost like a character establishing the mood of the screenplay (*Alien* and *Driving Miss Daisy*).

Film is a highly paced medium and the production designer's work helps to unravel the intricacies of plot and character that pass quickly before the eye. In film the decor can change infinite numbers of times, frame by frame, if necessary, and so the production designer must create dozens of settings, some seen for just seconds (*GoodFellas*). Layers of meaning can also be added or elaborated on in film decor in ways that stage decor does not even attempt (*Driving Miss Daisy*).

No film ever succeeds because of the *mise-en-scène* alone (*Sliver*). But a careful observation of production values shapes a reading of the film for subtleties of meaning (*Jungle Fever*) and of character. Whole lives can be summarized on the screen by a production designer in a few frames of film (*The Sunshine Boys*).

The history of production design in American films, through the big Hollywood studio days, was surveyed by me in an earlier book, *Hollywood Art: Art Direction in the Days of the Great Studios* (McFarland, 1990). The work of yesterday's art director and today's production designer is basically the same, but significant changes in the way production designers operate to achieve their

1

results have occurred since the dissolution of the large studios, most of them in the 1950s.

When I wrote *Hollywood Art* it was tremendously difficult to find even rudimentary information on art directors, even their screen credits, which were not listed in standard reference sources. This situation has been remedied today, partly by the inclusion of the production design credit in such standard reference sources as the *New York Times*.[1]

Today, only Universal Studios and Disney Studios have art departments anything like those of earlier times, where under one roof all of the functions of creating and building screen decor were housed. In those days, permanent art departments were organized just like an architecture office. The supervising art director oversaw all of the work put out by the studio. It was he who assigned individual art directors to particular pictures, and they then did the actual planning of the settings. Sketch artists and draftsmen executed in detail the ideas of the art directors. Special effects were usually handled by the art departments.

A construction department within the studio built the sets. There were separate shops for scenic painting, matte painting, miniature and model construction, and plaster work. Large property warehouses stored everything from furniture to parts of buildings. The studios also maintained large standing settings — the back lots — where western and European streets, theaters, and other locations could be found. They were used, redressed, and reused time and time again.

The backing of the studios' technical shops made life physically easier for art directors in those days than it is in the present. Just as the days of the large, architecturally varied and refined movie palaces are gone to be replaced by the multiplex shopping mall theaters with their many tiny viewing spaces that resemble the earliest nickelodeons, the production designer today must employ methods much like those employed by the earliest art directors, who were sometimes called technical directors.

Contemporary production designers must assemble their own art department for each film. They virtually start from scratch on each new job, although production designers frequently use the same personnel from film to film. The work of fashioning the settings is jobbed out to separate contractors. This results in the production designer having to run from place to place in order to oversee and coordinate the work. Production designer Bill Stout explains it this way: "Often times on films there is a kind of war between the production people and the art department. They like to control things. At Cannon they made me feed things out all around town, because they don't like to give one person too much money. I had a guy who could have done everything, but I had to run all over town checking on things being built and made for the film [*Masters of the Universe*, 1986]. They also cut the ten percent of the budget given to the art department for sets, to five percent when they saw that I was

saving money. This on a twenty-five million dollar film. I'll never let that happen to me again. You learn on every film, what to do and what not to do."[2]

Production designers hire an assistant, now referred to by the earlier title of art director, who helps in these tasks. The final sets are always overseen by the production designer during filming, so that they are not altered without consultation, they are lighted as has been conceived, and because changes may be desired by the director during shooting.

Fortunately, despite all of the added leg work, the quality of design in contemporary films has not diminished in a way that is analogous to the way the total movie viewing experience has been diminished by the loss of real theater spaces for the screening of films.

Other types of difficulties arise for production designers today because so many movies are made on location, a phenomenon that had its origins in the post–World War II era. Sometimes, the resources needed to execute a film's design may be difficult or impossible to obtain at the site. They then have to be imported or substitutions have to be made. While working on *Amadeus* (1984) in Prague, Patrizia von Brandenstein remembers, "I needed cities, not studios. I needed London for wigs, Rome for costumes and fabric, Paris for ribbons."[3]

In the days of the large in-house art departments, designers were always educated in an aligned art, as they usually are today. Many came into the work through scenic design for the stage, which had and still does have the support of more sophisticated university education programs than does film art direction. Others came into the field through art schools, usually they had majored in illustrating or painting. But the great majority of studio art directors had been graduated from schools of architecture.

Many of these architects had been educated during the Depression, and when they got out of school could not find jobs. They eagerly accepted work in the film industry. Some of these art directors developed architectural practices on the side, and some reverted to the field later, particularly in the design of amusement theme parks, like Disneyland and Universal Studios Tour. The architect/production designer is scarcely in evidence today.

Whatever their backgrounds, production designers of all periods admit to having learned the greater part of their craft while on the job.

At present, a few universities with sophisticated film training programs offer one or two courses in film design. As they enter the industry in the 1990s, art directors work under the watchful eye of the production designer, and some fortunate individuals develop a mentor association with their boss, as did Carol Wood with Albert Brenner. This sort of mentoring had been going on all along and was perhaps even more prevalent in the days of the great studios. Then everyone worked on a contractual basis for the studio and relationships had a greater chance to flourish because movement between studios was relatively rare.

The broadly understood term "art director" from the studio days has now been generally replaced by the term "production designer." In silent films the title "technical director" was sometimes used to describe the same job, but it soon faded from usage.

The term "production designer" was given currency by David O. Selznick for William Cameron Menzies' work on *Gone with the Wind* (1939). Menzies was brought onto the film early and produced sketches and a complete frame-by-frame storyboard that was followed throughout the course of the production.[4] His sketches were refined and detailed by art director Lyle Wheeler and a large staff. But it was Menzies' vision that saw the film through five separate directorial changes when perfectionist Selznick first hired and then fired one eminent director after the other. Victor Fleming got final screen credit as the director.

Academy Award winning art director Tambi Larsen, who began his career working in the studio system and is now an independent designer, has commented on the name change from art director to production designer, "I have personally felt that 'production designer' was unnecessary pomp. As was the change, a little later, from 'draftsman' to 'set designer'! ... However, in time I used the 'production designer' credit, too. Agents like to use it."[5] There is truth to Larsen's assertion, as a production designer today does fundamentally the same work as the art director did yesterday.

However, not only agents, but production designers too, have come out in defense of the later term. Ted Haworth believes, "The basic difference between production design and art direction is that a production designer has a closer tie with the film, and is usually hired by the director. He then functions in total creative accord to visualize the script on paper, illustrating every complex scene and sequence. The director and the production designer work as collaborators to reshape the script, add the third dimension, almost to the degree of pre-editing the final film."[6] Haworth is right with reference to the director choosing the production designer who then helps establish the overall visual look of the film.

In the studio days there were perceivable "looks" to films, set more by the studio itself and the entire studio art department than by an individual art director. Exceptions did exist though, as with director Josef von Sternberg, whose close collaboration with his art director, Hans Dreier, at Paramount allowed his own visual stamp to be placed on each of his highly personal films.

Today most successful directors contractually demand the final cut on their films, something that was almost unheard of in the studio days. This gives them and likewise their chosen production designers much more control over the way the film finally appears visually, and likewise, over the content, the meaning that the film conveys.

Many directors, once they have established a good working relationship with a production designer, may choose to stay with that person on subsequent

films. Woody Allen has mostly used Santo Loquasto or Mel Bourne on his films, and Spike Lee usually uses Wynn Thomas. Such pairing goes back to studio days when art directors and directors frequently worked together on more than one film, but in those days it was because both of them were under contract to the same studio. If a particular film turned out especially well, the studio's supervising art director would assign the same art director to a director again, hoping for similar results.

In some ways, it is sad to see the forthright and explanatory title art director changed, because it was so hard won. Over the years film directors objected to the use of the term as it shared the noun "director" with them. Battles ensued between the directors' guild and the art directors' guild, until the directors reluctantly agreed to the art director title, which had been current anyway since the silent era.

The sequence of work in production design is fairly standard. Initially the script is read by the production designer and broken down into separate scenes with individual settings. Those that will be built and those that will be done on location are decided upon. A budget is then prepared for the decor. The ability to calculate the budget comes from experience and from conversations with the construction people. Some lucky production designers choose their own construction foreman. Others have to work with those that the film company has hired.

The production designer then assembles the art department to translate the film's designs into finished drawings, blueprints, and storyboards for the production of the film. Any props or special effects are also produced. The computer generated imagery used so much today, in films like *Star Wars*, is given over to companies who specialize in their production. Such imagery must be coordinated with the setting, so that there is a great deal of interchange between production designers and these imaging artists.

During the shooting of a picture, the production designer, and the assisting art director, oversee the building of the settings or their transformation if they are locations. In this phase the designer must work carefully with the set decorator to see that concepts are carried out correctly.

The set decorator is principally charged with finding and placing the objects within the *mise-en-scène* that have been projected by the production designer. Many of the latter, like Patrizia von Brandenstein and Richard Sylbert, like to look themselves for the principal properties that will fill their sets. But this is a time consuming job and the greater proportion of it must be left to the set decorator.

Location scouting is another task of the production designer. Sometimes this is done in the company of the director or the production manager, or both. Photographs are taken of potential sites and these are then culled to those that the director, location manager, and production designer think will serve best. This phase of production design, like all the others, is highly collaborative.

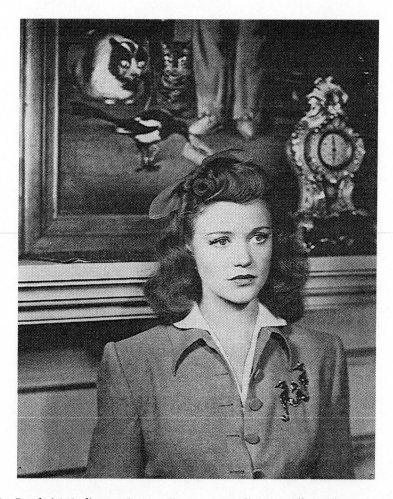

Cat People (1942, director Jacques Tourneur, art directors Albert D'Agostino and Walter E. Keller). Since silent films art directors have used the decor to underscore the story. In this classic studio horror film, a portent of evil is seen in this seemingly innocent image of Irena, the cat woman, before a painting by Francesco Goya of *Don Manuel Osorio de Zúñiga and His Pets* (c. 1787). The predatory cats are eyeing a dinner in the unsuspecting bird.

On a daily basis, while in production, the designer has to check the sets, maybe even redesign them, or find new locations. In post-production, the designer's work is usually over, but on occasion it may not be, depending on whether reshooting is to be done.

Production designers, like their brother art directors of earlier days, do not strive to have a distinctive style. They want to adapt their craft to the story and the way it is being told.

Partly this is attributable to the fact that American narrative film has chosen to be what is usually defined as "realistic." The viewer is supposed to be able to recognize most settings which are tied to the story's time and place. The flamboyance and exaggeration in cinematic decor found in German Expressionist film of the 1920s and in some later European directors, Peter Greenaway and Federico Fellini, for example, were never developed in American film. American film has chosen to remain more down to earth, perhaps an indication of the pragmatic and reality driven American psyche. American directors and American production designers go to the material and call up a film's look from it, rather than imposing a style upon it.

Nonetheless some American production designers' films, like Richard Sylbert's, are recognizable. Sylbert designs so holistically that his work appears to be seamless. Every detail within each frame seems preconceived for the effect of the whole. This is not a highly self-conscious quality that pops out at you from the screen; rather it is almost subliminal and only evidences itself upon careful analysis. It is a quality that on first viewing you feel, rather than notice.

How, after analysis, is the viewer to judge good production design from bad? The bad is often obvious; it may be inadequate, inaccurate or merely inconsequential. It may, for no reason, overpower the actors, who must be at the film's center, or it leaves them dangling in a phony no-man's-land.

Despite the artifice, decor in a narrative film does not constitute reality. It is a contrived reality, reality given form and function. It is used reality. It serves a purpose. If it doesn't, then it is bad production design.

Some good production design may intentionally call attention to itself. It becomes an indispensable character in the film. A case where this happens is in the design of *Batman Returns* by Bo Welch or *Dick Tracy* by Richard Sylbert. Both motion pictures are based on comic strips. The entire *mise-en-scène* is contrived to evoke the unreal world of the comics. Over-designing is appropriate to those films' vital cores of fantasy and humor.

But in most American films, the design is deliberately less self-conscious, as in the popular *The Silence of the Lambs*. There designer Kristi Zea forwards the theses of the plot in almost every frame, but nothing seems obvious. With little suggestion offered from the novel, the film decor carves out whole areas of meaning, like the dichotomy between good and evil, and the narrow boundaries between them. Hannibal Lecter's cell is in a dungeon and Clarissa Starling's training takes place in basements and a fitness course that is first perceived as a big hole in the ground.

For the careful viewer of films, the question then becomes a discernment of what is going on in each frame with regard to the *mise-en-scène*. This calls for a closer reading of the frame for things other than actor, or camera angle, or format. Such a reading adds to the dimensions with which one can appreciate films. It takes the viewer to a level beyond the visceral in their appreciation of films, much as understanding camera work and lighting do.

This is not to say that motion pictures are not to be enjoyed viscerally, as other art forms are. But understanding and being able to read production design is a means of adding another dimension to the interpretation of each film.

My primary emphasis in the pages that follow will be on analyzing films from the standpoint of their design. The productions chosen for such analysis are mostly from the 1980s and 1990s. All are from the post-studio days.

The particular designers, who are discussed in a separate section of this volume that also includes their filmographies, have been chosen because of the quality of their work and because their work represents a wide variety of film genres requiring a variety of design solutions.

I haven't dealt with films that are primarily special effects oriented, what used to be called "trick" films. Special effects have been treated elsewhere in several recent books, and whole volumes have been written on important trick movies like *Star Wars*. Special effects used to be supervised by the art departments, and some still are today, but more and more as these effects have become computer generated or are so intensely mechanical, they have been turned over to experts in these fields (see section on *Alien* in the text).

Music and sound effects are, of course, non-visual sources used in films that add to the totality of the movie viewing experience. These have nothing to do with the initial production design. They are normally added to the edited film. They may, however, affect our perception of the decor. How many otherwise visually neutral settings in a Hitchcock movie, for example, have been made menacing through the addition of music?

Filmmaking is a collaborative enterprise. The contributions of the members of the film crew under the director are often difficult to assess, but there seems to be general agreement that the director, the production designer, and the cinematographer are responsible for how the film looks on the screen.

The director's and the cinematographer's roles have been much more frequently explored in print than has that of the production designer. Partly, this was because of the reticence of earlier art directors and then production designers to draw attention to themselves and away from the director, who has, after all, the supervision of the entire film's production. Also, some of them were afraid of taking the "magic" out of "movie magic."

Today's film viewers seem to thrive on a familiarity with the process as well as the product. Evidence for this is the spate of books on the production of individual "big" films and the publication of their screenplays. Understanding the important role of the production designer adds immeasurably to the depth of our understanding of each film.

Opposite: The European street on the Universal back lot in the 1940s is seen behind its designers supervising art director Alexander Golitzen and art director Joseph Wright. The few remaining back lots are still used for pictures such as the Academy Award winning *Dick Tracy* (1990).

The best film designers work from individual perspectives, using similar methods, to create visual solutions tailored to the screenplay. They have simple design philosophies, for complicated visual problems. Above all, their work underscores the visual nature of film and the necessity to fill the screen with more than actors to tell the whole story.

Notes

1. A major directory of cinematography, art direction, and costume design, divided into volumes by country, has been appearing slowly from the German Saur Press, since 1981.

Lone Eagle Press has for several years been producing a popular annual entitled *Cinematographers, Production Designers, Costume Designers, and Film Editors Guide.* Although it is aimed primarily at the film industry, and is not scholarly, it is helpful for obtaining credits on individuals. Unfortunately it does not tell just what a person did on a picture, so, for example, in the section on production designers four separate names are listed for the film *Alien*, while in the film credits only Michael Seymour is cited as the production designer.

2. Interview with the author, May 1987.

3. Carlos Clarens and Mary Corliss. "'The Pit' and the Production Designer," *Film Comment*, April 1986, p. 4.

4. These designs and storyboards are still extant in the Archives of the University of Texas (Austin).

5. Letter to author, 1985.

6. Ted Haworth. "Production Designer vs. Art Director," *Film Comment*, May/June, 1978, p. 36.

I. THE FILMS

1. Films with Realism Set in the Present

Jungle Fever (1991)

DIRECTOR: Spike Lee
PRODUCTION DESIGNER: Wynn Thomas
MUSIC: Stevie Wonder and Terence Blanchard
SCREENPLAY: Spike Lee
CINEMATOGRAPHER: Ernest Dickerson
EDITOR: Sam Pollard
PRODUCER: Spike Lee

It's strange to hear the main character, Flipper, in Spike Lee's *Jungle Fever* say at one point, "I always hated Disney movies," because in many places the director's movies use a lot of the colorful, crisp, freshly painted production values associated with Disney films.

Jungle Fever, Do the Right Thing, and *Mo' Better Blues*, despite dealing realistically with contemporary issues which traditional Disney films never did, are characterized by contrastive and sometimes unbelievable production values, like immaculately cleans walls and streets in Brooklyn. The question about the films becomes, "Why does Lee want these specific values in this specific spot in his film?"

Jungle Fever opens with views of Harlem and Bensonhurst behind the titles which are carried on signifying road signs. In this jumpy and immediate way, which matches the tempo of the music by Stevie Wonder and Terence Blanchard, Lee locates the action in two New York City neighborhoods and even sets out the methodology of telling the story. It will continually jump back and forth between the two main characters living in their respective neighborhoods.

For more information on the production designer of this film, see Part II.

11

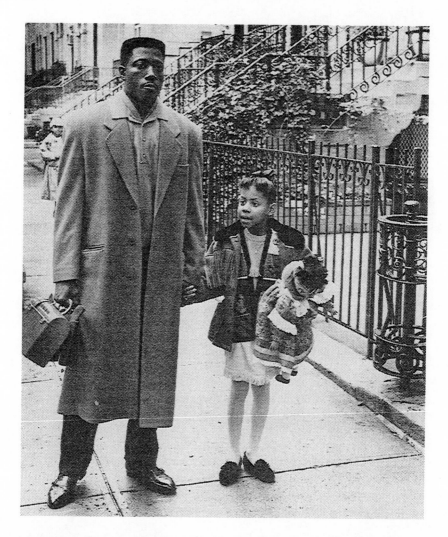

Jungle Fever (1991, director Spike Lee, production designer Wynn Thomas). Successful architect Flipper Purify (Wesley Snipes) takes his daughter Ming (Veronica Timber) to school through the well-groomed streets of his section of Brooklyn.

The story is of a brief affair between Flipper (Wesley Snipes), as an African-American architect, and Angie (Annabella Sciorra), as an Italian-American temporary secretary who works for him.

The narrative opens with Lee's camera floating over Harlem in an early morning light and then down onto a pleasant sun-splashed street lined with elegant older brick and stone apartments and townhouses. Large trees line the street shedding their leaves onto immaculate sidewalks.

Places are always important in Lee films and he usually establishes them during the opening credits. A lot of what *Jungle Fever* is about on a philosophical level is "place"; where is a person's place in physical, mental and emotional terms? Are we defined by our place, or defining it? Are we communal, specifically racial creatures, or individuals living unique lives that transcend our family and community boundaries?

As the action begins the *New York Times* is being delivered to Flipper's door. The camera glides to the architect and his wife's bedroom window and goes inside. The apartment's yellow brick exterior, with its fine wrought iron railings, flowers on window sills, and Roman shades have already been glimpsed from the street.

The couple's bedroom is filled with a luminous golden light which establishes a feeling of well-being that has already been set forth with the views of the building's exterior and continues throughout the rest of their home. The couple is making love and the camera stays in close on them. The first rooms that are really seen are their child's room and the kitchen. These are sophisticated interiors of a family both well-educated and affluent and with a fine sense of design. In fact, designer touches abound in the interior decor; there are bentwood kitchen chairs, stylish wall decorations, and the latest kitchenware. This is appropriate to their taste and concerns because not only is Flipper an architect but his wife (Lonette McKee) is also in the design field; she buys clothes for an upscale department store. They both dress expensively and with great flair.

When the architect walks his daughter to school, we see the seamier side of Harlem streets than the one he lives on, giving a fuller reading to the place. These streets are dirty and littered; the buildings are covered with graffiti, including "BONE CAPONE" (the opening reference to the sexual texts of the story).

Flipper works in an antiseptically modern architectural office where his work cubicle is wedged between a glass wall and white divider panels. Right across the aisle is the temp secretary's cubicle. In these intimate confines a romantic relationship will develop between Flipper and his new secretary, an Italian-American from Bensonhurst.

The introduction of Angie into the office poses a problem for Flipper, who had asked for an African-American assistant; he doesn't like being the token black in the firm. He confronts his racist bosses over an enormous desk in their spacious private office. The enormous desks of power brokers form a physical analogy for the phrase "which side are you on" in Lee's films; he used a desk in the same way in *Mo' Better Blues* when the main character, a jazz musician played by Denzel Washington, confronted the night club owners over a huge desk about money issues. In both cases the white bosses won't "do the right thing."

At this point, Angie's background begins to be etched by Wynn Thomas in her physical surroundings. They are seen in the same minute detail as were those of Flipper.

After her first day's work, Angie trudges home to Bensonhurst; it's already dark outside. She is toting bags of groceries to the house where she lives with, and takes care of, her father and brothers. It is a small, working-class, vinyl sided house with a neat little yard and porch. The aluminum storm door has an American eagle emblazoned on it.

The house's interior is decorated in a cheap 1950s style. A pole lamp, bowling trophy, and photographs of family members in dimestore frames provide the setting for lives lived in the ordinary lane. Angie passes by her loutish brothers sprawled on a sofa that is wrapped in shiny plastic. They're watching television and waiting for her to make supper. She moves through the frumpy wallpapered dining room with its crucifix on the wall into a cramped and old-fashioned kitchen.

In these few rooms Wynn Thomas has given the viewer a thumbnail sketch of Angie's background: her family's interests, their plebeian taste, their family loyalties, their religion, and their overt patriotism. We don't know if the rooms reflect Angie's personal taste, but we know where she comes from and where she's living. The house's interiors are diametrically opposite the refined and tasteful interiors of Flipper's apartment.

Aside from these two domestic interiors, there are several other major and minor settings that articulate the subtexts of the film. Flipper's parents' (Ruby Dee and Ossie Davis) spacious apartment is one of them. It is neat and furnished in 1930s middle-class taste with floral carpet and heavy overstuffed furniture. Before we enter this dwelling, the scene is opened by Lee with a shot of record covers of the gospel singer Mahalia Jackson, his father's ("the reverend doctor" to his wife) favorite singer, whose voice is heard on the soundtrack. "The reverend doctor" is the dominant force in this household, everything and everyone is expected to bend to his will. The husband and wife are sitting on chairs at opposite ends of a sofa; he is reading aloud from the Bible. A very white Jesus Christ, with long flowing locks, is seen in a framed picture.

This traditional decor is like the dated, authoritarian value system the father represents and tries to impose on his family, which besides Flipper includes a drug-addict son, Gator (Samuel L. Jackson). The father is a judgmental personality, one who finds it easy to pinpoint the "sins" of others, despite the fact that he is himself a preacher defrocked for sexual misconduct. Flipper's background is obviously one from which intellectually he has moved far away.

Angie has been involved with a neighborhood boy, Pauly (John Turturro), who works in his father's L. Carbone Candy Store. Pauly's struggle with the definition of his own personality is a subtext of the story. When Angie rejects him he has to resist the pressures from his culture in order to pursue a new relationship with an African-American woman whom he has been admiring from afar.

Pauly's story is acted out in the candy shop, a small storefront with a dark

wood-paneled interior lined with booths. Here he serves a lot of egg creams, sells newspapers, and listens to the prejudices, especially racist, of the guys who hang around the place. The dusty, dimly lit candy shop looks like nothing has been changed in it since it opened — and given the rigidity of Pauly's father (Anthony Quinn), probably nothing has.

As Angie and Flipper's affair progresses and its repercussions are felt in both of their lives, the action switches between the major interiors and locations, especially during walks taken by the characters along the streets in both Harlem and Bensonhurst.

Another subplot, involving Gator's drug addiction, takes Flipper to the vilest part of Harlem — a war-torn street of vacant and boarded up buildings, empty lots, and garbage filled gutters. He's told he can find Gator at the Taj Mahal, "the Trump Tower for crack heads." This drug den, as defined by Wynn Thomas, provides Spike Lee's film its most memorable place.

Flipper approaches it through an iron gate that leads to a trash infested alley. He enters a dark, smoke filled winding stair. Climbing upward he's led to a cavernous upper room, a loft running, it seems, into infinity. Its crumbling plaster and brick walls are barely perceived in a darkness that is broken only by dozens of matches being struck by the junkies as they light up. Their dirty, scruffily clad bodies are strewn all over the floor.

Flipper finds Gator and his girlfriend propped up against a filthy mattress, pills all over the floor surrounding them. This is a raw, hellish wound of a world: one where all hope and humanity is gone. At the farthest end of this vast space, a stream of sunlight is seen; it seems to be from another world. This place indicts and pillories the drug culture even without a word of dialogue.

The story returns to the major text and the progress of Flipper and Angie's affair, which is found out by both of their families. Flipper is thrown out by his wife and he and Angie briefly take an apartment together. It is an empty open space, in an older building, with many large windows, polished wood floors, exposed brick walls and a fireplace. But there are no furnishings. Lee seems to be saying that they have nothing to bring to it. Later its only furniture will be a bed. The implication is that their affair was only about sex.

At the film's end, both Angie and Flipper return to their respective places — she reluctantly, he hopeful for a full reconciliation with his wife.

Lee takes the action in the final sequences back to Flipper's apartment and in the last scene to the street where it all began. But it is not the bucolic street of the film's beginning. There has been trouble in Flipper's life and the perfection of the first scene has been broken by the intrusions of infidelity and the death of his brother Gator at his father's hand.

As he reaches the corner after spending the night with his wife, a young teenager asks him if she can "suck your big black dick" for $2.00 and he screams, "No," at the top of his lungs. It is the same "No" that Pauly screamed out when his "friends" beat him up for going out to date a black girl. It is a "no" to the

destructive elements in both the black culture of Harlem and the white culture of Bensonhurst.

The specific design values that Spike Lee and his production designer Wynn Thomas achieve throughout the film are both realistic and surrealistic, for a purpose. In the end they question the easy definition of place, the artificial niceness of Bensonhurst and parts of Harlem, where surface appearances belie underlying conflicts and easy solutions yield tragic results.

The Presidio (1988)

DIRECTOR: Peter Hyams
PRODUCTION DESIGNER: Albert Brenner
MUSIC: Bruce Broughton
SCREENPLAY: Larry Ferguson
CINEMATOGRAPHY: Peter Hyams
EDITOR: James Mitchell
PRODUCER: D. Constantine Conte

The Presidio is set in San Francisco, on the military base overlooking the Pacific, and on the city's streets. A mystery story with a human interest sub-plot, the film mainly uses carefully picked locations that fit and enhance the action. San Francisco, as a place, is strongly felt throughout the picture.

The film has two main characters, the head of Military Police on the base, Provost Marshal, Colonel Caldwell (Sean Connery) and a former soldier who has been under his command, now a San Francisco police detective, Jay Austin (Mark Harmon). The subplot involves a romance between Caldwell's daughter Donna (Meg Ryan) and Austin.

In the same way that their dwelling delineated the characters of the two old performers in *The Sunshine Boys,* the two major locations here seem to characterize the two main protagonists.

Caldwell is a soldier to the core; he knows the rules and tries to live by them. He is in control in the controlled environment of the fort, the Presidio. Austin, the younger man, has left the army because Caldwell has protected an abusive officer, Lawrence, and cost him a stripe. Austin is less uptight, more individualistic, than the colonel. Austin is at home in the streets of San Francisco, and is quick to let Caldwell know that he has jurisdiction over those streets.

The Presidio opens with long shots of the city — its hills, cable cars, Coit Tower — over the credits and then comes up close on a review of troops and a

For more information on the production designer of this film, see Part II.

saluting Caldwell on the Presidio parade grounds. The story then begins with a cut to a foggy night-lit base, fog horns blowing in the distance. The fort's ambiance, its neat white buildings, tree lined streets that have been made sleek wet surfaces by the fog, is wonderfully atmospheric. Street lights and sign lights cast shadows that are deep.

A military policewoman goes on patrol and chases a car away from a lovers' lane beneath a towering bridge. The policewoman stops to investigate a car suspiciously parked in front of the Officer's Club. She is shot inside its dark interior and the rest of the film is devoted to unraveling the mystery around this murder. Two men escape by car and are pursued through the forested back roads of the Presidio. They exit the fort and career through the streets of nighttime San Francisco at high speed. They escape, but not until we have seen the city by night from its hills. It is a beautiful backdrop to the horrible violence that follows in the wake of the escapees.

Next, we glimpse Austin at the police department, snakeskin boots propped on a desk, wearing blue jeans and a windbreaker. He proceeds to the scene of the crime at the Officer's Club. The interior is now well defined; it is the kitchen area, and dusty light streaks through its pale white and beige interior. Austin and Caldwell meet. We understand they don't like one another.

The following morning, Austin goes to Caldwell's base house. It is a prim and proper white Victorian clapboard, old-fashioned, much like Caldwell himself. The interior is discreet, correct, traditional. But not so the daughter, Donna.

As the story unfolds the various dimensions of the city are explored. There is another auto chase, this time Austin chasing Donna in her Corvette to his flat on a steep hill. His apartment is warmer, more casual than Caldwell's chilly house. He has a fireplace that is lit as the couple emerge from their first lovemaking. They are under an afghan on the floor, a white sofa behind them, and there are books on shelves surrounding them.

The next day finds Caldwell visiting his Vietnam buddy, Ross (Jack Warden), at the Presidio's Army Museum which the latter oversees. They talk about Caldwell's daughter and the crime that has been committed as they walk in a circular pattern through the Museum's musty exhibits displayed behind plate glass. Albert Brenner has used a space with many doorways, and he has paced the architecture to fit the dialog. The patterning of this space has allowed movement in a scene which is wordy and could seem long.

The investigation takes Austin and Caldwell to several locales including a couple of studio built interiors: an opulent and cold modern office, and a smoke filled bar with wooden booths and neon beer signs.

But it is the well-chosen locations, for example of streets in Chinatown, and the way they are tied to the action that makes the film flow so effortlessly from part to part. At one point Austin and Caldwell follow a water delivery truck through the bustling streets of San Francisco and onto the Presidio. The

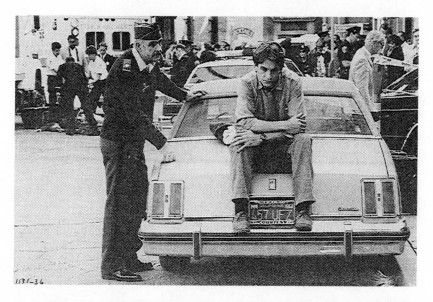

The Presidio (1988, director Peter Hyams, production designer Albert Brenner). In well-chosen locations, like here in Chinatown, Colonel Caldwell (Sean Connery) and detective Jay Austin (Mark Harmon) chase down elusive murderers in San Francisco.

activity of the streets, flowing around them, makes their quest for the murderers more real.

The penultimate scene in the film is the tracking down of the criminals, including Caldwell's best friend Ross, in a water bottling factory on the Embarcadero. The maze of metal conveyor belts and machinery of the factory is streaked with sunlight as the violence unfolds. The film has come full circle from the light streaked nighttime violence that was its opening.

Reversal of Fortune (1990)

DIRECTOR: Babet Schroeder
PRODUCTION DESIGNER: Mel Bourne
ART DIRECTOR: Dan Davis
MUSIC: Mark Isham
SCREENPLAY: Nicholas Kazan, based on book by Alan
 M. Dershowitz
CINEMATOGRAPHY: Luciano Tovoli
EDITOR: Lee Percy

For more information on the production designer of this film, see Part II.

Mel Bourne's work on *Reversal of Fortune,* directed by Babet Schroeder, was a much more straightforward piece of production design than was *The Fisher King* (see p. 39). Yet its straightforward quality, which matches completely the directorial style, is deceptively simple. The correctness of the setting completely matches the correctness of staid Claus von Bulow (Jeremy Irons), the film's main protagonist. There is a cool accuracy in the settings that matches the cold barrenness of the marriage between von Bulow and his wife, millionairess Sonny von Bulow (Glenn Close).

The film opens with a helicopter shot that sweeps over the palatial summer homes of the wealthy at Newport, until it reaches Sonny's "cottage," a mansion surrounded by a baroque garden she calls Clarendon Court. The rest of the film takes place in interiors there, in the couple's New York City apartment, and in attorney Alan Dershowitz's (Ron Silver) residence/law office, a slightly battered, late 19th century house in a quiet residential area near the college where he teaches.

The movie's production design did not have an adequate budget according to Mel Bourne, "We didn't have the money to go to Newport. We didn't have the money to even dress that movie properly."[1] The exteriors of the von Bulow residence were shot at the Lynhurst Mansion, a National Trust property. For the interiors the company took over a Long Island mansion and Bourne changed the plan. "I built the bedroom and bathroom from scratch inside what was the living room, because it was the biggest room, and I used the dining room for the living room. I had to build what amounted to an interior set in an actual location."[2]

The film opens, closes and frequently cuts to Sonny von Bulow in a permanent coma in a hospital room. She delivers part of the narrative from within her vegetative condition (much as the writer in *Sunset Boulevard,* who, found drowned at the beginning of that film, nonetheless narrates it).

"This was my body," Sonny tells us from the hospital room which is frozen under a bluish-white light, as she is frozen in time. The room overlooks a river that Sonny cannot see, and is furnished with antiques, including Louis XV chairs, a style which is favored in her residences. Her bone white body is covered with the same white lace trimmed sheets and white comforter that covered her bed at Newport. Despite these personal touches the room is nightmarish.

Sonny's vast Newport residence is built of durable stone and its rooms seem to have stepped out of the annals of America's monied aristocracy; they are impeccably outfitted with 18th century European antiques. The rooms are designer perfect, meant to please, but not intrude, something like Sonny herself, whose self-destruction is all done behind closed doors.

Sonny spends a lot of time in bed and her Newport bedroom has walls of white paneled boiseries in the French style, a crystal chandelier, and a four poster bed that is placed before a tapestry covered wall. She glides haltingly through this world almost a shadow figure, dressed mainly in grey.

Sonny's bathroom, where she hides away to take drugs, is in a style borrowed from Versailles, covered with multi-colored marbles and mirrors. Its regal coldness is uncomforting and is the place where she falls into her last and permanent coma.

Claus von Bulow is convicted of inducing his wife's coma and hires Alan Dershowitz, a well-known advocate for the poor and disenfranchised, to take his appeal case. Dershowitz first meets Claus at the couple's New York apartment. On entering from the private elevator, his comment on its opulence is, "Holy shit." It too is a mansion in scale and appointments. Dershowitz has stepped into a columned foyer from which a winding stairway leads to upper floors.

In the von Bulow's apartment, all the appointments are of museum quality. In fact one wall of the library has glass enclosed shelves containing an eclectic collection of art objects, including antique sculpture and pottery. Personal touches in this world are constrained to photographs housed in elaborate and expensive frames.

As the story unfolds from various points of view, principally Claus von Bulow's, we see these settings backing up the narrative line. Sonny first falls into a coma around Christmas after she spends a day drinking 10 to 12 eggnogs in the Newport living room. She sits rigidly in a gray sweater and skirt on a cheerful yellow damask covered Chippendale sofa discussing divorce all of the afternoon. The lonely Christmas tree sits in the house's huge arcaded rotunda which has a second story balcony and vaulted ceiling. Even the large tree seems dwarfed and inconsequential in the formality of this severe space.

In a flashback, we see a gorgeous looking Sonny in a gold lamé ballgown at a summer party. She is being told by Claus that he is having a serious affair with a member of their set. Several such flashbacks take place — one when they are first lovers during Sonny's previous marriage, at balls, lawn parties and elaborate dinners.

We learn that Sonny has made a suicide attempt at the New York apartment. It was preceded by the couple arguing in their now loveless bed. The bed's elaborately carved and gilded headboard has Cupid in the center pushing his arms outward as though separating rather than bringing lovers together. Its symbolism is not lost on this occasion.

Dershowitz's house, a large rambling affair, is where in separate rooms the defense team, who are investigating and formulating strategies for Claus' appeal, are ensconced. They work and eat together in these informal and unpretentious surroundings in a friendly way that is in direct contrast to the unfriendly demeanor of von Bulow. When he visits the house to speak to the assembled legal team, Claus appears ill at ease despite his best efforts to appear open and to make light of his predicament.

Although Dershowitz tells von Bulow, at one point, that he does not understand him, Mel Bourne's production design offers the audience entry

into his world of privilege, one which he is afraid of losing. This opens a door to his character.

Claus von Bulow's world is one of wealth, the finest things that money can buy: fine foods, service, yachts, elegant parties. Dershowitz says that from what he's seen of the rich, "You can have them." Von Bulow replies, "I have."

Notes

1. John Calhoun, "Mel Bourne," *Theatre Craft*, April 1991, p. 55.
2. *Ibid.*, pp. 55–56

She's Gotta Have It (1986)

DIRECTOR: Spike Lee
PRODUCTION DESIGNER: Wynn Thomas
MUSIC: Bill Lee
SCREENPLAY: Spike Lee
CINEMATOGRAPHER: Ernest Dickerson
EDITOR: Spike Lee
PRODUCER: Shelton J. Lee

Wynn Thomas has been Spike Lee's production designer since the director came onto the national scene with *She's Gotta Have It* in 1986. The complexity of his designs has grown with the ever increasing budgets that Lee has had to work with on each successive film. But his talent is already abundantly evident in *She's Gotta Have It* on which the design budget was an unbelievable $800.

The visual representation of Brooklyn in this film depends on several elements: a great many exterior street scenes, the principal character Nola's (Tracy Camila Johns) spacious loft apartment, and black and white still photographs. The evocative photographs, many character studies of people doing everyday activities, open the film and recur periodically as the narrative proceeds.

The photographs evoke the exuberance of life in the New York borough. Lots of children are seen playing, old people sit around and talk, and street people just trying to survive etch the richness of life in the neighborhoods of Brooklyn.

The exterior locations provide more of this background, Nola is followed along the street by Jamie (Redmond Hicks), who is smitten with her on first sight as she passes him at a bus stop. They become lovers.

For more information on the production designer of this film, see Part II.

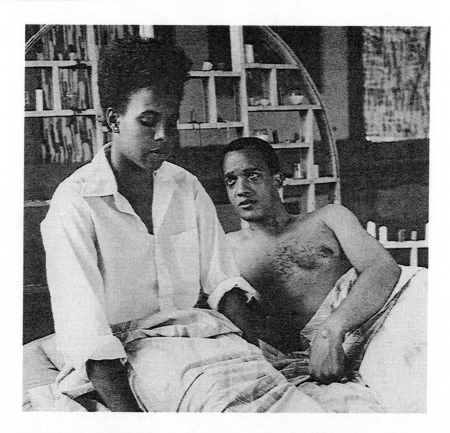

She's Gotta Have It (1986, director Spike Lee, production designer Wynn Thomas). Nola Darling (Tracy Camila Johns) with Jamie (Redmond Hicks), one of her lovers, are seen surrounded by the candlelit bed shrine of her own design. The bed suggests the serious way Nola views her own sensuality.

Later, another of Nola's boyfriends, the conceited Greer (John Canada Terrell), poses in his fancy car and on his patio in a more upscale setting than most of the others in the film. Mars, (Spike Lee), the third of Nola's lovers, is seen mainly on the street on his bike; he's a sort of overgrown kid, very proud of his expensive sneakers and able to make Nola laugh with his childish patter. All three male characters, speak directly into the camera from time to time from the streets. Not much is shown of any of their dwellings; budget constraints seem to have restricted the delineation of their characters to lines in the dialogue.

Nola's loft apartment, the principal interior, is the home of an artist with her art work on the wall. The most dramatic element in it is the setting for her bed, also the focal point of the story which is about Nola's exploration of her sexuality and her freedom as an individual.

Nola prefers making love in her own bed. As designed by Wynn Thomas, it is a sort of shrine to her sexual curiosity; her exploration of this aspect of herself and of her lovers.

Thomas, in an economical and believable fashion, has used simple wooden arches to create a bed shrine that is free-standing and, in looks, is reminiscent of a Gothic tracery window. It picks up the general shape of the apartment's tall windows before which it stands. Nola has filled every one of the multiple layers of this creation with candles which she lights before making love.

The bed setting underscores several aspects of Nola's sensuality. She is romantic and deeply conscious of each of her lovers' personalities. She isn't promiscuous, in the usual sense, because as the setting indicates, she feels deeply about her sensual nature. Love making is a very deliberate act for her involving a certain amount of ritual behavior.

Each of her partners knows part of her and she part of them; she selects them and takes some pains to keep relationships with each of them going. She is simply as she says at the end of the film, "not a one man woman."

One of Nola's large paintings, occupying most of a wall of her apartment, presents in collage form the many issues in her life as they develop and change. Nola is introspective. The semi-abstract work contains images of couples, a crying figure, and Uncle Sam. She pastes somber newspaper headlines, among them "Honor Student Slain"; she is touched by current events, not just those in her own private life. Nola keeps working on the image as the men in her life try to get her to conform to their ways of thinking. She won't. She is separate; she has her own point of view and won't be swallowed up by theirs.

At the end of the film, Nola goes to bed alone, no lover at her side, but the candles glimmering behind her, and she rests certain that following her own path is really what is best for her.

Wynn Thomas, with little design capital, but with tremendous help from the often exquisite lighting of cinematographer Ernest Dickerson, raised an otherwise totally realistic film, in a cinema *vérité* style, into a more poetic realm through his conception of Nola's apartment, especially her bed. His later big budget films allow a lot more range for his imagination, but in *She's Gotta Have It* necessity seems truly to have been the mother of invention.

The Silence of the Lambs (1991)

DIRECTOR: Jonathan Demme
PRODUCTION DESIGNER: Kristi Zea

For more information on the production designer of this film, see Part II.

ART DIRECTOR: Tim Galvin
SET DECORATOR: Karen O'Hara
SCREENPLAY: adapted by Ted Tally from Thomas Harris' novel
CINEMATOGRAPHY: Tak Fujimoto
COSTUMES: Colleen Atwood
EDITOR: Craig McCay
SOUND MANAGER: Chris Newman

The story line in *The Silence of the Lambs*, about the hunt for a serial killer, gave director Jonathan Demme ample opportunity to use the *mise-en-scène* to provide clues to the crime and enhance the film's thematic premises. Such themes as: the loss of innocence, gender identification, and violence in the American psyche are explored in the narrative along the way to the capture of the killer.

Production designer Kristi Zea incorporated strong imagery in the sets and their furnishings that present the *leitmotifs* used to explore these themes. They also provide clues to the killer's personality and obsessions, and finally to his identity. We see, among other repetitive visual motifs, the use of: pits, bird imagery, cats, lambs, cocoons/moths/butterflies, flesh, mannequins, sewing implements, and Americana, like flags and the bald eagle.

The film opens on tree tops and a greyish sky; birds are heard chirping and the flutter of their wings makes a pounding sound as they fly away. As the camera lowers, FBI trainee Clarice Starling (Jodie Foster) is seen climbing by a rope out of what looks like a pit. She's on a fitness course at Quantico, Virginia. It won't be clear until later, but the image of her climbing out of what is actually a steep hillside is a visual simile for the pit in which a kidnapped girl, whom Clarice will try to rescue, is kept in the home of a serial killer.

Several other visual and auditory motifs that will figure recurringly in the film are presented in the first few frames. The birds heard overhead are an initial reference to her name, Starling. Later, the father of the first murder victim will be seen by Clarice tending his birds, domesticated pigeons. Birds can be benign and also malevolent in the context of the film, for imagery of the bald eagle, a bird of prey, will be seen repeatedly. The central theme of the film is of the serial killer preying on "birds" (slang for girls).

Clarice is persistent as she runs the course, and can understand on several levels the sign seen along the way, "Hurt, Agony, Pain, Love it." The sign can be interpreted positively or negatively ... the serial killer she will shortly be assigned to pursue, "Buffalo Bill," inflicts pain on his victims and "loves it," while for Clarice, in running the course the sign is referential to her acceptance of FBI discipline, punishing herself rather than others to achieve her goals.

Clarice is called to the unassuming office of Mr. Crawford (Scott Glenn), who is head of the Behavioral Science Services Division, where Clarice hopes

to work. His office, in the basement of the modern FBI headquarters is the first of several basements that figure prominently in the story. Among its ordinary furnishings — a desk, computer table, and wall hung with commemorative plaques — is one wall covered with gory snapshots of the female murder victims of Buffalo Bill ... the first of several rooms in the film to be covered with photographs. As Clarice gazes at this wall, the camera moves in on a newspaper clipping with a headline that screams "Bill Skins Fifth." The photographs provide a window on the killer; they yield clues to his crimes. Windows, literally and figuratively, are very important to the unraveling of the mystery.

Crawford gives Clarice the job of interrogating already imprisoned serial killer Hannibal "the Cannibal" Lecter, a psychiatrist. He cautions Clarice, "You don't want Hannibal Lecter inside your head." Lousy advice because Lecter and Clarice immediately become locked in head games. Head games, after all, are what psychiatrists know best.

Clarice arrives at the red brick asylum to be told by Doctor Frederick Chilton, the sleazy charlatan in charge of the place, that Lecter "...is a monster." The doctor turns out to be right about this one thing. Chilton leads Clarice ever downward through the institution via a deep stairwell, as the designer, Kristi Zea, turns the building from a benign hospital into an underground dungeon reached through a blood red iron gate. As the pair enter this prison hell a brilliant red light bathes over them. Other "monsters" are confined here too, with Lecter in the last cell along the corridor, penned up behind a window of clear, impenetrable glass. No one is allowed inside and objects may only be passed to him through a sliding tray; he likes to tear living people apart with his teeth.

Lecter's cell is made of rough hewn stone and brick and is decorated with his elegant charcoal drawings of the Florentine Duomo as seen from the Belvedere (which literally means a place affording a fine view). Lecter is a man of culture and a gentleman who would not be "rude." He tests the naive, but smart and ambitious, Clarice with his questions. After she has been insulted by another prisoner, Lecter helps Clarice by giving a clue to the "Bill" killings, telling her to investigate a former patient of his, a Miss Hester Mofet.

The games between them begin as Clarice figures out that Hester Mofet is an anagram for "the rest of me." Lecter, along with the other serial killer, has identity problems. The "Rest of Me" is also the name of a storage facility.

Investigating this lead, Clarice must creep under the sliding door (an obstacle course once again) of Hester Mofet's storage compartment to get into its creepy morass of objects. Her flashlight first strikes a black plaster eagle with wings menacingly outspread. Such traditional symbols of America recur throughout the film around instances of violence. Later, American flags crop up in unexpected places, like the wall with red and white stripes beyond Lecter's cell in a police station in Memphis or after Clarice kills Bill near the movie's end. The obvious inference is that violence and killing are the all–American

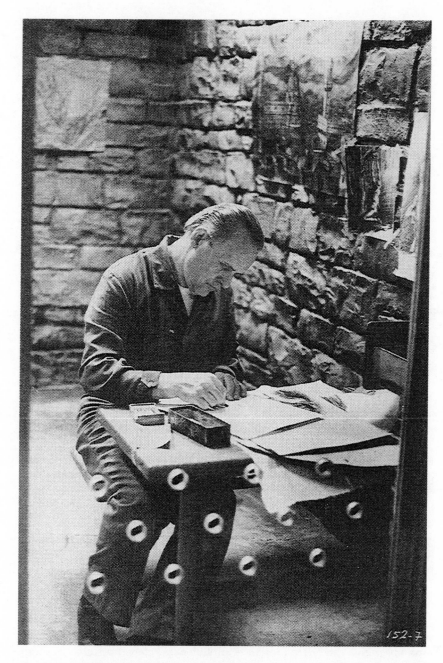

The Silence of the Lambs (1991, director Jonathan Demme, production designer Kristi Zea). Dr. Hannibal Lecter (Anthony Hopkins) in his dungeon cell behind a glass wall makes charcoal drawings of beautiful architecture and human body parts.

preoccupations. Even hinting subtly that there may be something all–American about serial killers, Hannibal Lecter wears first a blue costume, than a red one, and finally an all white outfit.

Clarice's flashlight next falls on dismembered mannequin parts (the first of several images of mannequins), and on an upright piano (Lecter loves music; later we'll see him absorbed in Bach's Goldberg Variations even as he murders two policemen). Then she sees a car draped in the American flag. Clarice opens the car's door to find a decapitated mannequin, elegantly dressed in female clothing, on the back seat. An old book lies beside it and emits tiny fluttering moths when she opens the pages (the first visual injection of the cocoon, moth, butterfly theme into the film). Is this an analogy for Clarice who, like the moths, is beginning to emerge from her own cocoon as a student?

In a bottle hidden beneath a red floral printed cloth Clarice uncovers her last find: the ghastly decomposing head of a man wearing eyelashes and lipstick. The head's smeared red lips are a reminder that red, the color of blood, had already been powerfully and suggestively used in the earlier scenes in the film. It first occurred as tiny Clarice, dressed in blue sweats, stepped onto an elevator in the FBI building at Quantico, the lone female among a crowd of male agents all dressed in blood red shirts. She emerges alone ... Are the men bonded in blood? Hellish red will later suddenly appear when Clarice enters the level of Lecter's dungeon prison. The emotive color red, in the direct form of real blood, makes ever more frequent appearances from this point on in the movie.

Returning to Lecter's cell, Clarice requires some explanations from him: "Whose head is in the bottle?" The components of Lecter's personality, some of them strangely like that of Buffalo Bill — they are, after all, both serial killers — are beginning to occur to her as she realizes Hester Mofet is Lecter. He insists that he is innocent of murdering the man in the jar. It was, he maintains, the first effort of a fledgling killer.

Lecter proposes that for a prison window on the real world, he will help with a psychological profile of Buffalo Bill from the case evidence. The window, as metaphor for understanding, learning, knowledge, is again asserted as a *leitmotif* of the film; Clarice is getting to know Lecter through his cell window of glass.

The action turns to the kidnapping of a new victim by Bill, who stalks his prey through the magnified images in binoculars (later he will stalk Clarice through infrared glasses). In both cases he sees through green light. The green light of covetousness Hannibal calls it. In the penultimate scene of the film, we will learn what Hannibal already knows, that Bill not only covets the woman victim, but he covets her gender. Bill reveals this while prancing in front of a mirror in make-up, his genitals hidden, so that he looks more like a woman.

Kathryn, whom Bill is stalking, is about to enter her apartment building in Memphis. Her cat is meowing a welcome from a window. She calls to it,

"Hey, little cheeper." She is an ordinary, country music loving, gullible, plump young woman, who is easily lured into assisting the killer as he struggles to put a chair into his panel truck. He puts Kathryn in too.

Bill bludgeons her into silence, so that he can find out whether she is his perfect size 14. She is. Bill likes plump girls; he starves them for a few days, loosening their skin then using it in his sewing project.

The scene shifts increase in rapidity from now on, and the next one finds Crawford and Clarice flying to examine the newly found body of another of Bill's victims. During an examination of the girl's body, in the cool green tile and oak paneled funeral parlor mortuary, a rare foreign moth cocoon is found stuffed into her throat. A butterfly pattern of flesh has been removed from her back. Clarice finds two experts who reveal that the cocoon is a "Death's Head Moth," a rare specimen that, she will find, has been imported and lovingly cared for by the serial killer Bill.

At this point, for the first time, the camera shows us the interior of the killer's house. It is a dark scary place, where dog barks and screams are emitted from the depths of the basement.

Clarice and Lecter talk again, she brings him Bill's case file and tries a head game on him; if he cooperates he will be allowed a furlough on an isolated island used, appropriately, as an Animal Disease Research Center. Lecter wants more than this though. He wants to know the story of Clarice's life, of her pain. She reveals the finding of the cocoon in Bill's latest victim and says it was also in the throat of the severed head. Lecter advises her that she is getting close to the way she will catch Bill. He tells her that change is significant and that Bill wants to change too.

The film cuts again to the killer's dungeon-cellar and this time directly to the source of the screams, the girl Kathryn in the well. We have seen basements before, as Crawford's office and Lecter's cell. The implication is that there are prisons of all sorts; some necessary (Lecter's), some institutional (Crawford's mind set), and some unjust (Kathryn's).

Lecter, trussed up like a caged animal, is transferred by Dr. Chilton to the Memphis airport to speak with the victim's mother, who is nothing less than a U.S. senator. The aircraft hangar where they talk is cast tonally in shades of black and of orange. These colors establish the site and are used again in a police facility to which Lecter is transported; the slightly unreal tonality suggests that the "cannibal" cannot function in the real world of color and light.

Lecter is confined in a cage in the center of an enormous room in a police facility; he must always have special treatment because of his ferocity. The room's polished wooden floor and walls hung with lighted pictures are unlike a prison's. As Clarice again approaches the serial killer, the wall behind him is seen to be painted in broad stripes of red and white, reminiscent of an American flag. But there are no stars. This time an American emblem is a precursor to the worst violence in the film.

Lecter's cage has been surrounded by police barriers so that no one can get close to the bars. Clarice shoves drawings he has given her back to him and tells him, "You can see out that window."

The intimate exchange that follows has Clarice outside the bars pacing like a caged animal while Lecter sits calmly under a saturated golden light. She reveals her innermost secret, the screams of the lambs before slaughter when she was a child, and we have our window into her desire to protect and rescue people. Clarice wants to be a savior, like Jesus the Lamb of God; she, in this instance, of serial killer victims.

Much of this scene is done in reverse close-ups by director Demme, which makes both Lecter and Clarice appear to be behind bars. In this way he makes a play on the theme of prisons and prisoners, real and imagined.

Lecter returns the "Bill" file at the last moment as they are interrupted by the bizarre Dr. Chilton. Lecter leads her closer to Bill by telling her to start with simplicity, "What does he do?" he asks. "What does he covet?"

Clarice pieces all the clues together coming to the conclusion that Bill knew his first victim, Frederika Bimmel (called "Freddie" a play on the female/male confusion in the killer's mind).

The action returns to Lecter's cell with a camera pan over his drawings of a beautiful Clarice cradling a lamb. A lamb chop dinner, a special request, is served to him as he listens to Bach. Lecter's diabolical planning produces an escape that conjures up a bizarre series of images. The most telling and repulsive/attractive is that of a large butterfly shape backlit with an eery white light, which the police find while storming Lecter's empty cell. It is one of the officers Lecter has killed and then tied to his cage with American flag bunting.

From the gory scenes of the slaying of the police officers the action shifts to Lecter's escape through a gruesome head game: he cuts the face off of one of the policemen and wears it over his own. The next scene moves to the killer sewing human flesh on a sewing machine. We can only guess what he is making.

These ghastly images are supplanted by views of Belvedere, Ohio, a sleepy all–American town, which was the home of Frederika, Bill's first victim. Clarice is there following up on her deductions about the killer.

Freddie's father gives Clarice permission to look around the girl's bedroom, which has remained unchanged since her death. This house and its furnishings holds the final visual clues Clarice needs to find the killer.

There are no words spoken as Clarice slowly walks through Freddie's world, just the sounds of birds chirping, pigeons' wings pounding the air as they fly away, and the tinkling tone of a music box when it is opened. The view from the window is to Freddie's father tending his pigeons and to a broad river; all of the killer's victims have been found in rivers.

As the camera pans around her room it picks up a book on counting calories (Freddie was pudgy), snapshots taken with her dad, another book *Silken*

Threads, a child's doll house, a porcelain cat, and a picture of her with her cat and a friend. Hidden in the music box Clarice finds photographs of Freddie wearing nothing but underwear and hair curlers and posing shyly for the camera. Kristi Zea's production design, of the house, of Freddie's room and its furnishings, have provided a vivid portrait of a gentle, loving, and innocent young woman.

Clarice spies Freddie's beloved black and white cat in the doorway across the hall and moves into the girl's sewing room. We'll soon find out from Freddie's girlfriend that, "Sewing was her life."

We realize from the objects in Freddie's room what the serial killer has become fixated upon. The walls are covered in butterfly wallpaper. From a cocoon comes a thing of beauty, Lecter has reminded Clarice. Freddie was still in a cocoon of youth, she might have become a beautiful woman. Clarice glances into the closet to find a dress pinned with a butterfly design; it matches exactly the pattern of skin removed from the latest victim's back.

Clarice understands what the killer is after and what he is doing after seeing this room. He is making his own butterfly, a gruesome beauty of human flesh and form. He is making a new self.

Clarice telephones Crawford to reveal what she now believes about the serial killer, but he won't listen. He has solved the mystery himself and is on his way to apprehend the killer.

The interior of Bill's house is the last significant interior setting in the film. We have only seen bits and pieces of it before this point. Now an exterior shot pans over the railroad tracks in quiet Belvedere, to a spacious house on an isolated lot right beside them. It is an old house, and in a stone pit in the cellar Kathryn is seen struggling to lure Bill's yappy poodle, Precious, into the pit with her, while her captor plays with his moth collection, telling them that they are "so powerful, so beautiful."

When Clarice rings the doorbell of the house Bill, at his desk before an American flag, jumps for his revolver from beneath a quilt patterned with a blood red swastika. There is a mannequin in the room. We remember how he likes to sew.

Clarice is given entry; her slow traversal of the first two ground floor rooms tells her everything she needs to know. Butterflies are mounted on the wall. Large skeins of thread attract a large fluttering moth. She draws her gun; Bill escapes into the kitchen and a chase ensues that leads into the bowels of his house through a maze-like basement to the pit with the trapped girl.

During the chase, further frightening visual clues occur until finally Clarice sees the mannequin of human skin from Bill's victims. In a darkened room (his moths like darkness), where he is observing her through the green tone of infrared glasses and covetously almost touching her, she follows the click of the cocking of his gun and shoots him. In the momentary flash of the gunfire Clarice is seen before a flag. The killer dies shivering like a butterfly on a car-

pet of blue bows that look
like wings. One of the gun
shots has broken open a
window in the room, and as
light streams through it a
small American flag flutters
in the breeze. The camera
turns to find a spiral orna-
ment painted with a but-
terfly twirling slowly.

Most of what appears
in the design of the film is
not even mentioned in the
novel by Thomas Harris.
None of the references to
violence in the American
psyche found in the images
of Americana occur there.
The dungeon-like cell in
which Lecter is kept is
obliquely mentioned, but
not described. Lecter has
bars on his cell not the
evocative glass window
wall. Lecter makes no cos-
tume changes in the colors
of the flag. Frederica's father
keeps pigeons but other
bird references are not
recurrent. All of the rich
subtext of imagery dis-
cussed here has been fabri-

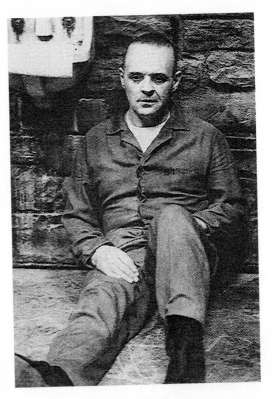

The Silence of the Lambs (1991, director Jonathan
Demme, production designer Kristi Zea). Dr. Han-
nibal Lecter (Anthony Hopkins) sits on the floor in
his cell. The washstand beside him suggests a
human face with the towel covering the mouth.
Lecter, a serial killer, at first won't reveal his secrets
to FBI agent Clarice Starling.

cated by the production designer, with the director and screenplay writer's
assistance, to make a gravitating and unforgettable canvas for the story to be
painted upon.

Kristi Zea's inventive production design has richly added texture to the
screenplay at every moment. It has been wed to the film's plot in intricate ways
that stimulate the viewer's imagination and it has been used by Demme to pace
the film in the absence of words.

Sleeping with the Enemy (1991)

DIRECTOR: Joseph Ruben
PRODUCTION DESIGNER: Douglas Kraner
MUSIC: Jerry Goldsmith
SCREENPLAY: Ronald Bass
CINEMATOGRAPHY: John W. Lindley
EDITOR: George Bowers
PRODUCER: Leonard Goldberg
COSTUMES: Richard Hornung

Sleeping with the Enemy has a simple plot line and deceptively simple contemporary settings. Yet together with the costumes, they cut to the emotionally laden heart of the story. The plot, in summary: a husband is fatally and brutally attracted to his beautiful wife; she fakes her own drowning, runs away, takes on a new identity and meets a nice young man. The husband gets wise, finds her, stalks her and ends up with three bullets in his chest.

The opening sequence sets out the dichotomy in their separate characters, it finds Laura Burney (Julia Roberts) digging clams on the beach at a little distance from a modern International Style house with terraces of concrete painted white and with walls of glass. She is wading and is dressed casually in jeans and a soft blue colored cardigan. In the distance a man approaches, her husband Martin (Patrick Bergin), who strides purposefully toward her in an elegant black suit holding a long flowing raincoat that flutters beside him. The color black will be identified with his malevolent character throughout the film.

The house seems, even at a distance, all his, which it is. To borrow Le Corbusier's phrasing, it is, the perfect "machine for living." Laura, from the first frame, is identified with natural things.

Inside the beach home, everything is hard edged. The dominant colors are black and white — white walls, black leather sofas. The surfaces all shine; the floor is black granite, there are glass and chrome tables, and lacquered cabinets. There is a chilliness about the decor that matches the coldness of Martin's personality. Even the kitchenware is lustrous and black. At night this quality is enhanced by a blue light that filters through the rooms from unseen sources.

Martin is the dictator of his wife's life. Her every move must be calculated for his satisfaction. On the beach she is digging the clams for their dinner, but is told that he has accepted a party invitation. She obediently puts on a white evening dress; he prefers her in black, so she changes. There is a subliminal threat in all of his supposed "suggestions," and a look of fear in her eyes as she complies.

For more information on the production designer of this film, see Part II.

Martin is a total disciplinarian; he exercises ferociously on a machine to achieve the perfect physique. He loves perfection and his wife is perfectly beautiful. "We will always be together, nothing can keep us apart," he assures her.

Unfortunately, although she may be physically beautiful, she is flawed and must frequently apologize for getting things wrong in his house. Martin brings her in from breakfast on the balcony to show her that the bathroom towels have not been left hanging absolutely straight. She is contrite.

Everything in Martin's world has its place, in an order established by him, and nothing may be moved. Cans on kitchen shelves must face forward and be in straight rows.

Laura's role is to keep this order and serve his other needs; she must prepare exquisite gourmet dishes for his meals. He inquires about supper and she rattles off the menu like a waiter in a restaurant.

Their sexual life is run by him and for him and must be accomplished to Berlioz's *Symphonie Fantastique*. The choice of music is appropriate, for Martin's entire life is a fantasy of his own making.

Psychological terror enters the story when we learn that if Martin gets upset, he punishes Laura. At first, the punishment is verbal, but it soon escalates into physical violence, and this has been of long standing. Violence is just beneath the tight surface of his fair, almost translucent, skin.

A new neighbor innocently mentions that he has noticed Martin's wife at the window. He returns to the house where Laura is fixing the exotic flowers that he prefers in a vase. Insanely jealous over this comment, he viciously knocks her to the marble floor and then kicks her. In a maniacal turnabout he immediately sits on the floor to comfort and kiss her. When he leaves the room, director Joseph Ruben composes an overhead shot that uses the decor and the glass walls to box Laura into this setting of luxury and entrapment. On the coffee table in front of the fireplace, we now see that the top of its white surface has a black diagonal cross bar on it, making the forbidden sign. Every freedom is forbidden to Laura in this house. Rarely is modern film decor so explicit, but here Doug Kraner has made it work perfectly.

Laura fakes her own drowning, and says in a voiceover, "That was the night I died, and someone else was saved." She takes a Greyhound bus to Iowa to be near her blind mother whom she has secretly put in nursing care there.

She rents a house that is a polar opposite to her husband's beach house. It's a cozy bungalow (c. 1920) on a quiet, tree-lined street with a wrap around porch complete with a porch swing. The interior is sun lit, the walls are covered with softly patterned wallpaper, the stairs have a bold Victorian rose pattern on the carpet. She repaints the dull green kitchen to a warm yellow and stocks the window sills with violets — no more exotic flowers for her.

Laura changes her clothing style from one of sleek sophistication to one of casual simplicity; her hair flows in curls. Her cooking changes to uncomplicated

fare; she steals some apples for an apple pie from her conveniently handsome, single, caring, college drama teacher neighbor, named Ben (Kevin Anderson). He invites her over for a pot roast supper.

Martin has accepted Laura's death, but one day gets a call in his office that puts him onto the fact that she has done things he has not known about. His office is as chilly as his beach house. It is somberly outfitted with a hard black leather sofa, glass walls, and on the desk top black porcelain apples, the forbidden fruit, one of which he hurls to the ground when he realizes the caller really has known his wife. The caller has casually asked if his wife was not the Laura who had so many bruises from studying "gymnastics."

Martin rampages through the beach house and finds evidence of her survival in her wedding ring that has lodged in the toilet, where she had flushed it away. In the front room he picks up the black basalt head of an Egyptian queen that was a gift to her on their honeymoon and hurls it through a plate glass wall of the house. His goddess has failed him.

Detectives are hired to find Laura. Martin then stalks her and Ben at a nighttime carnival (a Technicolor revision of Hitchcock's carnival scene from *Strangers on a Train*) where they ride a multi-lighted ferris wheel and kiss. The chaos of the carnival rides and lights matches the chaos of Martin's feelings, and in a vivid red light that bathes over his body, Martin is a livid tower of jealously.

Returning to her house later that evening with Ben, it slowly dawns on Laura that Martin is in the house ... the towels are straightened and so are the cans on the shelves. They struggle and she shoots, killing him. In the final shot, he lies in a pool of blood in her foyer, his arm outstretched toward Laura's wedding ring lying beyond him in a streak of light.

In *Sleeping with the Enemy*, the collaborative balance in the film on the production end, particularly its design, costumes and the music by Jerry Goldsmith have elevated this routine scenario and made it into a contemporary story with some resonance.

Sliver (1993)

DIRECTOR: Phillip Noyce
PRODUCTION DESIGNER: Paul Sylbert
MUSIC: Howard Shore
SCREENPLAY: Joe Eszterhas, from a novel by Ira Levin
CINEMATOGRAPHY: Vilmos Zsigmond
EDITOR: Richard Francis-Bruce and William Hoy
PRODUCER: Robert Evans

For more information on the production designer of this film, see Part II.

The psychological thriller *Sliver* takes place entirely in a neostreamlined modern apartment building wired for video in every one of its rooms. It only cost its owner Zeke (William Baldwin) $6 million to set up in this way for his own amusement. He is, quite obviously, a sicko and so is the other male protagonist, novelist Jack Landsforth (Tom Berenger). The heroine, Carly Norris (Sharon Stone), will only discover this in the last convoluted moments of the picture.

The director Phillip Noyce involves us in the video images already in the action that plays out behind the credits at the film's beginning. We first see a video image of the exterior of the modern apartment that the press have labeled "the Sliver" and "horror high-rise," the site of three deaths already. Actually, it is called 113 by the tenants. It is an otherwise anonymous building among the high-rise apartment buildings of Manhattan.

Throughout the film the video images, which are frequently intercut, are always tinted in the cool color blue. The play between cool/cold and hot is frequently suggested in the screenplay by Joe Eszterhas in terms of the players' emotions. The decor by Paul Sylbert continues this theme as does the costume design, which is intimately related to it.

The plot hinges on the murder of a woman, a Carly look-alike, who has lived in the apartment that Carly is about to rent. Carly first approaches the apartment building, in a muted beige outfit, seeking a rental. She seems cool and detached, a businesswoman; she edits books. The apartment has all white walls with hardwood floors. It has many windows and a balcony (from which the other woman, the last tenant, has been thrown by an unknown man). It overlooks the river and other Manhattan high-rises, "I love the view," Carly says.

She is already being watched by the landlord Zeke in his multi-video screening room. He likes the image too. She looks like the last inhabitant, with whom he has had sex, and like his mother, a deceased soap opera queen. He mostly knew his mother through the television set he watched each afternoon after school.

Carly is next seen in her office, walking rapidly through corridors with her friend Judy. She is amiable, her office is small and without much personal reference. Thematically, behind her desk is a poster for "Fire and Ice." Her clothes are drab, beige or black. But when she returns home the cool facade evaporates and we end up voyeuristically watching her masturbating in the circular tub in her bathroom on Zeke's blue video screens and through the color camera eye of director Noyce.

Carly meets both Zeke and Jack in the apartment building, and they attend a cocktail party she gives to inaugurate her new dwelling. Her apartment is warm, filled with traditional furnishings, wooden chairs with golden damask upholstery, jade lamps and candles in brass holders. It is like her, traditional; she is seeking a substantive relationship.

She meets another tenant, a woman, in the hall and helps her bring her luggage into an eccentrically decorated apartment. Golden mannequin forms wear hats, lamps are shaped like flames, the furniture is orange colored. Vida is a coke-addicted prostitute, a friend of Jack's. Later, she is murdered in the stairwell by him.

Carly is attracted to Zeke and ends up in his apartment, but not in his video screening room. His apartment is decorated with modern pieces, high-tech television and other clues to his passion for watching his neighbors through his surveillance system of hidden cameras. He, like Vida the prostitute, has bright orange and red leather chairs and sofa. The floor is covered with an expensive Frank Lloyd Wright–designed abstract rug. His favorite conversation piece is a red volcano lamp. He is obviously not afraid of passion and soon becomes involved with Carly.

After Vida's murder, when Carly is not sure who did it, Zeke declares his love. He shows her his video room, its dozen screens spying upon his neighbors. He can even blow up parts of the images to catch in greater detail their most intimate moments. Carly is at first repulsed by the blue video images and then attracted to them. It is dark in the room, a secret place with blue and black the dominant colors. Although the room is Zeke's real passion, he is cool about it when he tells her how he set it up.

The story in *Sliver* hinges on ideas of privacy, intimacy and the dehumanization of life possible with modern technology. The places where the action occurs are almost entirely in the apartment building owned by Zeke. The building is the set, and the subtlety of its individualized decor by Paul Sylbert translates into character studies of the main players.

The Sunshine Boys (1975)

DIRECTOR: Herbert Ross
PRODUCTION DESIGNER: Albert Brenner
SCREENPLAY: Neil Simon
CINEMATOGRAPHY: David M. Walsh
EDITOR: John Bumet
MUSIC SUPERVISION: Harry V. Lojewski
COSTUMES: Pat Norris
PRODUCER: Ray Stark

On almost half of Albert Brenner's feature films he has teamed with a director whom he has worked with previously. Herbert Ross, the director of *The Sunshine Boys*, is among them. Good working relationships with Gary Marshall,

For more information on the production designer of this film, see Part II.

Peter Hyams, Robert Mulligan, and Sidney Lumet have led to other multiple collaborations for Brenner. Such associations fit an old pattern from the days of the big studios when art directors and directors were frequently paired because they were both under contract to the same management. In today's world of picture production, such collaborations are entirely free-will and speak to Brenner's abilities, as he puts it, "to anticipate what a director will want."*

The Sunshine Boys is one of Albert Brenner's five Oscar nominated films. The other nominations were for *The Turning Point* (1977), *California Suite* (1978), *2010* (1984), and *Beaches* (1988). He modestly claims, "All of the nominations were a complete surprise and I never knew exactly why they were nominated."

Of his design techniques, Brenner says, "To me the concept is always important and I like to stay with the concept, once it has been agreed upon. For *The Sunshine Boys* the concept was that Willie's [Walter Matthau] apartment had been very large when he was a giant in show business. But the apartment got smaller [it was subdivided] as his fortunes declined, but the tremendous amount of memorabilia remained the same. So the apartment becomes progressively cluttered with pictures, playbills and so on."

Brenner continues, "Herbert Ross went with the concept, and I designed the apartment set, which was built in the studio, to the timing of the dialogue so that when Matthau or George Burns [playing Al] walk around the apartment during their frequent arguments, the dialogue would end where he wanted it to in the set. I fit the timing of the jokes to the apartment set."

Brenner had a chance to deal with memorabilia and its display again in the Billy Crystal film *Mr. Saturday Night* (1992). There, the memorabilia appears beneath the opening credits and is a sort of recapitulation of the main characters' entire life, which then unfolds in the action of the story.

The Sunshine Boys is the kind of movie cameramen approve of, Brenner comments. "Cameramen want to see something on every wall. Films are cluttered with something or are no good, according to this thinking." He recalls seeing *Hud* (1963), a film directed by Martin Ritt and designed by Tambi Larsen: "I was amazed when I saw it. It was minimalist, nothing on walls, no clutter anywhere. You can't do that today."

Although *The Sunshine Boys* opens on some location shots in New York City and goes back to location work throughout the picture, most of the dialogue takes place in Willie's apartment, which is first seen when he is old and down on his luck.

There is a large living/sleeping space with a bay window on one wall. But the space is hard to read because of the clutter of the objects in the apartment. Much of it is snapshots, framed photographs, and theater programs of himself and his partner Al in their heyday as the "Sunshine Boys." This is a dwelling

Quotations are from a conversation with the author.

that focuses on memory, as does much of the plot. The walls are wallpapered in floral patterns, long out of date, like the other furnishings. More modern touches, like the television and television tray for eating, tell us what Willie's life is focusing on today. He does not consider himself retired and keeps looking for work, despite the limitations of his memory and despite the fact that his style of comedy is out-of-date.

Early on we learn that the apartment building itself is old, as we see Willie pass through its lobby (the Ansonia Hotel in New York City was used for the exteriors). Once it was the elegant height of fashion, but now it is shabby, like Willie's apartment. Yet the building has retained its marble floor, mail slots, and stainless steel elevator doors — signs of an earlier dignity.

The comedy partners were once very successful, although they are different in every way and, over the years, have developed a complete aversion for each other. We see Al, in retirement, content in a nicely furnished and clean suburban New Jersey home, surrounded by potted plants and a garden. He is enjoying his retirement. Willie is still looking for work. Willie's nephew (Richard Benjamin) wants them to get together and reprise their act one last time for a television program. The story's problem is that they will have to meet to do this and they can't stand one another. Their only method of discourse is arguing.

They do eventually meet in Willie's apartment, which the nephew tries to tidy by picking up trash and bottles that litter what little space is not taken up by the memorabilia. They have to move some of the furniture to make a mock set for their comedy rehearsal and disagree at every turn as to how it should be done.

The apartment is laid out in a circular pattern, with many doorways with heavy frames leading from the old-fashioned tiny white tiled kitchen, to the bedroom/living room, or to the small bath. The two actors move through these spaces at various paces, including a chase which has an angry Willie going after Al brandishing a kitchen knife. They constantly want to move farther away from each other and do by circling the cramped apartment. They are going around in circles, both physically and verbally.

At the television studio Willie has a heart attack, and the last scenes are played out back in his apartment. He has a nurse and the apartment has been cleaned up; the junk has disappeared. The apartment is filled with flowers which have arrived with no card in them. Get-well greetings are strung around the windows and the place actually looks warm and livable for the first time. We realize that once it had been much finer. Its diminishment is a matter of the passage of time, and some hard economic facts of life.

2. Stylized Films Set in the Present

The Fisher King (1991)

DIRECTOR: Terry Gilliam
PRODUCTION DESIGNER: Mel Bourne
ART DIRECTOR: P. Michael Johnston
MUSIC: George Fenton
SCREENPLAY: Richard LaGravenese
CINEMATOGRAPHY: Roger Pratt
EDITOR: Lesley Walker
PRODUCERS: Debra Hill, Lynda Bourne

Terry Gilliam is a director who loves big sets and deftly uses them as major story-telling devices. In pictures like *Brazil* (1985) and *The Adventures of Baron Münchausen* (1988) the imaginative and evocative sets are more like what many European directors, Peter Greenaway, Federico Fellini and others, are willing to conjure up than what most American directors will risk.

American movies have been, from their beginnings, more tied to the realist tradition of the 19th century stage than has European film. No daring scenic genius like the Frenchman Georges Méliès at the birth of films was to be found in America. Nor did America have a period of highly stylized film decor like that of the Germans in the '20s with such expressionist works as *The Cabinet of Doctor Caligari* (1919) or *The Golem* (1920).

The closest that American film ever came to such expressionist decor was in the films of Warner Brothers created by art director Anton Grot, like *Svengali* and *Captain Blood*. They were mostly done with director Michael Curtiz in the 1930s and 1940s. German born director Josef von Sternberg's pictures at

For more information on the production designer of this film, see Part II.

Paramount were also vehicles for strange and stylized settings, particularly his *The Scarlet Empress* (1934) which starred Marlene Dietrich as the Empress Catherine the Great of Russia, on which Hans Dreier was the art director.

Likewise, although American critics and audiences have been appreciative of such film stylists as the Swedish director Ingmar Bergman, directors in America have seldom attempted such personal stylization in their films, except in bits and pieces. Bergman has also relied on richly textured realistic settings, like those in *Nicholas and Alexandra* (1982) and these were more in line with what art directors in America were able from the days of the Silents to produce for the narrative film.

In *The Fisher King* (1991) director Gilliam keeps the acting realistic (except for some scenery chewing by Robin Williams as Parry), while the story line involves elements of fantasy and myth. The principal settings designed by Mel Bourne (see p. 111) are divided between those that are realistic and those that indulge the imagination and come close to European exemplars. Among the settings in *The Fisher King* that are unexpected and bizarre: an encampment site for the homeless which is lit by firelight and by colored spotlights on the structural stone piers beneath a bridge; Parry's subterranean dwelling, a maze of pipes, steam and found objects; a millionaire's "Feudal" mansion on the East Side of Central Park; and an eerie, other-worldly hospital asylum, part Goya and part *Brazil*, with an octagonal core, raked ceilings and huge semi-circular windows.

Throughout the story these evocative settings alternate with realistic sets, like Anne's (Mercedes Ruehl) apartment and video store, and stylized realistic settings like the radio station where Jack Lucas (Jeff Bridges) works and the super modern apartment where he first lives.

The production design of New Yorker Mel Bourne is shown by Terry Gilliam from what seems like every possible camera angle — from low vantage points, from bird's eye views, on slants, so that the correct size of objects is often hard to make out with many things looking abnormally huge (like the bridge piers and the facade of the millionaire's mansion).

The story begins in a radio studio where Jack is broadcasting his vitriolic sunrise talk show. He sits in a small rectangular space that is first approached from overhead by Gilliam's camera. From this angle it appears to be a cage or prison cell because of its narrow confines and because of the shadow play on walls that looks like bars. In color, the set is black and gray with a bluish light filtering over its many machines. Jack harasses and belittles his audience in clothes that match the decor: gray silk shirts, gray trousers or black suits.

The studio is high-tech and minimalist, without human touches. Jack sits in the darkened space wearing sunglasses while tensor lights focus downward onto the equipment that surrounds him. On one wall hard white light emanates from the glass enclosed engineer's booth, where more brilliantly lit machinery forces itself into the image.

Jack preys on the dependent and unhappy people who call him on the telephone, always managing to insult them and the world at large in his comments. His theme song is, "I've Got the Power." He does over at least one regular caller, Edwin, a societal misfit. Jack informs Edwin that he'll always be a loser and referring to Yuppies, he says, "It's them or us." That same night, Edwin goes out and has a murderous shooting spree in a restaurant popular with young professionals; he kills seven people and then himself. This event propels the story.

Jack is on the quest for fame, money and power. He's arrogant, a user. The studio setting corresponds absolutely to his character: cold, modern, and inhuman, and so does his apartment which is created with identical production values. It is high up in a triangulated glass-walled skyscraper, decorated in black and gray, and has chilly touches like a hung, steel staircase in a living room that focuses on a sharp right angle of glass. The apartment is edgy, high-tech modern, filled with photographs of Jack, and completely lacking a human touch.

Jack sits in a bathtub, mud pack on his face, and rehearses a line "forgive me" that he's supposed to deliver for a sit-com that he hopes will make his face as famous as his voice. The phrase will soon resonate in his own life.

In his living room Jack hears, on the three television sets that blink in the sterile environment, about the murders by Edwin and their tie-in with the telephone call to his talk show. He set the killer off.

Titles then bring us to a point three years later. Jack is now living above the "Video Spot" movie rental store with its voluptuous owner, Anne (Mercedes Ruehl), whom he under appreciates and uses like he has the other people we've seen in his life. The first words we hear are, "People are garbage ... pigs," then we see him sitting in the store in front of a poster for *Brazil* (a Terry Gilliam film set in a barbarous future time). Jack looks much the worse for wear. The heavy bags under his rummy eyes and five o'clock shadow betray a wasted lifestyle.

Ann's apartment is like her, comfortable, on the cheap side, but humane, even funny. The apartment is stuffed full of 1950s and 1960s furnishings: couches, a glass table held by a Moor, pole lamps, and odds and ends of the fun times she's had in life.

Jack is a drunkard, haunted by the people he "killed" in the restaurant shooting. One rainy night, he wanders off to find himself in front of the Plaza Hotel. A little boy who calls him "Mr. Bum" gives him a wooden Pinocchio doll, the storybook character who couldn't discern the difference between truth and lies. It seems a proper emblem for his cynic's life.

That night Jack decides to end it all by jumping into the river beneath a New York bridge. Suddenly he is attacked by two young thugs who beat him up and douse him with gasoline thinking he's one of the homeless who are infesting their neighborhood.

Enter Parry, Jack's savior. Parry is first seen in silhouette with a visionary light shining from behind him. Parry is a former university professor who has been half crazed since his beloved wife was killed, her brains blown all over him in the restaurant slaughter of three years earlier. The rest of the story involves Jack and Parry's reciprocal rescue, both psychologically and spiritually, of each other.

Parry takes the beat-up Jack to the places of his world; all the major settings of the film. They first go to "a place with great ambiance," which turns out to be a squatters' camp beneath the stone pillars of the bridge. It is wondrously lit with white and blue lights. By camp fires, the fringe dwellers carouse to the stupefaction of Jack.

Next morning Jack awakens in Parry's "home," a subterranean boiler room which he has filled with found objects and candles. Jack is not allowed near Parry's Holy of Holies, a candlelit alter dedicated to the Holy Grail, and covered with memorabilia, particularly of his wife.

The spaces within this maze of pipes, tubes, and junk are hard to make out and the humans look uncomfortably confined by it in a way that is similar to Jack's confinement in the prison of his radio studio. Beyond the physical constraints, we see that both men are in psychological cages of their own making.

Parry explains that the "little people" who appear to him have told him that Jack is "the One" to help on his quest for the Holy Grail, which is being guarded by a fierce Red Knight. The Grail, he says, is in the possession of a millionaire who lives off Central Park. Jack balks at this strange pronouncement and leaves giving Parry the Pinocchio doll. The fictional character now symbolizes both of them, for neither can face the truth of their own realities.

Madness closes in on Parry whenever the death of his wife begins to surface and drunkenness closes in on Jack when he thinks of how his callous ambition and heartlessness led to murder. Parry's Red Knight represents, on a literal level, the "red night" when his wife's blood and brain splattered over him in the restaurant. The Red Knight on horseback spews fire from his head, like the real pain of memory in Parry's head.

Parry has located the "Feudal" mansion off Central Park of the millionaire with the Grail (which is actually a sports trophy Parry has seen pictured with the man in a magazine) and shows it to Jack. Mel Bourne created a mansion that has a massive brick facade, complete with corner turret, stained glass windows, and roof top crenellations. It looks impregnable, but its walls later will be scaled by Jack when he returns to steal the Grail for a catatonic Parry.

The trip to see the mansion eventually lands the pair inside Central Park and into combat with the Red Knight. After rousting him, Parry lies nude on the grass to engage in "cloud busting," one of his favorite activities. Gilliam's use of a park setting, at moments menacing and then pastoral, is one of the best seen in films since Antonioni's *Blowup*.

The Fisher King (1991, director Terry Gilliam, production designer Mel Bourne). *Left to right:* Parry (Robin Williams), Anne (Mercedes Ruehl), Jack (Jeff Bridges), and klutzy Lydia (Amanda Plummer) have a hilarious accident-filled dinner in a flashy booth at a Chinese restaurant.

In a realistic/surrealistic sequence Gilliam next comments on society's attitudes toward the poor and homeless, and on the power of romantic love to transform perceptions of the world. Jack and Parry chum around with some of the panhandlers in Grand Central Station as Parry seeks to catch a glimpse of his enamorata, a homely unloved office worker who doesn't know of his existence. People pass through a Grand Central Station concourse oblivious to the pain and squalor around them. They dutifully drop coins into panhandler's cups so they won't have to look at or feel anything about them. But when Parry spies his "lady," Grand Central Station changes from a place of gritty reality to a place of dreams. It becomes, in Parry's mind's eye, a giant ballroom, the hundreds of passengers turning into waltzers and the clock in the main concourse showering sparkling light down on the transformed scene.

At Jack's insistence, he and Anne become involved in "helping" Parry. Jack, in reality, is attempting to expiate his guilt. The couple devise a plot to introduce the shy bum to his even shier lady love, the klutzy Lydia (Amanda Plummer). They lure Lydia to the Video Spot with an offer of free rental videos.

There follow some of the funniest moments in the film, as the four of them eat at a Chinese restaurant. Mel Bourne's set picks up the wild and silly mood of the scene. The two couples sit in a booth, whose background is an exaggeration of outlandish Chinese-American restaurant decor. Behind their booth, the wall is covered with orange silk and gilt-carved dragons on a field

of back-lit blue grass. Gilliam is able to let the riotous decor make a full comment on the joyous action, reinforcing it by pulling back both at the beginning and end of the scene to view the set in its total splendor.

The Fisher King's last haunting and persuasive setting is the hospital asylum where Parry is confined after a horrible beating by thugs. Mel Bourne has made this hospital setting arresting in ways that hospitals seldom are in films. He's created an octagonal commons room at the center, whose ground level columns carry an upper balcony, all of it lit by an overhead skylight.

Parry's bed is in a long, broad corridor with a ceiling that slants on a raking angle toward large semi-circular windows. The interior spaces are separated, in an old-fashioned institutional way, by stark white curtains on metal rods. Light filters into the whiteness of the interior in an atmospheric way from behind the curtains; it is both tranquil and otherworldly. As the camera passes through the interior spaces, images of demented inmates are used by Gilliam as framing devices. It is not like anything we've ever seen in real life, but is like something we might have seen in a dream.

The Fisher King is part fantasy and part morality play. Mel Bourne's production design pulls from the real world of New York City streets and from a visionary world. Many of his settings are dream-like, both bad dreams and good dreams. It is a cement for the rambling story and its many plot turns, as it makes visual the words of Parry's favorite song, "I Love New York in June."

Return of the Living Dead (1985)

DIRECTOR AND SCREENWRITER: Dan O'Bannon
PRODUCTION DESIGNER: William Stout
MUSIC: Matt Clifford
CINEMATOGRAPHY: Jules Brenner
EDITOR: Robert Gordon
MUSIC: Matt Clifford

When I asked William Stout whether directors can visualize a film, he replied without hesitation, "Almost none. Dan O'Bannon on The Return of the Living Dead could." The three principal sets on that film: the Uneeda Medical Supply Building, a cemetery, and the Resurrectional Funeral Home take a terrible beating in the course of the action, a not infrequent occurrence in horror films. They are torn up, boarded up, assaulted by chemicals, and at the end are bombed out of existence.

The compact settings (all of them are located next to each other on the same city block in a fictive Louisville, Kentucky) house the overwrought action

For more information on the production designer for this film, see Part II.

of the plot, which has corpses rising from the dead fueled by a mysterious substance. The medical supply company looks all normalcy from the outside, but from the inside is seen to be the repository of skeletons, halves of dead dogs, and other curiosities including corpses of the "living dead." These are cadavers that have been stored and misplaced by the army after their "escape" some years ago when activated by chemicals.

There is an upstairs in the medical supply warehouse, where the strange materials are stored, and a basement where drums hold the dead who will escape again to eat human brains thus assuaging their rage against the loss of life.

The early scenes of the film acquaint us with all the major spacial settings, so that when the action really takes off we are on familiar turf. A cut is made early in the story from the major settings to the opulent mansion of a stiff-necked military commander on the Pacific coast. The hard-bitten soldier is in charge of looking for the missing corpses. His well appointed house is removed and cold, a match for his personality. Later he will give the nod to killing 4,000 people in order to wipe out the "living dead."

Early on, we meet a group of rowdy teenagers on the streets. They decide to wait around and pick up their buddy, Freddie, from his first day of work at the Uneeda Medical Supply warehouse. Tired of cruising, they decide to camp out in the cemetery adjacent to the warehouse.

Of all the sets, the cemetery most belies William Stout's background in illustration and comics; it looks like it stepped right out of a comic strip. It is classically creepy; walls surround its eerie gnarled trees, tombstones and above ground sarcophagi. All of the elements in the cemetery are cast in the rays of the setting sun as the teenagers enter. Slowly, as they tramp about it becomes pitch dark. Then raking blue and white lights are bounced off of the monuments, casting theatrical shadows. In a while, cadavers will emerge from the oozing, puddled soil. This puts a slime over the "living dead" which clings to them as they menace the humans.

The bumbling medical supply workers, Freddie and his boss, attempt to contain the anarchy that they have loosed by accidentally spilling chemicals. They burn a body (the only one they presume has been affected by the spill) in the crematorium of the Resurrection Funeral Home. The mortuary setting is appropriately sinister with its sterile, mechanistic embalming room that harkens back to the laboratories of mad scientists of earlier horror stories. The funeral parlor is done in traditional decor and is traversed, upstairs and down, as the humans try to escape the tide of "living dead" that have been unleashed.

The story becomes increasingly fast paced as it unfolds, and the sets, after their purposeful introduction, are just backdrops fleetingly perceived behind the heinous goings-on of the "living dead." They are "realistic," but in an affected way that partners the absurdity of the plot.

3. Period Films

Amadeus (1984)

DIRECTOR: Milos Forman
PRODUCTION DESIGNER: Patrizia von Brandenstein
ART DIRECTORS: Josef Svobota (Opera Sets), Karen
 Cerny
SCREENPLAY: Peter Shaffer
CINEMATOGRAPHY: Miroslav Ondricek
COSTUMES: Theodor Pistek
MUSIC: conducted by Neville Marriner
PRODUCER: Saul Zaentz

In *Amadeus*, the elegant sophistication of early 18th century Rococo architecture — palaces, churches, theater, houses — is brilliantly played off by director Milos Forman and his production designer Patrizia von Brandenstein against the somber setting of an insane asylum inhabited by the narrator of the movie, the composer Antonio Solieri (F. Murray Abraham). This is done in a manner that is analogous to the way that the wit, insolence and joyfulness of his imagined antagonist Wolfgang Amadeus Mozart (Tom Hulce) is played off of Solieri's own serious, obsequious, and joyless persona.

Peter Shaffer's screenplay cuts to the heart of Solieri's fixation on Mozart which has led to madness, in the opening sequence. A snowy lamp-lit Viennese street (the locations are done in Czechoslovakia, mostly in Prague) is seen and within seconds we hear a jarring hysterical scream uttering Mozart's name. Solieri is then seen racing up palatial stairs to barricade himself behind marquetry doors of exquisite artistry, which his servants plead with him to open.

For more information on the production designer of this film, see Part II.

Alarmed by Solieri's sobbing they force entry to find the old man has cut his own throat.

The excesses of Solieri's life are music, God, and ambition, references to which have been assembled in the few seconds of the opening: in the scream of Mozart's name, in the icons on Solieri's walls, and in the rich surroundings which attest to his success. This is a perfect mesh of screenplay, art direction, and acting managed by director Milos Forman to thrust the audience into the emotionally overwrought center of the story.

We see Solieri carried away in a wicker stretcher to an insane asylum, of long white vaulted corridors, where the inmates in various states of mental agony line the wall, many of them in chains. Solieri proceeds to tell his tale of malevolence toward Mozart to a priest in his lonely cell. The first portion of the film is told in flashbacks with cuts between the past and the present of Solieri and the priest.

The composer recalls seeing Mozart as a child prodigy in a resplendent palace setting when he first realized, "I was jealous." Solieri pursued his own musical education and eventually found himself in Vienna, a piano tutor to the Emperor Joseph, and one of the most famous composers in Europe. The flashbacks of this section are economically handled until the first big set of the film occurs, as Solieri describes, "the night that changed my life." Mozart's music is about to be played in the grand salon of the Prince-Bishop of Salzburg, Mozart's benefactor. It is a sumptuous Rococo hall of white boiseries, stucco ornamentation, candlelit sconces, polished mirrors and Louis XV furniture.

Solieri, seeking to meet Mozart, enters an antechamber containing the buffet for the guests; tables are heavily laden with ornate piles of sweets, game and other costly dishes that have stepped out of a book on 18th century festivals. A bouncy well-endowed young lady rushes into the room and hides beneath a table; Solieri secretes himself behind another table and peeks through a Meissen candelabra as the action unfolds to his deep disgust. Mozart enters, and in the spirit of a mischievous child plays hide-and-seek with Costanza (Elizabeth Berridge), his landlady's daughter and soon to be his bride. Suddenly noticing that his music is being played without his direction, Mozart scampers through an enfilade of doorways and Rococo rooms to take over the baton.

As in all of the palatial settings of the film, Mozart seems completely at home — he has, after all, been brought up in there as a prodigy — and at the same time oblivious to his surroundings. Unfortunately, he is also sometimes oblivious to the elevated status of the occupants of these rooms.

We learn, in the course of the story, that Mozart actually loves the good life: precious objects, elegant clothes and wigs, and spending money, but takes nothing but his music really seriously. Solieri takes little but music and God seriously. A vow to God has led him to eschew the hedonistic pleasures of this world, so that God will bless him with a great musical talent. He has shown

fidelity and austerity in his life but God has failed him, for on hearing Mozart's music he comments bitterly, "I am the patron saint of mediocrity."

Milos Forman makes much of Mozart's tiny size in comparison to the vast spaces in the palaces. Yet the composer more than fills them with his personality and his music. This is particularly true in the scene where he is first interviewed by Emperor Joseph. Mozart is escorted, again through an enfilade of elegant tapestried rooms, by a liveried doorman (the actual location is the present Cardinal of Prague's residence). He does a comedic little skip and dance trying to see around the large man. The emperor is playing a Solieri march to honor Mozart's presence. Mozart's fluttery gestures on entry make light of the pomp of the court ceremony, yet as he sits down at the piano to improve on Solieri's march his mercurial nature becomes magisterial.

The Royal Theater (Prague's Tyl Theater) is central to the film's action; it is where Mozart premieres his music in the film and where he actually conducted the first performance of *Don Giovanni*. The theater's interior is in the tradition of intimate, horseshoe shaped theaters of the 18th century as they were built around Central Europe. Mozart conducts the innovative *Abduction from the Seraglio*, for the emperor (Jeffrey Jones) in the light from a setting of hundreds of flickering candles. The emperor and courtiers are seated in the orchestra on silver trimmed red damask chairs, while Solieri bathed in red light lurks in a corner of one of the boxes. As the opera progresses, and Solieri's jealousy smolders, the light on him changes to a dark crimson red and we hear him in a voice-over telling his priest confessor, "My heart was filling up with hatred for that little man." Solieri begins plotting to destroy Mozart.

As Mozart's music is increasingly rejected by the court due to Solieri's machinations, the composer turns to the popular Comedic Theater for the production of his work. This popular theater is a comfortable, but not opulent circular room, again lit by the glow of candles. The audience stands, jostles each other, and generally submits to the music while participating in it in a hearty way. It is at a performance of his *Magic Flute* at this theater that Mozart's illness surfaces publicly.

As transitions between dialogue scenes, Forman injects exterior shots; of Mozart conducting an outdoor concert in a magnificent orchestra shell, again a small figure in a mammoth architectural setting. Also, Viennese streets are of importance and especially a hilly, narrow street near Mozart's rooms. In good times Mozart bounds up the hill and later its snow and slush seem fitting accompaniment to his devastating illness as he attempts to drag himself to work and back.

Mozart and his wife live in small, unkempt, but finely furnished rooms.

Opposite: *Amadeus* (1984, director Milos Forman, production designer Patrizia von Brandenstein). Mozart (Tom Hulce) conducts the orchestra in one of the film's lavish location settings in Prague.

Antique furniture, Mozart's writing desk in particular, attest to his taste and his fortunes. At the end, when Solieri takes the gravely ill composer home from the Comedic Theater, most of the furniture has been removed by creditors.

Mozart's funeral is a coda to the film's story. In a pouring rain, the funeral party stops at the town's gate and Mozart's body in a rented coffin is taken alone to the graveyard where he is deposited with other paupers. As the cart with Mozart's coffin heads down the narrow road, a herd of cows and herdsmen cross behind it; ironically making of this tragic day for the history of music the most ordinary of days.

The magnificent music of Mozart, conducted by Neville Marriner, is exquisitely presented throughout the film and is matched in the costumes of Theodor Pistek, and the settings by von Brandenstein. A credit to her design skill is the fact that the 20 built sets blend seamlessly with the well preserved locations seen in the film. There is no air of the filmed play in *Amadeus*, and a major factor is the many distinct settings created by the production designer.

Barton Fink (1991)

DIRECTOR: Joel Coen
PRODUCTION DESIGNER: Dennis Gassner
MUSIC: Carter Burwell
SCREENPLAY: Joel Coen and Ethan Coen
CINEMATOGRAPHY: Roger Deakins
EDITOR: Roderick Jaynes
PRODUCER: Ethan Coen

In *Barton Fink*, the settings resonate with the film's several somber themes, like the arrogance of intellectuals, especially those who conceptualize the "common man." It's about what can be known of others' rational mind, and what can never be known of the feelings of others, of their particular pain.

Brilliantly directed by Joel Coen and produced by his brother Ethan, the screenplay for *Barton Fink* was written in collaboration by them.

In the Coens' films, *Miller's Crossing* and *Barton Fink* there are subtle hints to themes or plot line creeping virtually unnoticed into the decor, like those found in Polanski's *Chinatown*. Everything in each frame is in place for an absolute purpose. In this regard, their films are like Renaissance paintings. Meticulous planners, the Coens storyboard the whole picture before they begin filming. Production designer Dennis Gassner, who worked on both pictures,

For more information on the production designer of this film, see Part II.

has produced a minimalist decor, to suit the Coen's method, their wordy screenplays and their stylized direction.

The opening titles of *Barton Fink* are seen over beige wallpaper which carries a large leaf pattern; it is the first of several progressively assertive and then menacing wall coverings.

The action begins backstage on opening night in a Broadway theater; it is 1941. An actor's voice is heard as the camera pans down to the playwright, Barton Fink (John Turturro), standing anxiously in the wings. It's apparently a social-conscience raising tale about fishmongers and milkmen. Fink, we'll soon learn, wants to be the voice of "The Masses." Yet, in elegant evening dress, he seems perturbed when a "common" stagehand rather than an actor does a fishmonger's cry as part of the action on the stage.

Fink then joins friends who are celebrating his success in a posh Art Deco restaurant and bar (the real ocean liner, the *Queen Mary*, only slightly disguised). Super serious Fink declares his play to be "merely adequate" and yearns to write for a "real living theater" of the common man.

In the chrome and mirrored bar, Fink and his agent discuss the possibility of capitalizing on his success by accepting an offer from Hollywood to write for big money. Fink is messianic in his zeal for a proletariat theater and misses the joke when his agent suggests that there might just be one or two workingmen in Hollywood.

Coen cuts to surf pounding onto a rock along the California coast, which lets us know that Fink has capitulated and accepted the Hollywood offer. Fink, dressed in a wool overcoat and carrying his valise, is seen passing through a vast hotel lobby stuffed full of easy chairs, spittoons, tables with lamps aglow, large tropical plants and slowly whirling fans. It's hot in L.A.

Fink seems tiny and lost in the cavernous unpeopled lobby which cinematographer Roger Deakins has lit with the soft glow of the many table lamps and with sunlight that streaks in through unseen windows in the upper reaches of the room. California's physical beauty will be kept safely at bay by New Yorker Barton Fink, until the very last scene of the film. The spaces of the hotel will remain lonely and unpeopled, except for Charlie Meadows, Fink's next door neighbor, and Chet the bellboy.

After Fink rings an echoing bell, Chet comes up through a trap door in the floor behind the front desk. What's beneath the surface of this hotel? Chet has Fink register on stationery that reads: "Earle Hotel, a day or a lifetime." The phrase is cautionary for the tale that will unfold between Barton and his neighbor Charlie.

The eerie feeling in the 1930s lobby continues into the sixth floor corridor that Fink enters after a ride up with a semi-comatose, skeletal looking elevator man whose face is pitted with a long scar. The length and emptiness of the corridor heightens a tension and anxiety that the shabby hotel evokes from the start. The corridor's wallpapered walls have a brown background with green

and yellow palm fronds splashed over them; nature will continue to be eviscerated, abstracted and reproduced in the decor of the film. Brown wooden doors, opaque glass light sconces, and periodic ceiling arches punctuate the corridor, that seems endless as Fink walks to his room which is directly in the middle.

Fink's room, the main set of the picture, will soon become his prison. Its box-like space has the feel of a prison cell. Two windows stare out onto the brick wall of another building, a usual occurrence in New York hotels, but not in California hotels. He has sought out this particular hotel, because it isn't "Hollywood."

The room's drab and spartan furnishings include a squeaky double bed on one side and a desk against an opposite wall. Fink sets up his Underwood typewriter on the desk directly below a tinted photograph of a girl on a beach with rolling surf in the distance and a striped beach umbrella beside her. She wears a two-piece bathing suit and faces the sea, shielding her eyes as she looks out over it. This image represents the California most people yearn for ... a place of sensual pleasure and a carefree lifestyle in the sun near the sea. Fink becomes fixated on this image, his eyes returning to it over and over. In Fink's room, the only real reminder of that California is the shimmer of sunlight that comes in through the windows.

Fink goes to bed and stares straight upward into a peeling ceiling. This is only the beginning of the gradual physical deterioration of his room; an analogue to the deterioration of his mental faculties as he tries to write for the moving pictures.

Fink has been summoned to the office of the head of the studio, Jack Lipnick (Michael Lerner). Brilliantly lit from the ceiling and from two French doors behind Lipnick's desk, it is an oblong space. Fink travels the length of it to be welcomed and later to be fired. It's modern in the Art Deco manner with a double curved entry wall of glass brick and two pretentious semi-nude sculpted Atlas figures that are encircled by the company's "Capitol Pictures" logo. This is an elegant office with pale wood wainscoting, designer furniture and semi-abstract pictures on the walls. Its character is pure artifice and in stunning opposition to the vulgar character of its occupant, Lipnick, who looks a lot like Louis B. Mayer and talks like Harry Cohn. It is a room designed by the studio art department as he models himself as a fictive colonel.

Fink's assignment is to write a wrestling picture "with that Barton Fink feeling" to accommodate star Wallace Berry. Fink doesn't go to the pictures, hasn't seen a "wrestling" picture (a non-existent genre, but close to the boxing picture formula), and probably doesn't know who Wallace Berry is.

Returning to his room, through the hotel corridor now lined with pairs of shoes waiting to be polished, belonging to men he'll never see, Fink is worried. He sits before his typewriter but can't concentrate because of the sounds of a man's muffled voice sobbing, laughing and moaning in the next room.

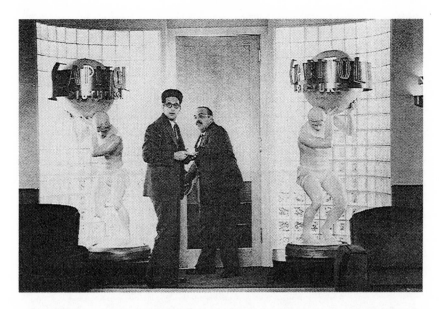

Barton Fink (1991, director Joel Coen, production designer Dennis Gassner). Barton Fink (John Turturro) is intimidated by the head of Capitol Pictures as he tries to leave by an office which is flanked by semi-nude Atlas figures standing before a curving glass brick wall. Lou (Jon Polito), the resident flunky, escorts him out.

Barton calls down to the bellboy who rings the man's room. Within seconds, the neighbor, Charlie Meadows (John Goodman) looms in Fink's doorway; a big, blousy, fat man holding his head and dwarfing the short and skinny writer. Charlie invites himself in, sits down on the bed, and offers Barton a drink from his pocket flask. They talk professions. Charlie says he sells "peace of mind"; he sells insurance. This is the first of Barton and Charlie's emotionally laden conversations, which always take place in Barton's room.

Barton, posturing and exclamatory, says he wants to write about real people, their hopes and dreams, people like the insurance salesman himself. Charlie injects, "I could tell you some stories." But despite two additional repetitions of his offer, Barton doesn't stop to listen to Charlie. He doesn't need to listen, because he holds a finished concept of the common man, of Charlie, in his head.

Later, after Charlie leaves, as Barton stares down at the paper in his typewriter with the few lines he has written, the room's ugly grayish wallpaper begins to peel off the wall. Glue oozes out of the seams between the sheets of paper as he tries to press it back onto the wall; the slimy substance gets all over his hands.

Fink returns to the studio seeking help for his "writer's block." A frenetic producer tries to take him in hand and then he seeks out help from W.P.

Barton Fink (1991, director Joel Coen, production designer Dennis Gassner). An uninspired Barton Fink (John Turturro) leans back in his chair in an overhead shot down onto his desk with its silent typewriter. In a surreal shot, Barton seems detached from the surroundings as he is suspended above the garish floral carpeting of his hotel room.

Mayhew (John Mahoney), a distinguished novelist, who is a cross between F. Scott Fitzgerald and William Faulkner in their Hollywood days. They meet in a men's room where Mayhew, a drunk, is retching. Barton is invited to Mayhew's office in the writers' building for counseling, but only gets to talk with the great writer's private secretary/mistress, Audrey Taylor (Judy Davis). She's

keeping a ranting and raving Mayhew out of sight. The sympathetic Taylor sizes Fink up at once, and asks him not to judge them. Barton idolizes Mayhew and thinks he knows the kindred "creator," but all he knows is his intellectualized construct of him, similar to the mental construct he has of the "common man."

While trying to repair the deteriorating wallpaper of his room with the temporary expedient of tacks, Barton hears the sound of lovemaking through the wall. His own repressed sexuality, expressed thus far in the obsessive way he looks at the girl in the photograph, is made explicit as he presses his ear to the wall, and the camera zooms into the hole in his typewriter ribbon holder.

The extroverted Charlie bursts into a startled Barton's room, making himself at home there. He's got an infected ear, it's "a chronic thing" that he stuffs with cotton to keep the pus from coming out. The unsettling idea of pus coming out of an ear reverberates to the pus-like glue seeping out of the seams of the wallpaper in the room. Charlie says he'd trade in his head for a new one. Quickly passing over Charlie's pain, Barton sermonizes on how really painful the "life of the mind" can be.

Barton's anguished creativity consumes much of his thought, and in the next setting, a picnic in a roadside park with Mayhew and Audrey, he explains that "…good work is not possible without personal pain." Mayhew retorts, "I just like making things up." The novelist gives Barton a copy of his book, *Nebuchadnezzar.*

The park is on a curve in the highway which makes it appear to be between two roads, two separate pathways. In the right background is the opening into a tunnel. Recurring tunnel images seem to be metaphors for Barton's blocked vision and his sexual frustration.

The tunnel images and the black hole recur in the film, when the camera passes down the tunnel-like (by radical foreshortening) hotel corridor and again when it moves into the eye of the typewriter. Later after Barton has had sex with Audrey the imagery is more explicit as the camera pans into the bathroom and then zooms into the drain opening which becomes a dream image of a dark and perilous tunnel.

The director cuts to Barton's room, where from the first, beside the peeling, oozing walls, he has been harassed by mosquitoes. They buzz over his bed, sucking blood that leaves welts on his face in the morning … he covers these with Band-Aids, an expedient like the tacks, but, like them, doing nothing to alleviate the problem. These blood-sucking insects are obviously referential to the human vampires, like Lipnick, in the studio system, whose pretense of respect for writers veils their contempt.

Charlie barges into Barton's room and complains that people can be cruel; they make comments about his weight. Then he asks, "How goes the life of the mind?" It doesn't go well; Barton can't even get started with his screenplay.

Charlie is going away to the head office in New York, which unnerves

Barton, who has come to depend on him. He'll return, he says: "This [the hotel] is home to me." They watch together as more wallpaper peels from the wall. Is it the heat?

Barton's neurotic behavior intensifies as the deadline for presenting his film outline nears; he's terrified and regresses to an infantile status. He has tantrums, walks in circles and in desperation calls Audrey for help. She comforts him; they have sex. In the morning he finds her dead in a pool of blood. Screaming hysterically Fink rushes to Charlie's room for help, dressed in little boy one-piece underdrawers. "I didn't do it," he says as he cringes in a corner. Charlie takes over and disposes of the body.

Barton is put in charge of keeping a large square brown paper wrapped box during his friend's absence. Charlie cautions, "keep your head," which sounds like good advice, especially when in the next scene, we learn that the insurance salesman is a shotgun murderer who decapitates his victims.

Charlie explains that the box contains personal stuff, all he has kept from a lifetime. "It's more than I've got," replies Fink. Charlie's comment as he leaves, "Good-bye compadre [comrade]," has a double thrust — besides being a proletarian salute it now refers to their being partners in crime.

On the way out, Charlie magnanimously tells Fink to keep the box for "good luck," and to use him as the inspiration for his wrestler. Fink, lost and alone, sobs uncontrollably. Director Coen fades to the hall corridor as the camera keeps pulling back through the tunnel-like space.

Barton Fink again sits transfixed before his typewriter, but this time he spies a Gideon Bible in the desk's top drawer which he opens to the story of King Nebuchadnezzar in Daniel II, verse 5:

> The king Nebuchadnezzar, answered and said to the Chaldeans, I recall not my dream: if ye will not make known unto me the dream, and its interpretation, ye shall be cut in pieces, and of your tents shall be made a dunghill.

Fink flips to Genesis I, the creation story, and his own paltry first lines of the wrestling movie appear as the opening verses, followed by the actual Biblical verse, "Let there be light, and there was light." There still isn't any for the writer.

Detectives, a German and an Italian, in the cavernous hotel lobby, tell Fink about Charlie's (his real German name Karl "Madman" Mundt) murders and that Audrey has been found dead and without her head. Returning to his room and rattling the box, Fink begins at last to write, with the box on his desk (for inspiration?). He puts cotton in his ears against noise, and writes intensely until he has completed something "really big." In a large USO canteen he dances wildly and ecstatically telling the crowd, "I create for a living. I am a creator." Pointing to his head, he says this is how he serves the common man.

Returning home down the empty corridor and into his room, Fink interrupts the cops reading his manuscript. They say Charlie has struck again, Mayhew has been killed, and they ask if he's the "idea" man behind Charlie's murders. Barton feels the heat in the room, "It's hot, he's back."

The cops hear the elevator and see flames begin to lick up between the cracks at its door. As Charlie steps out and faces the cops down the hall, flames break out from beneath the doors on either side of the hall.

Charlie looks like the devil in the bowels of hell on a medieval tympanum. Flames shoot all around him, as he hollers, completely insane, "Look upon me, I'll show you the life of the mind." Then he blasts both cops with his shotgun, shouting "Heil Hitler" as he blows one's head off.

The Coens have placed the movie during the first years of World War II, and although the specific handling of the theme is weak, seem to point us toward identifying the madness of common man Charlie (not coincidentally of German extraction), with the madness of the German common people who elected Hitler. Barton Fink, a Jew, then becomes, symbolically, the over intellectualizing Jews of the Weimar Republic, who misunderstood the intentions of their fellow citizens, the German masses, whose virulent anti–Semitism was, by analogy, the pus emanating from the head of the body politic.

In the verses from the Book of Daniel Fink has read, the Chaldeans interpret the dream, and placate the King. They rescue themselves. Further along, in the Book of Daniel, in Chapter III, three Jews are thrown into a fiery furnace because they will not worship a false god, and they are rescued through divine intervention. But we, the audience, know that the Jews were not able to save themselves from the ovens of the concentration camps.

The question now becomes whether Fink can rescue himself, both literally, for he is handcuffed to the bed with Charlie standing over him, and spiritually, for his mind is like a closed box. And through what intervention? That is what the rest of the film addresses.

The corridor is, by now, an inferno, but disregarding the flames, it is Charlie's turn to talk. Barton says to Charlie, they call you "madman Mundt" to which he replies, "Jesus, people can be cruel. If it's not my build, it's my personality." His explanation for the killings is that most guys feel trapped, and he tries to help them out; he wishes someone would do the same for him. People put you through hell, but he understands what it feels like when things get all balled up at the "head office."

Barton wants to know, "Why me?" "Because you don't listen," Charlie screams. Fink only *thinks* he knows something about pain. Charlie's whole life is pain. "You're only a tourist with a typewriter. I live here." Charlie lives with the madness in his head, he lives with his feeling of entrapment, he lives in the desolate hotel. Barton came into his home and all he could do was complain about the noise.

Charlie frees Fink from the bedstead, and informs him that he'll be next

door, "If you need me." In parting, Charlie tells Fink that he visited his folks in New York (what did he do to them?) and that he lied, the package isn't his.

Fink takes the box and his manuscript, puts on his woolen coat and leaves the hotel down the fiery corridor. Charlie opens the door to his own hotel room and walks into his own oven.

The scene switches back to the studio, where Lipnick tells Fink that his manuscript is lousy, despite the writer's assertion that it's his best work. "You ain't no writer, Fink. You're a goddamn write-off." Lipnick continues with ironic accuracy, "You arrogant son-of-a-bitch. You think the whole world revolves around whatever rattles inside of that little Kike head of yours." Lipnick won't let him out of his contract. Furthermore, the studio owns all of his work while under contract, and they won't produce any of it.

In the final scene, Barton Fink walks along the seaside in his wool suit carrying the wrapped box. It's the first time we've seen him in the sunny natural outdoor setting of California. He sits in the sand and watches as a beautiful girl approaches in a swimming suit. She sits down near him and asks,

"What's in the box?"

"I dunno."

"Isn't it yours?"

"I dunno."

She nods as though understanding this enigmatic reply. "You're very beautiful. Are you in pictures?" he ventures. "Don't be silly," she answers. Then turns to look out to sea, exactly like the girl in the photograph in his hotel room. Barton Fink has taken a tentative step toward redemption. He hasn't let go of the box. But it looks like he wants to. We'll never know.

Chinatown (1974)

DIRECTOR: Roman Polanski
PRODUCTION DESIGNER: Richard Sylbert
ART DIRECTOR: W. Steward Campbell
MUSIC: Jerry Goldsmith
SCREENPLAY: Robert Towne
CINEMATOGRAPHY: John A. Alonzo
PRODUCER: Robert Evans

Roman Polanski's *Chinatown* is a perfect blend of story, acting, cinematography, music and art direction. It is a classic American film deriving from the Hollywood film noir tradition and from the hard-boiled detective fiction of writers like Raymond Chandler.

For more information on the production designer of this film, see Part II.

Private eye J.J. "Jake" Gittes, ex-cop from the Chinatown beat, is like Chandler's Phillip Marlowe: cynical, mindful of his professional reputation (although he mainly chases errant spouses), and, at least in this story, unrelentless in pursuit of the truth. Gittes dropped out of the police force because of corruption in the power structure and, on a personal level, because he failed to protect a woman he had pledged to help. Jake is a loner, like Marlowe, and the screen story unfolds from his subjective point of view.

Chinatown presents a cinematic portrait of late 1930s Los Angeles, yet Polanski, production designer Richard Sylbert and art director W. Stewart Campbell have avoided all of the visual clichés of films set in this period. We don't see any of the (by now) familiar landmarks of the period, like the Griffith observatory, that are too frequently trotted out by filmmakers to evoke this era.

The production team have scouted period bridges, houses, alleys and untouched stretches of hills and valleys that provide a vivid image of L.A. as a desert community. Dry riverbeds, empty arroyos and storm drains, dusty roads all sustain the story's underlying theme: L.A.'s thirst for water, especially, as in *Chinatown,* during a drought.

In the screenplay, water will be the reason for the death of Hollis Mulwray, chief engineer of the Department of Water and Power. Mulwray has discovered a swindle underway to build a reservoir and send water meant for L.A. to the San Fernando Valley.

The film opens in Gittes' inner office where he is showing a client, Curly, photographs of his unfaithful wife in compromising poses. His modern 1930s office is decorated with Art Deco furniture and decorative art: a wooden radio, a Frankart statuette of a female dancer, a photograph of FDR, and on the wall an autographed picture of that fashion plate actor, Adolf Menjou. In white suits, Gittes is a snappy dresser himself. Curly confronts his sorrow by attacking the furnishings, he starts to chew on the wooden venetian blinds, Gittes tells him to take it easy, they were "just installed on Wednesday."

Shortly, Gittes is duped by a phony Mrs. Mulwray (Diane Ladd) into tailing Hollis Mulwray and with this the L.A. locations begin to unfold. Mulwray first drives over a dusty riverbed to its dry bottom while Gittes watches him from a bridge through binoculars. The cinematography of John A. Alonzo captures the arid landscape in brilliant sunlight so that all the objects on the screen are hard edged. You can almost feel the heat sear off the rocks on the riverbed. Mulwray then leads Gittes to the clear azure of the Pacific coastline where the chief engineer scrambles downward to the coastal edge so that he can check a runoff drain from below.

Water now begins its visual and visceral recurrence in the film. It has already been discussed in the story previously, but now the on-screen images of water become obsessive. Polanski focuses several scenes, at Echo Park Lake, a pond on the Mulwray estate, and the L.A. river, around water.

Richard Sylbert includes references to water or aquatic life in the sets, in

Chinatown (1974, director Roman Polanski, production designer Richard Sylbert).
All parts of drought parched L.A. in 1937 seem to be traversed by detective Jake Gittes
(Jack Nicholson). Here on a stake-out he's perched on a tile covered roof overlook-
ing a Spanish-style courtyard.

a similar obsessively recurrent way. Prints on the walls of Mulwray's private
office are Oriental seascapes; his deputy chief has stuffed fish on his walls; Gittes
is picked up from the Albacore (a fish) Club at the ocean and taken to Noah
Cross' ranch where they dine on fish. (Cross is really Mrs. Mulwray's father,
played by John Huston.) Even in his office Gittes talks to his operatives in front
of a container of bottled water, and when he looks for the purchasers of valley
property it is in the Mar Vista Rest Home.

Gittes takes what seem to be compromising photographs of Mulwray with
a young girl and they are illicitly printed in the newspaper. Back in his office,
the detective is confronted by the real Evelyn Mulwray (Faye Dunaway), who
plans to sue him over the incident.

Gittes has been set up and wants to clear things up; he goes to Mulwray's
office fishing for information. Mulwray's office is much more conventional
than that of the modish Gittes. It is given a sepia tonality by the lighting, and
there is brown in the tonalities of the furnishings and of the walls that are cov-
ered with photographs. There is a picture of Evelyn in riding attire holding a
horse by the reins on Mulwray's desk.

Still trying to find Mulwray, Gittes drives to the chief engineer's estate, a
Spanish Revival mansion, on a grassy knoll. We already know from their
wardrobes that the Mulwrays are wealthy, and their house gives further

confirmation of this. They employ an Oriental gardener who appears in the next scenes.

Gittes meets Evelyn Mulwray in the garden as she is returning from a long bareback ride dressed in jodhpurs. She wants him to drop the whole thing, and says she won't sue. Gittes persists and she says that her husband might be at the Stone Canyon reservoir around noon.

Gittes approaches the deep blue colored water of the reservoir through a landscape of barren hills. The police are there; the drowned body of Mulwray has turned up in a watery run-off channel. The already convoluted plot line begins its more intricate turns at this point.

Gittes criss-crosses L.A. trying to learn something about what's really going on. He hits the police station, the morgue, returns to the river bed and then the reservoir that Mulwray was investigating before his death. He's turning up complex and frequently contradictory bits and pieces of the puzzle. Gittes and Evelyn Mulwray meet in an elegant restaurant; he's hoping to get "the whole story" from her. They sit together in a booth covered in a flaming red leather that is the same color as her lipstick. He tells her that her husband may have been murdered for knowing too much about the theft of water and the proposed use of the new reservoir. All Gittes gets out of Evelyn is that her maiden name was Cross.

Gittes charges on by himself and learns that Noah Cross and Hollis Mulwray once privately owned the Water Works. A meeting is set up with Noah Cross on his ranch. As Gittes is driven up the roadway to a sprawling Spanish-style ranch house, the camera first finds some horses at a bend in the road.

The horse and rider motif have been insinuating themselves into the story and the decor of the film since the beginning. They are the film's metaphor for desire, for sexuality.

Noah Cross has committed incest on his daughter Evelyn. They have had a child; she is the young girl that Mulwray was seen with in the photographs leaked to the press. She has been protected in Mexico by Mulwray since her birth, but is now in L.A. to be near her mother.

The horse is a traditional symbol for virility and for sexuality in general. In this film it is particularly identified with Evelyn and with her sexual partners. When Gittes sees her picture in Mulwray's office it is in riding attire with a horse, she meets him at her house dressed in jodhpurs. Now, as Gittes approaches the ranch, although he doesn't yet know of the incest between father and daughter, it is suggested by the horses that are our first glimpse of the Cross ranch. In their conversation, Cross wants to be sure Gittes is not taking his daughter "for a ride," and then bluntly asks if he is sleeping with her. His daughter's sexuality is very much on his mind. They discuss Chinatown. Jake says that assignment was just "bad luck" for him.

Gittes also is part of the sexual undercurrent of the film. After Evelyn hires him and joins with him to discover what is going on and who killed her

husband (they narrowly escape from thugs when they investigate the Mar Vista Rest Home), they have sex. Clues that tie him into the metaphoric meaning of the horse are seen in subtle ways in his personal surroundings and in props. He's seen riding the *Racing Record* in an early scene. His office is decorated with sculpted equine heads and plaques. Finally to put a fine point on this imagery, when Gittes returns home after having sex with Evelyn, two paintings of horses' heads are seen above the bed in his apartment.

Gittes has already found the mystery girl by following Evelyn to a modest L.A. bungalow-style house of the 1920s, where she is being hidden from Cross. Because it is just a way station for the girl and we don't know who lives there, Sylbert gives it less of a personally defined character than any other interior in the film. Yet even in this neutral interior, there are pictures of sampans on a river, evocations of both China and water.

The carefully defined interior of Ida Sessions' apartment (she was the phony Mrs. Mulwray) is in direct opposition to the neutral treatment of the bungalow. She lives in a 1920s court-style apartment. Polanski introduces us to it via a long shot taken from across the street that allows us to see the stuccoed exterior archway into a long narrow court with apartments facing each other across a central sidewalk.

The period houses and apartments in the film help complete Polanski's cinematic portrait of vintage L.A., providing the urban mix to go along with the barren hillsides, dry riverbeds and ocean that are the natural side of the portrait.

The Sessions apartment is a pristine example of a disappearing form of 1920s to 1930s apartment. Its tiny interiors tell us about her: she is an actress of apparently little success, probably a bit player (as she was when she posed as Mrs. Mulwray). The front door opens into a living room, with a wall of built-in cabinets behind glass. It is cluttered with cheap bric-a-brac, porcelain plaques and tiny figurines. Two cops staking out the place emerge from the small bathroom through a screen of silk stockings hung from laundry lines in the kitchen.

In *Chinatown*, the decor provides major points of commentary on the thematic currents of the film. It is unobtrusive, and registers in an almost subliminal way as you watch the film, adding to the totality of things that make *Chinatown* a great film. References to China and the Orient recur in the dialogue and decor throughout the film. The first time Gittes meets the real Evelyn Mulwray in his office, he is telling a joke about a Chinaman making love. Mrs. Mulwray has Oriental servants. Images of the Orient occur with regularity in the pictures on the walls of offices and homes.

The final scene is played out in the often mentioned, but until this point, never seen, streets of Chinatown. Gittes has worked there with Lieutenant Escobar (Perry Lopez), the officer investigating Mulwray's death, when he was cop. Jake is asked several times during the film about Chinatown — by Evelyn

and by Cross. Evelyn questions him about it while they are in bed; he hated it, saying, "You can't always tell what's going on there. It was just 'bad luck.'" He tells her about the past, that he was trying to keep a woman from being hurt, and ended up making sure she was hurt. Prophetically, this is what will happen between himself and Evelyn.

"Not knowing what's going on" or "never knowing the whole truth" is Jake's problem throughout the film. It is hard to know what reality is as the facts unfold in a jumble of false leads. Things are not what they appear to be many times in the film. Polanski's direction richly works to confound our sense of the real. We look with Jake through binoculars at Mulwray in the river bed; images appear on the surface of the binoculars, on car side view mirrors and on dash mirrors. They allow us to see the action unfold. But is that all that is happening? Why is it happening? Is there something off the mirror we are missing?

When Cross asks Gittes about Escobar's abilities as an investigator, Jake reassures him, but adds, "he has to swim in the same water we all do." And that water is Chinatown whose surface makes a contorted image and whose current has a treacherous undertow.

Screenwriter Robert Towne has explored that popular conception of the 1930s, of "the inscrutable Orient." Chinatown is unknowable; it is dense and powerful and corrupt.

The qualities attributed in a mythic way to Chinatown are attributable in a personal way to Noah Cross. He is the arch villain of the plot: inscrutable, powerful and evil. And Cross is capable of great corruption; he's stealing water during a drought, masterminding the reservoir swindle, driving orchard growers to sell their property at rock bottom prices. Gittes asks him, "How much are you worth?" he replies, "Millions."

"Why are you doing it?"

"The future, Mr. Gittes, the future." Cross sees himself as a visionary.

Beyond this, on a moral plane, he maintains that he is beyond guilt for fathering a child with his own 15-year-old daughter. Cross tells Gittes that, "Most people never have to face the fact that at the right time and the right place, they're capable of anything." And beyond incest, he has now killed his daughter's husband, his former partner.

We enter the final scene through the brilliant neon lit streets of Chinatown. Cross tries to take the child Kathryn, who is about 15, from Evelyn. She responds with a gunshot that wounds him in the arm. As Evelyn tries to drive away with her daughter, the police shoot and kill her. She has just finished telling Gittes that, "He [Cross] owns the police."

Noah Cross has survived it all. He puts his arms around Kathryn, covering her eyes, and leads her away. Evil and power have triumphed, corruption has won out. The pessimism expressed in the ending goes even beyond the cynicism that has always permeated Gittes' world view. In the last line of the film,

Walsh, his operative, who is helping Gittes walk away, tells him, "Forget it Jake, it's Chinatown." It's Noah Cross. It's the power structure. It's the world. It's Chinatown. Like Kathryn, with her eyes covered, Gittes should, in the words of the ancient oriental proverb, "See no evil."

The Cotton Club (1984)

DIRECTOR: Francis Ford Coppola
PRODUCTION DESIGNER: Richard Sylbert
ART DIRECTORS: David Chapman, Gregory Bolton
MUSIC: John Barry
SCREENPLAY: Francis Ford Coppola
CINEMATOGRAPHY: Stephen Goldblatt
PRODUCER: Robert Evans

Francis Ford Coppola's *Cotton Club* pulls together complicated stories of crime, love, race, and the popular performing arts of tap dancing, singing, and jazz music around the famous white-owned Harlem nightclub in the late 1920s that featured all black entertainers.

The film is part musical and part melodrama. The $40 million budget allowed for a lavish principal set. It was based, by production designer Richard Sylbert, on original photographs of the Cotton Club and descriptions of it, and on pure imagination. The photographs are found in Jim Haskins' book, *The Cotton Club, a Pictorial and Social History of the Most Famous Symbol of the Jazz Era* (1977), which apparently inspired much of the screenplay. (Edited by Toni Morrison for Random House, this volume also appears to have been a partial inspiration for her novel *Jazz* [1991].)

From the photographs it would be impossible to recreate the club with great exactitude, and anyway that wouldn't necessarily have served Coppola's needs. For one thing, the Cotton Club seated 700 people in two tiers. It has been described as barn-like. People came there to see the famous floor shows that were the equivalent of a Broadway musical. The cast was enormous and over the years the Cotton Club bands included those led by Duke Ellington, Cab Calloway, and Jimmie Lunceford.

Sylbert's Cotton Club is much more intimate than the original. The built sets, which besides the dance floor include the small proscenium band stage, the entryway, halls, stairs, offices and backstage areas, are required by Coppola for plot purposes.

In the opening scene, a dance by the chorus line of beautiful female dancers, Sylbert and cinematographer Stephen Goldblatt give the club a

For more information on the production designer of this film, see Part II.

gold-brown tonal quality that continues on and off throughout the film. The chorus line, appropriately, is singing a number about sepia girls.

The wooden dance floor, surrounded by a horseshoe of tables, is bordered with yellowish lights shining upward over the dancers' bodies. In the background the band plays before a mansion house setting with a real door, windows and shutters; a touch of the old Southern plantation and a reminder that at the time the film opens, in 1928, blacks were not admitted to the club as customers.

Actually more than a plantation, the original Cotton Club tried to evoke a jungle atmosphere, and many of the staged numbers had "primitive" jungle motifs and songs with suggestive "race" lyrics. Harold Arlen and Ted Koehler, two white men, did much of the writing of these songs.

Sylbert covers the tables in the set with white linen cloths as did the original Harlem club; it always strove to have "class." The production designer suspended a glittery mirror ball from the ceiling, and at periodic intervals around the room there are old fashioned street lanterns like those seen in photographs of the club. Beyond the tables are booths and behind them large fake trees.

The Cotton Club's facade, seen later in the film, is an imitation log cabin painted black with a long black and white striped canopy leading to the entrance. Interior corridors are veneered in the same rustic material. Haskins does not publish an exterior view of the club in the late 1920s, but all famous nightclubs in Harlem, like Connie's Inn, had distinctive exteriors and curbside canopies.

The first major narrative scene takes place in the Bamville Club, whose clientele are ethnically mixed. The Bamville was with the Cotton Club, one of the top clubs in Prohibition day Harlem. The filmic version of it is modern in decor, colorful Art Deco murals cover the walls. The Bamville was known for featuring progressive music. So appropriately, the jazz band here plays before bead curtains, rather than a plantation facade. A cornet player, Dixie Dwyer (Richard Gere), tries to captivate Vera (Diane Lane), a gorgeous flapper, with his playing. As the action ensues, he saves the life of mobster "Dutch" Schultz (James Remar).

Vera is intoxicated and Dixie protectively sees her to her apartment. Its bedroom, all sensuality with a large vanilla covered bed and silken draperies, shows her expensive taste. Vera isn't rich, but likes expensive things, as the apartment lets us know. She eagerly becomes Schulz's "girl." Dixie reluctantly becomes Schulz's "boy," his favorite musician. Dwyer's brother Vincent (Nicolas Cage) horning in on the action, takes advantage of Dixie's bravery and insinuates himself into Dutch's mob.

Other than the mobster angle, the second major plot line of the film involves black artists, principally an ambitious dancer Sandman Williams (Gregory Hines), his brother, and an equally ambitious singer Lila (Lonette

The Cotton Club (1984, director Francis Ford Coppola, production designer Richard Sylbert). The distinctive canopied entrance and log- and shingle-covered exterior of the Cotton Club in Harlem is seen several times in the film.

McKee). Lila and Sandman meet at the Cotton Club and their love story unfolds backstage and on tree lined Harlem streets of well-kept brownstones, and in modest apartments of the neighborhood.

The Cotton Club's owner, Owney Madden (Bo Hoskins), trying to avoid a gang war, sets up a meet between Dutch and a rival mob boss at his swanky New York apartment. Owney and his partner Frenchy DeMange (Fred Gwynn), are not fictive characters. They both made a fortune from the bootleg beer business and from the club. Production designer Sylbert's vision of Owney's apartment is appropriately lavish. The next few scenes come alive visually through their decorative details.

Owney's white paneled living room has a sweeping curve at one end. As the camera first enters the room, it looks like a posh brothel. Beautiful women are draped over all of the furniture and some of the men. The lighting is again sepia in tone. As the camera moves about the room's details begin to register beyond its inhabitants — a baby grand piano, cut flowers in expensive vases. This is, one gradually realizes, a mob party.

After negotiating peace between them, Owney urges the rival mobsters into a more private side room to dine. Sylbert has had the food displayed in

opulent piles on linen covered tables around the room. It is a feast and a feast for the eye. At this moment, in the beauty of this rich setting, Coppola inserts the most violent sequence in the film. Dutch shoots and kills his rival and blood splatters over every lovely thing in the room. It is a ghastly and unexpected moment that has been carefully orchestrated through the inanimate objects of the decor, especially the luscious looking foods.

Much of the narrative in the *Cotton Club* takes place in Sylbert's interiors, but street scenes and car rides are interjected with regularity to open the picture up a little bit. Through montage the rapidly thickening plot is moved along until it is 1930 and we're in Vera's Club. She's been Dutch's girl now for a while, despite her attraction to Dixie, and has succeeded in opening her dream club on Broadway.

Nightclubs have, since silent films, been a staple in mobster films. Not many were ever more lavish than Sylbert's Vera's Club. It is an Art Deco masterpiece done mainly in white, even Lane has changed her hair from brown to platinum blond; she wears a black sequined dress to pick up the other principal colors in the room. The white walls are covered with black silhouettes of dancing figures. The chairs are covered in exotic zebra striped materials, while rarefied lilies of the valley deck out the tables. The race issues addressed throughout the film are evoked in the *mise-en-scène* of this room in particular.

As the years go by the Cotton Club's interior alters, as it did in actual time. The shows changed every six months to keep the clientele interested in coming back. In the Cab Calloway days, the curtains behind the band became silvery. The styles of the dance change frequently, too, and Coppola returns his focus to the floor show periodically.

One of the most intriguing Cotton Club sets is Owney's office, whose walls are covered with erotic murals. Sylbert's design has females in homoerotic poses; a play on a suggested homoerotic relationship between Owney and Frenchy which is never made explicit.

The setting and the cinematography have lent a tonal quality to *The Cotton Club* which has made it seem, at critical moments, like sepia tinted pages of an old book, a device Coppola used in the *Godfather* series, as well. The page has definitely turned near the film's end as Dixie Dwyer, now a movie star, says he is returning to California and asks Vera, once again, to join him. Behind them we see a movie marquee advertising "Mob Boss," Dwyer's newly released first film. It is the end of an era, of old time racketeers in the Prohibition days, and of the old Cotton Club of Harlem.

The film ends like one of the big Cotton Club reviews. There is a montage of happy endings for the lovers, an unhappy ending for Dutch who is murdered gangster style. A train station in New York is the backdrop for the last "number" and the director leaves one wondering whether what has been seen was a musical or a melodrama. If he had known himself, the picture might have been a greater box office success.

Miller's Crossing (1991)

DIRECTOR: Joel Coen
PRODUCTION DESIGNER: Dennis Gassner
MUSIC: Carter Burwell
SCREENPLAY: Joel and Ethan Coen
CINEMATOGRAPHY: Barry Sonnenfeld
EDITOR: Michael Miller
PRODUCER: Ethan Coen

Under the cover of the 1920s gangster film, the Coen brothers in *Miller's Crossing* have built a complex story of criminality, friendship and morality. In a world of violent beatings, murders and Prohibition style political corruption, they explore these concepts and the illusive "heart question," that of love. Heart questions change things, even in the criminal underworld.

The principal characters, Liam "Leo" O'Bannion (Albert Finney), Tom Reagan (Gabriel Byrne), and Verna Birnbaum (Marcia Gay Harden), struggle with emotions they find hard to define and that are often injurious to themselves and to the objects of their affections.

Leo is the closest to really knowing himself — his capabilities and his feelings — even though he doesn't always know what's going on as the plot unfolds. Verna and Tom are just groping along: unsure, unwise, in lust, immature. Leo's older; he's been around the block in the romance department and knows his options are limited.

Leo believes he's still in charge of the underworld of the city, but actually it is Tom who bails him out of a gang war that breaks out between Leo and Johnny Caspar's (Jon Polito) factions.

The production designer, Dennis Gassner, working from locations in New Orleans and many built sets, manipulates the visual ambiance to fit the tight directing style of Joel Coen. Although this is a "realistic" film, the decor often seems sparse and edgy.

The film opens on the sound of ice clinking. Then we see ice cubes dropping into a highball glass and whiskey splashing over them. Drinking is of ritual importance to the film: many of the important confrontations take place over a drink. Tom, who is making this drink in Leo's office, tries to cement his tenuous life with alcohol, in dangerous ways. Verna calls him a rumhead. We see him hung over more than once.

Drink in hand, Tom slides down the edge of the lengthy, oblong space of the office, over a broad expanse of floor, to stand appropriately at Leo's right hand. This is also the first of several scenes to use the traversal of lengthy empty

For more information on the production designer of this film, see Part II.

spaces as a prelude to the dialogue, a device that draws attention to the distance between the characters' points of view.[1]

Leo's office is a man's place of paneled walls, brown leather furniture, lighted paintings. His expansive desk stands at one end of it in front of a large semi-circular window. At the opposite end there is an elegant streamlined bar. From this haven, Leo controls police chiefs, politicians, and other mobsters.

An authoritative masculine atmosphere prevails, too, in Leo's Shenandoah Club on the floor beneath his office where, despite the presence of ladies, the wood on the walls, the teal blue carpeting, and chrome suggest that men are in control.

The design of the sets and the outfitting of locations never draws our attention away from the film's complicated characters. Gassner's production design inserts a crispness into the sets that compliments the crispness of Coen's direction.

A favorite tool of the director is the use of the sets, particularly doorways, to frame, literally, the characters in the story. Figures, sometimes pairs, pause for a few seconds in doorways, either in full light or back-lit so that only their silhouettes register as they speak. The effect is to bracket the scene, to leave it in its own space.

The dynamics of the entire movie are laid out in the initial scene in Leo's office. Johnny Caspar, an Italian mobster, tells Leo that he wants to take out a grifter named Bernie Birnbaum (John Turturro). Bernie has been chiseling Caspar on the fights he fixes. Leo, because of feelings for his girlfriend Verna (who is Bernie's sister and Tom's lover) uncharacteristically ignores Tom's advice to give up Bernie rather than start a gang war. Caspar storms out in anger, tired of getting "the high hat."

The titles begin as the camera focuses into the tops of tall trees in a woods called Miller's Crossing, the primary outdoor setting. A plaintive Irish melody is heard in the background. The camera pans down the trees as a black fedora plops onto a dirt roadway and then skips off into the distance until it can't be seen anymore.

The next morning, a hung over Tom awakens in the Shenandoah Club wondering where his hat has gone. He has lost it gambling to Verna and Mink (a homosexual who partners Bernie, played by Steve Busemi). Hats, both costume item, prop and symbol, have already made multiple appearances in the film.[2] Eddie Dane (J.E. Freeman), Caspar's homosexual first lieutenant, has worn his hat and also held his boss' hat over his fist pointed at Leo (it looks like he's concealing a gun) during the opening argument. At its end, Tom exiting the room, put on his hat, opened a door, and revealed Leo's black fedora hanging between two prongs on a coat rack. Leo's hat resembled an abstract bull's head, a symbol of his potency as both a man and a mob boss. When the film ends, Leo will be in certain control of his city again and he'll have Verna at his side.

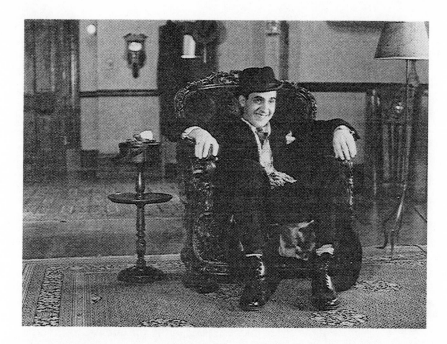

Miller's Crossing (1990, director Joel Coen, production designer Dennis Gassner). Bernie (John Turturro) is swallowed up by an easy chair in the almost empty center of Tom's living room as he connives his way out of trouble.

Tom opens up intimately only once in the film and it is to Verna; he tells her about a dream. In it, he was walking in the woods when a wind came up and blew his hat off. Verna excitedly injects that he must have chased it, and then it became "something else, something wonderful." "No," Tom replies, it remained a hat and he didn't chase it. "Nothing is more foolish than a man chasing his hat," he concludes.

Yet Tom is obsessed with holding onto his hat even after he gambles it away, and as Mark Horowitz observed about it:

> It operates not so much as a clearly defined symbol but as a palimpsest of Tom's feelings about longing and loss, about losing his head [literally or figuratively], about control, and about death. Finally, the hat is less important than Tom's odd obsession about holding on to it at all costs.[3]

Tom is a man, unlike Leo, who cannot express his true feelings. Like his hat they have to be tightly held onto. Whenever he gets close to revealing himself, he hides behind a wisecrack.

Tom shows up at Verna's apartment looking for the hat he lost gambling and needing a drink. The next action, that same night, takes place at Tom's apartment where they've gone to avoid being caught together. Verna is asleep

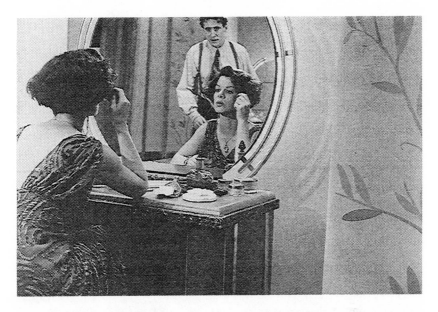

Miller's Crossing (1990, director Joel Coen, production designer Dennis Gassner). Myra (Marcia Gay Harden) is completely in charge in her domain, an Art Deco powder room, as she argues with Tom (Gabriel Byrne).

in the bed, Tom is beside her smoking a cigarette. A knock brings Leo into Tom's living room, whose length he traverses to sit awkwardly in a large blue armchair.

In Tom's spacious apartment the furniture hugs the wall (this was also true in Leo's office). By this means, the center of the room is made to seem empty, open and unprotected. Director Coen has cinematographer, Barry Sonnenfeld, shoot part of the opening of the scene from a low angle which takes in the high ceilings and reinforces the empty center.

Leo has a drink. He's worried about Verna and has someone following her, but she has disappeared. Verna is, as we know, in the next room. Leo solicits his friend's help. Tom sounds off on the Bernie problem again, telling Leo he's letting his feelings for Verna interfere with business. For good measure, he tells him that Verna is a tramp and Leo should dump her. Always the gentleman, Tom repeats his accusation to her after Leo leaves.

Unable to stop Leo from bringing them to the brink of a gang war for "no reason," Tom decides to confront Verna about her brother Bernie. He bursts into the powder room of the Club where she's sitting at a vanity table in front of a lighted circular mirror. Gassner's set is a wonder of Art Deco detail, the one room in the film that fulfills all of that style's requisites. It's a wonderful place to stage an argument in which Verna is in full control. The room is a woman's domain with peach colored walls that are stenciled with silver floral

motifs. Tom may have scattered the other occupants on his entrance, but he can't win here. In anger he hurls his whiskey glass at Verna, but she just flounces out.

The antagonism between the gangs, among other things, runs along ethnic lines. Gassner gets a chance to express in the art direction certain clichés about ethnic taste, especially in the mansions of the two rival bosses, Irishman Leo O'Bannion and Italian Johnny Caspar (formerly Costello).

Caspar's house, seen only in the interior, is a gaudy, overdone late Victorian affair. Its hallway is filled with florid carved ebonized furniture. The den has a mammoth fireplace, it seems totally unrepresentative of him, more suited to an English lord. The walls are paneled in Tudor fashion and hunting trophies hang on the walls. Caspar, a street smart guy, worries a lot about everyone giving him "the high hat," but in his own home, he's clearly trying to put on the "high hat" himself.

When Leo won't give up Bernie, Caspar sends two thugs to kill the mob boss in his home. The action that follows is some of the most violent in the film, and it is played out to the syrupy tune of "O Danny Boy" on the Victrola.

Leo's taste befits what we know of his personality and the ethnically more middle-of-the road Irish, it runs to American furnishings of the turn-of-the-century. Leo's taste betrays his age: there are overstuffed chairs, crystal chandeliers, a heavy oak bedroom suite, and paintings in heavy gilded frames. Its substantial mass goes up in flames as Leo knocks off Caspar's men, his would-be assassins.

In Leo's office Tom again tries to persuade his boss to lose Bernie. Leo won't be moved and in desperation Tom reveals that he and Verna have been lovers. Leo follows him out of the room and beats him up; Tom loses his hat but doesn't fight back. At the fight's end, Leo throws him the hat and tells him, "It's the kiss-off." Tom has sacrificed his job and their friendship in an attempt to protect Leo.

The major theme of the film revolves around love and the protection of the loved one: Leo loves and tries to protect Verna, she does the same for Bernie. Tom loves Leo and sacrifices his friendship and almost his life to protect him. There is also a subplot of homosexual love (Bernie and Dane and others), that gives an edge to the relationship between Leo and Tom.

Tom clearly feels displaced by Verna in Leo's affections. Leo is not following Tom's advice, not letting him do his thinking, as in the past. Leo is following Verna's wishes.

As the plot shifts and turns in the second half of the film we're reintroduced to Miller's Crossing — an eerily beautiful place of tall trees, pine cones and bird song. When Leo won't listen to reason, Tom pretends to go over to Caspar's side and gives up Bernie's address to gain the Italian's trust. Tom and a couple of Caspar's men drive Bernie to Miller's Crossing to whack him. At the last moment, Tom is told to shoot Bernie himself, in a test of loyalty to the

Italian. The two men go off into the woods. Bernie cries, and prays, and weasels his way out of it. Tom shoots two shots into the ground and tells Bernie to get permanently lost.

Tom will finally kill Bernie, although by that time, as Caspar has already been eliminated, there is no real reason to do so. The grifter is no longer a threat to Leo, yet Tom kills Verna's brother thereby killing her love for him. In the end, she takes Leo permanently away from Tom by asking him to marry her; he agrees.

The closing of the film is in a cemetery in Miller's Crossing; Bernie is being buried, with only Verna, Leo and a priest in attendance. Tom shows up, and cruelly quips, "Big turn-out." Verna replies, "Drop dead." She drives off with the car rather than share it with Tom. Leo and Tom start to walk back to town. Leo expresses his gratitude for Tom's "smart play" against Caspar, tells him he's marrying Verna, and pleads with him to come back to work. Leo forgives him for the Verna incident saying, "you're both young." Tom says he deserves no forgiveness and tells Leo, "Good-bye." Without further protest, Leo donning his black fedora walks on down the road, alone. It's the same fedora that blew away when we first encountered Miller's Crossing during the titles.

The question remains: "Why did Tom kill Bernie?" Verna has been maintaining all along that Tom really wants her to leave Leo for him. She would like to believe he has a "heart" for her. Did Tom permanently alienate Verna so they could never be together, and she'd settle on Leo? One can't be certain, but in the end the only person Tom did have a "heart" for was Leo.

The precise and immaculate directing style of Joel Coen is perfectly matched by the settings of production designer Dennis Gassner. A stylization seen in the directing is demanded in the sets. Their execution would seem to indicate a pair working in great harmony.

Notes

1. Other instances occur when Leo visits Tom's room, when Tom enters to find Bernie waiting in his room, and when Caspar answers the front door of his mansion.

2. For commentary on the meaning of the hat, cf. Mark Horowitz, "Coen Brothers A–Z: The Big Two-headed Picture," *Film Comment,* 27, 5, Sept.-Oct., 1991, pp. 28–29.

3. *Ibid.,* p. 30

Ragtime (1981)

DIRECTOR: Milos Forman
PRODUCTION DESIGNER: John Graysmark
ART DIRECTORS: Patrizia von Brandenstein and
Anthony Reading (UK)
SCREENPLAY: Michael Weller, for E.L. Doctorow's
novel
CINEMATOGRAPHY: Miroslav Ondricek
MUSIC: Randy Newman
PRODUCER: Dino De Laurentiis

Taken from the novel by E.L. Doctorow, *Ragtime* interweaves themes of racial injustice, family values, the society murder of architect Sanford White, and the birth of the motion picture. Set in the first decade of the century, director Milos Forman's film never loses its sense of intimacy with the lives of the story's many characters, some historic and some fictional, and their quite radically different surroundings.

The settings help focus the film's several story lines and define the characters' varying lives in different social strata. Sanford White lives in the world of high society defined by opulent, vaguely decadent banquets in sumptuous surroundings; the Victorian family live in a large, comfortable home in New Rochelle that sits beyond a spacious lawn and garden; an immigrant Jewish silhouette artist makes portraits and children's flip books on the sidewalks of New York's lower east side and lives with his daughter in a tenement, while the African-American ragtime pianist composer lives in silent picture nickelodeons and night clubs, and drives a new Model-T Ford.

The diversity of characters and dramatic situations challenged production designer, John Graysmark and his art directors Patrizia von Brandenstein and Anthony Reading (UK) to create what is tantamount to a visual history of the Gilded Age. Milos Forman has had cinematographer Miroslav Ondricek lovingly photograph their sets and the hundreds of decorative objects within them to build an image of that era that is picture book perfect, even painfully so at times.

Forman's direction, like Bruce Beresford's and others', is contextual. He doesn't have expensive sets built to throw them away in the editing room. Forman wants us to carefully measure the context of the characters which is, at times, antithetical to their real worlds of feeling or of aspirations. The smug, suburban New Rochelle setting of the wife, called "Mother" (Mary Steenburgen), and her younger brother (Brad Dourif) turns out to be too conventional to fit their emotional natures; the brother rebels by first falling in love with the

For more information on the production designer of this film, see Part II.

preoccupied Evelyn Nesbit (Elizabeth McGovern) and ultimately becoming a terrorist bomber, while "Mother" runs off with the silhouette artist Tateh (Mandy Patinkin), now a movie director, taking along the entire family and leaving her loving husband behind.

Forman, using a variety of means, introduces the many players and the main themes within an incredibly few minutes of the opening of the movie. Under the titles, in a dance sequence, Evelyn Nesbit, chorus girl lover of high-society architect Sanford White (Norman Mailer) and later wife of his millionaire assassin Henry K. Thaw (Robert Joy), makes her appearance. She is the tenuous thread that ties the historic sequences with the purely fictional ones involving the New Rochelle family and a family of blacks led by Coalhouse Walker, Jr. (Howard E. Rollins).

In black and white newsreels in a silent movie house, other historic characters are seen for the first time on the screen to the background accompaniment of piano music played by Coalhouse. The camera proceeds to sweep over an immense ceiling chandelier of crystal into a men's banquet in an elegant dining room probably designed by the well-known architect Sanford White, who presides over the tables laden with food and wine.

The camera moves on to the "family's" manicured lawn in New Rochelle and into the sunlit dining room, where light filtering through lace curtains falls on a silver tea service, porcelain dinnerware, and plates heaped high with home cooked food. The family is served by their maid.

This is the turn-of-the-century bourgeois ideal of family life personified. The father (James Olson) is a man of commerce. His wife stays home and dutifully watches over the children and household. Suddenly into this smug world an illegitimate black child and then his mother is thrust. Later Coalhouse will come to claim them. The father's immediate response is to dispose of the problem by giving the child to the public officials, but the mother, thinking with her heart, insists that they stay. She has opened up a world of spontaneous feeling, a Pandora's box, into the emotional vacuum of their lives.

Fortune and misfortune suddenly intervening in people's lives is an underlying theme in all of *Ragtime*'s concurrent stories: Sanford White is shot dead while watching a musical performance in Madison Square Garden; Coalhouse's life veers off course after some malicious firemen desecrate his fine automobile; "brother" turns to terrorism against society with Coalhouse when his love is spurned by Evelyn. Even ditsy Evelyn Nesbit returns to the stage career, for which she always hankered, after getting her guilty husband off free in White's murder. The Jewish immigrant flees town to get away from a history that includes an unfaithful wife and finds fame and fortune in the motion picture business.

The visually rich interiors of the film have an elegance that existed into the first decades of this century. Most scenes in the film are played against these interiors, but a few historic exteriors, like a small wooden firehouse of arched openings painted red, are also recreated.

Ragtime (1981, director Milos Forman, production designer John Graysmark). *Top:* The production designer's reproduction of the J.P. Morgan Library, a symbol of the white power structure and monument to European culture, is under siege from the police after Coalhouse Walker's (Howard E. Rollins) band of revolutionaries take it hostage. *Bottom:* A crystal chandelier lies shattered on an antique desk in the J.P. Morgan Library as Coalhouse plans his next move.

The largest facsimile exterior is that of the J.P. Morgan Library. The library's interiors recreate the rare collection of books, paintings and antique furniture that are world renowned and are where Walker and his friends hole up as the police surround them. Here both the "father" and, implausibly, Booker T. Washington (Moses Gunn) separately try to convince Walker to give himself up.

Coalhouse sits at a large antique desk whose front is obscured by a heavy crystal chandelier that has fallen from the ceiling. It is a visual reminder of the chandelier that glowed with light in the opening banquet sequence, and in its present state suggests the collapse of a society whose fissures were already evident at the banquet when Henry Thaw burst into the party to scream threats at Stanford White.

The Morgan Library is an important symbol to Walker's uprising; he has undertaken acts of vengeance for honor's sake and to avenge the death of his love, the mother of his baby boy. The Library has been conceived as a monument to the white man's Western European culture and has been filled with its treasures accumulated by a white capitalist. It is a place deemed precious and valued above human life by the dominant society; the lives of policemen will be sacrificed for it. It is a symbol of all that oppresses black people in a society that does not value their dignity. In the last frames of the movie, the Library, symbol of repressive white society, stands in triumph over Walker's gunned-down body.

Many of the problems that will plague America in the rest of the century are laid out in *Ragtime*'s multiple stories; racial tensions in Coalhouse Walker's story, as well as conflicts between blacks, seen especially in the confrontation between Coalhouse and Booker T. Washington in the Library. Their conversation reads a lot like the conflict in ideologies of Martin L. King and Malcolm X. The instability of relationships in the modern world is seen especially in the New Rochelle family's story, where the nuclear family unit dissolves and then reassembles. Insanity and out-of-control police violence in society can be related to the White-Thaw story and to the police handling of the characters in all of the stories. Lastly, and almost for comic relief, a nod is given to the importance of the motion picture as a new cultural medium in the story of the immigrant maker of flip books who becomes a movie mogul.

John Graysmark's settings are the glue that tries to hold the unwieldy film together. They succeed as visual metaphors for the thematic material of *Ragtime* where sometimes the dialogue, action, and montage falters. In fact, some of the most memorable moments of this Gilded Age melodrama occur when there is no dialogue and the images themselves tell the story, as in the days of the silent movies.

The Untouchables (1987)

DIRECTOR: Brian DePalma
VISUAL CONSULTANT: Patrizia von Brandenstein
ART DIRECTOR: William A. Elliott

For more information on the production designer of this film, see Part II.

SCREENPLAY: David Mamet
CINEMATOGRAPHY: Stephen H. Burum
MUSIC: Ennio Morricone
COSTUME: Marilyn Vance-Straker
PRODUCER: Art Linson

The Untouchables retells the familiar story of the U.S. Government, in the person of Treasury Department agent Elliot Ness (Kevin Costner) and his group of "Untouchables," in pursuit of Prohibition mobster Al Capone (Robert De Niro). It was an expensive production with many settings and locations and a film in which director Brian DePalma took maximum advantage of the sets, not throwing them away as he had done in The Bonfire of the Vanities.

The time is 1930, just before the repeal of the Halstead Act. The film action opens with an overhead shot of Capone in the barber chair, face wrapped in hot towels, surrounded by five people, little satellites around the big sun. Von Brandenstein had that in mind exactly when she worked on the visual concepts for the film: "DePalma wanted a big overhead shot, and I wanted architecture, mass and heaviness, a sense of mystery, an extremely complex design. And I wanted to establish Capone's colors throughout the film. And that visual arc, with the colors and the sense of the architecture, follows through the movie, right to the last scene."[1]

Von Brandenstein created a set with Neapolitan opulence, the parquetry floor has enormous swirls and diamond patterns on it. The silver and teal barber chair sits right in the midst of the pattern while the arc of the room is defined by gilded arched mirrors against burnt orange walls.

A sense of old world splendor continues in all of the mobster's living spaces. His plush apartment has brilliant red carpeting, stuccoed ceilings, and a sweeping stairway leading to a balconied corridor before his bedroom. Hot tonalities give way to blue in the bedroom where he sits majestically propped up on pillows to be served breakfast in a huge Victorian bed with Gothic carved ornament. There is a touch of decadence in these settings.

Capone parties with his associates in a banquet hall of huge size and elegance. In the center is a circular table set with white linens, silver service and flowers; the cronies sit around in tuxedos. Large mirrors again line the wall, this time painted a pure white, and potted palms add to the sense that this is some high-society affair. The refined atmosphere is a ruse for it is here, in his most violent moment, that Capone smashes the head of one of his lieutenants, who falls dead on the nice white tablecloth.

Everything about Al Capone's world is lavish, overdone, stuffed with expensive things, but never gaudy; a world that is sharply lit so that objects and people are in sharp focus. Just as the theme music changes for each major character the visual settings define their values, virtues and character flaws.

Elliot Ness' humble, cozy home, with its flowered wallpaper, 1930s popular furnishings, what-not shelves filled with cute figurines, is diametrically

opposed to Capone's world. The home is always bathed in a warm and glowing light. It is an all-American, middle of the road, law abiding home. Ness' wife is doing a little redecorating.

The Ness house could be a caricature, as could Al Capone's surroundings, but von Brandenstein's production design never oversteps the boundaries of suggestion. As much cannot be said for DePalma's direction of the players. His handling of Ness' wife and daughter makes them simplistic caricatures of the good wife and the dutiful child.

The only other "Untouchable" whose personal life is visually depicted is Malone (Sean Connery). He is an older beat cop, who has suddenly been turned into a crusading crime fighter by Ness. Malone is a no-nonsense man's man who lives alone in a shotgun apartment with a big front bow window on Racine Street. His home is plainer than Ness', more working class, vaguely lacking the attention that a wife might give it, but clean. It is well lived-in, familiar, and solid, with no frills; just like Malone himself.

Following Capone's barber chair newspaper interview, the story continues with a scene in which a little girl is killed by a bomb planted by the Capone gang in a corner pub. The little girl is first seen crossing a sunlit residential street walking toward the glass enclosed pub which is approached by the camera from the other side of a rattling El pier. The inside of the pub is bathed in a soft filtered sunlight, and like the street looks very peaceful and benign. The decor and lighting suggest the harmlessness of the inhabitants, which makes an explosion seem especially shattering.

A lot of the action takes place within the bland and neutral settings of police headquarters, where Ness sets up his office. The wood trimmed doors accent the plain beige walls, with other cool tonalities of gray and blue shot through in a fashion familiar for this kind of setting. The settings fit Ness' bland and institutional personality.

In contrast to these law enforcement settings, DePalma and von Brandenstein, when they are given a chance by David Mamet's screenplay, present moments of visual splendor in Chicago buildings. One of the best known landmarks used is the Auditorium Building by Louis Sullivan which is outfitted to be Capone's headquarters. Many of these fine old structures are seen in a shot DePalma favors, directly up from the floor. In an early scene, Ness and Malone seek out a Catholic church so that they can talk where "the walls have no ears," and the audience looks into a gilt coffered vault. In a later courtroom scene, when Capone is on trial for tax evasion, the scenes that take place in the courthouse corridors are often shot so that glass domes, vaults, and paintings appear dramatically to frame the character's faces.

DePalma builds one scene very closely around a set, a train station. An homage to the montage techniques of Sergei Eisenstein's Odessa step sequence in the *Battleship Potemkin* (1925), the carefully choreographed action involves a shootout over Capone's bookkeeper. Every detail of the stairway and

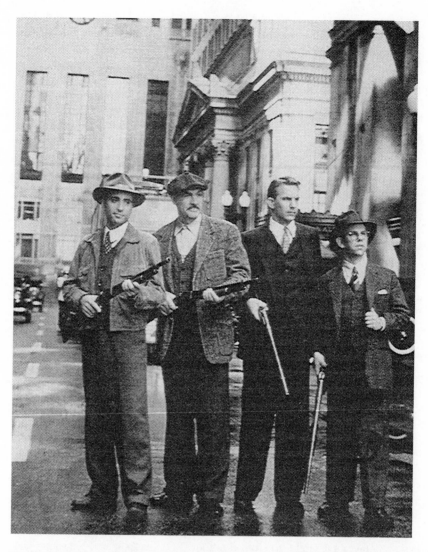

The Untouchables (1987, director Brian DePalma, production designer Patrizia von Brandenstein). Elliot Ness (Kevin Costner, second from right) leads his stalwarts (*left to right:* Andy Garcia, Sean Connery, and Charles Martin Smith) through the streets of Chicago during Prohibition.

its immediate doors and piers is used to purpose in the scene, whose emotional center is on a baby carriage bouncing out of control toward the bottom of the stairs as bullets fly in every direction.

Much of the production design of *The Untouchables* does not try for realism, but is, instead, conceived in bold strokes of color that sometimes change

quite suddenly for dramatic effect. In an alley scene where Malone corners a corrupt police captain and anger erupts between them, the light in the alley changes from a primary blue to a vivid primary red. In this way, the viewer is kept aware of a Hollywood polish to the film, which seems to have been an aesthetic choice by the director and the production designer.

There are only two extended outdoor sequences in *The Untouchables*, one at a bridge on the Canadian border with Mounties on horseback a part of the action and another where Ness chases Capone's henchman Frank Nietze on a Chicago rooftop finally tossing him to his death over the side. Both are orchestrated with DePalma's usual flare for violent action. They take advantage of the topography to open the movie up from its mostly interior settings.

Especially the rooftop set evidences von Brandenstein's usual care with every small detail; it is a study in textures: gravel, metal, brick and stone. The credibility of a film frequently depends on such details in such mundane places. Every production designer invests the big set with time and attention; the best of them, like von Brandenstein, address every set with concentration and imagination.

Notes

1. Carol Troy, "Architects of Illusions," *American Film*, August 1990, p. 37.

4. Period Films
That Move Through
Several Decades

Avalon (1990)

DIRECTOR AND WRITER: Barry Levinson
PRODUCTION DESIGNER: Norman Reynolds
ART DIRECTORS: Fred Hole, Edward Richardson
CINEMATOGRAPHY: Allen Daviau
MUSIC: Randy Newman
COSTUMES: Gloria Gresham
PRODUCERS: Mark Johnson and Barry Levinson

The history of one immigrant family, the Krichinsky's of the Avalon section of Baltimore, is told by Barry Levinson (the screenplay is also by the director) in terms of the intimacy of private lives. In the end the audience is aware of sweeping changes in American values and how they effect family life, yet those values are treated so incrementally in the story that the final impact is profoundly sobering and sad.

Avalon opens on the arrival of Sam Krichinsky (Armin Mueller-Stahl) in Baltimore on the 4th of July, 1914. It is a spectacular day filled with electrically lit arches and ornaments that line the street in "Electric Park" and leave the newcomer speechless. It is an old-fashioned celebration, with store windows filled with patriotic images, bunting lined streets, and people waving flags and sparklers from windows along the way. As the film begins, Sam is reliving this memory in a voice-over to his seven year old grandson Michael (Elijah Wood)

For more information on the production designer of this film, see Part II.

and other members of his family. At first the film seems to be a story belonging to Sam, but it is really Michael's story and that of several generations of Krichinskys as filtered through young Michael's memory.

Production designer Norman Reynolds' opening set of "Electric Park" is a dazzling avenue of lights that then becomes a real world of streets with celebrants whom Sam encounters as, for the first time, he walks through Avalon, the neighborhood where his three brothers live and await his coming. Levinson has a subjective camera look up into fragments of the tops of buildings with fireworks popping and then look down onto the scene into rain splashed brick streets with fireworks reflected in puddles. The mood is joyous, full of hope and expectation of the fulfillment of the American dream. Several other July 4ths will mark the passage of time in the film as will Thanksgiving holidays. In either case, none will ever be as good as the first one.

Avalon and later a suburban neighborhood are important to the evolution of the family, who are gradually distanced, first topographically and then emotionally, from one another. Levinson used real locations for exteriors in the film and had Reynolds replicate the interiors as remembered by the author (the film is partly autobiographical) and reconstructed from old photographs, furniture catalogues, and other research materials.

In the beginning, the Krichinskys all live in an extended family in separate row houses on the same block or close by in Avalon. They help each other get started in the new country and settle family matters in a meeting of the adults of the clan, called the "family circle."

The crowded conditions, with more than one family in a small row house, the literal overlapping of their lives, is like the overlapping in the architecture; shared walls, shared lives. Sam Krichinsky's row house, where he, his wife Eva (Joan Plowright), son Jules (Aidan Quinn) and daughter-in-law Ann (Elizabeth Perkins) and Michael all live is comfortable. Its walls are covered in floral wallpaper, there are oak trimmed doorways and the furnishings all fall into what salesmen would call "traditional" styles. When Sam and his family move to the suburbs, their taste will not change, and their domestic surroundings are always comfortable, middle-of-the-road and unassuming.

Yet one of their dreams is etched in the decor of the row house; the front screen door bares a painting of a cottage on a green lawn surrounded by trees and with a stream running in front of it. It represents the idyllic dream of suburbia, which the family hopes to attain and soon will.

In the beginning of the film, the family sit down to dinner together and have interminably the same conversations. Much of the dialogue of the film takes place over meals. Thanksgiving, that greatest of all eating holidays, is used repetitively throughout the film to reveal the changes in mores and attitudes of the family members. In Avalon at Sam's house, they first wait impatiently for Gabriel, the tardy brother. The children sit at tables in the front room and the adults at a long table in the connecting dining room. Later on, they all

await Gabriel in the same configuration in the house in the suburbs, where they finally end up cutting the turkey without him, thus precipitating arguments that tear the family apart.

Levinson makes frequent changes of location as the narrative unfolds and the director seldom takes the audience into an interior, which he hasn't shown them, however briefly, from the exterior. The use of real architecture, especially long views down streets in Avalon heightens the film's authenticity.

Along with their homes, the composition of the family living together gradually changes from extended family to nuclear family, and at the end to Sam alone confined to a little room in a nursing home by himself.

In the nursing home, we find that Sam's memory is growing weak. He feels acutely that he has been a witness to the erasure of memory that is part of the American psyche. Sam tells his grandson Michael, who is visiting him in the nursing home with his own little son, that he visited Avalon a couple of years ago and couldn't find his old house. The whole neighborhood was gone, the grocery store, even the entire street where his wife had once lived "…all gone." It was just a good thing, Sam concludes, that a nightclub he had once owned was still there because, "…for a minute, I thought I never was."

This moving tribute to the capacity of architecture to evoke life's memories has been visually underscored by the many loving images of Baltimore recurring in *Avalon*. When Jules was seen working as a door-to-door salesman, the city's monuments dotted the background. In one particularly poignant scene, Sam takes his grandson and other children to the Baltimore reservoir on a hot summer's night to sleep outside where they can catch a breeze.

The erasure of memory in America is paralleled by the erasure of family ties and even of recognition of family. At the nursing home, as Sam's great-grandson leaves after the visit, we realize that the child doesn't really know who Sam is. He is just an old man with a funny way of talking.

Thematically, *Avalon* also deals with the American economic dream of each generation surpassing the last one in affluence. Sam and his brothers were wallpaper hangers, but his son Jules, and a cousin, Izzy, in hope of making a lot of money, latch on to the new entertainment machine of the post-war world, the television. They open a discount television store — a revolutionary idea in the fifties — and then expand into yet more space, until they take over an entire waterfront warehouse.

The first television store is suggestively set on a neighborhood street corner next to an outdoor market. In several tracking shots the camera moves through the market with its wooden stalls of vegetables and other edibles and crowded with friendly shoppers. It is an environment that brings a hum of activity and community to the street. The market is then contrasted to the long rows of shiny, sleek, mechanical objects in the stripped down atmosphere of the television store and later the appliance warehouse. Levinson's comparison is a precise history of marketing in 20th century America, a change from

hands-on-know-your-customer merchandising to impersonal mass marketing. The settings tell it all.

Television is, at first, an object of humor and of veiled ridicule from Sam, who prefers radio. The entire extended family gathers around their first television, transfixed by the test pattern, as Sam injects, "That's television, you can only watch for so long."

The family is gradually drawn into a life built around television which now drones on behind the dialogue in most of the domestic scenes. When Sam and the family move to the house in the suburbs, they rush from the table when Milton Berle and the Texaco Hour come on, leaving their plates of food behind in the kitchen.

After Jules and his wife have a second baby, Sam and Eva move back to Avalon, and we witness one last melancholy Thanksgiving dinner. The turkey is cut in Jules and Ann's kitchen, while the nuclear family all sit and eat off TV trays in the living room in front of the television screen.

At the nursing home, during Michael's visit to Sam, we know that it is Thanksgiving day because the Macy's Christmas parade is on television; no meal of any kind is shared in this scene.

The 4th of July continues to be celebrated throughout the film, but it too reflects the changes in society. In the suburbs, the 4th is occasion to party at the country club. It is also the opening day of Jules' and Izzy's huge appliance warehouse and symbolically the inauguration of the national holiday of patriotism as a national shopping day.

The warehouse opening is a grand success and the husbands join their wives to dance at the club in the evening. Tragedy strikes when the warehouse burns down during the course of the night. Michael, believing he is responsible for the fire, flees back to his grandfather's house in the old neighborhood. As he races through the streets of Avalon, the celebration is reminiscent of Sam's first 4th in 1914. People in the old neighborhood have kept the spirit of a street festival alive. They've festooned their houses with flags and are racing about with sparklers in hand.

In the story, Michael and his young cousins always enjoy the pastimes of their grandparents better than those of their parents; they prefer the swimming pond to the country club pool. But we know change is coming to these children of the television era.

Michael as a grown man, tries to keep the memories of his family alive by telling their stories to his own son, who is named Sam for his grandfather. As they are leaving the nursing home he begins to retell the story of his grandfather's arrival in Baltimore. In the final shot we again see Sam as he was on that day, standing beneath a red, white and blue sign in Electric Park that read, "Our Flag Was Still There."

This is a nostalgic movie in which historically accurate and telling art direction is absolutely essential to weaving the web of the past. Norman

Reynolds' art direction helps keep the story, which tends to over romanticize the values of the grandfather, within the strict bounds of realistic decor. Nothing is exaggerated in them. A healthy patina of age exists in the interiors, their furnishings, and even the houses that are chosen (Jules' suburban home is not a new one).

The composition of many of the film's images is lyrical in mood: the Reservoir on a hot summer's night when many people are seen in an overhead shot sleeping on blankets, or at the swimming hole when the old folks sit in chairs in the water cooling their feet. In the end it is these images from the past, the lingering remembrance of them and sense of their loss, that affect us most deeply in *Avalon*.

Driving Miss Daisy (1989)

DIRECTOR: Bruce Beresford
PRODUCTION DESIGNER: Bruno Rubeo
ART DIRECTOR: Victor Kempster
MUSIC: Hans Zimmer
SCREENPLAY: Alfred Uhry
CINEMATOGRAPHY: Peter James
PRODUCERS: Richard D. Zanuck, Lili Fini Zanuck

Director Bruce Beresford evinces a profound sense of place, locales and settings in all of his picture. Bruno Rubeo, who worked with him on *Driving Miss Daisy*, is the latest of several production designers that Beresford has used in films on which his own involvement in every aspect of the visual design of his films is manifest.

In *Tender Mercies* (1983), the lonesome little weather-beaten motel placed in the bareness of the Texas plains sets out the landscape of the lives of isolation and loss that the three main characters feel at the beginning of the film.

In *The Fringe Dwellers* (1985), the squatters' shacks that are home to the contemporary Australian aborigines, the film's main protagonists, visually etch the hardship and frailty of their existence. There is no privacy, no comfort, or security in them. A strong wind would blow them away.

Trilby (Kristina Nehm), a young girl who is the story's main character, fantasizes about moving into a "real" house, of changing her life in some significant way. She spots her fantasy house, one owned by the housing authority, and manages to move her family into it. But houses don't change people; the character, lack of ambition, and cultural sensitivities of the family don't

For more information on the production designer of this film, see Part II.

allow them to settle into middle-class dwellings for very long. Even though they repaint the house, injecting their own lively sense of color and textures into it, they really seem happier when they must return to the old squatter home. Beresford's production designer Herbert Pinter produced settings for both films that seamlessly speak the language of the screenplay.

Herbert Pinter was again Beresford's production designer on *Mister Johnson* (1991) as on *The Fringe Dwellers*. The director in this film proves, as he has in earlier ventures, that he is one of the greatest manipulators of locations for story purposes since David Lean. Beresford gets on totally intimate terms with the places he explores, here Africa, and seldom draws back in panoramic long shots that linger and beg to be admired, as happens so frequently in Lean's pictures.

Mister Johnson takes place in 1923 in West Africa. It is an Africa of golden sunsets that sear the sky in red-gold light and create dark silhouettes of trees and hills. The landscape's sensual beauty is inviting, exhilarating, and unspoiled. Even the stiff English colonials of the story become entranced with it.

Mister Johnson (Maynard Eziashi), an African working for the colonial service as a clerk, fashions himself an Englishman through and through. He talks about England as "back home," and goes about on his bicycle wearing a white suit and a pith helmet.

Herbert Pinter's settings are handled by Beresford to point up the contrastive sides of Mister Johnson's nature, the two sets of customs and values in which he is enmeshed. The colonial office where he works is only a couple of darkish rooms painted green and ochre into which blinding sunlight shines through doors and windows. Johnson's wedding party is held in the "Kral," the African village where he lives. In it, he succumbs to the drum rhythms and dances with fevered passion revealing his more authentic self.

As the action turns, Beresford uses the landscape of Africa as an interlude; we see a moon alone in a dark sky or the sun creating silhouettes of trees and people on the horizon. These interludes inject a timeless element into a temporal narrative, suggesting that the story of cultural disjunction may only be a moment in the life of the continent.

Johnson and his boss George Rudbeck (Pierce Brosnan) plot together to build a 100-mile road to link up their small outpost to the rest of the country. Johnson gives all for the road, ultimately his life, and when asked by another man, "Why need road?" answers, "...it will bring civilization, and all men like to be civilized."

In *Driving Miss Daisy* (1989), which is basically a one-set film, Miss Daisy's home is the place where most of the story is told and it becomes a silent partner to the action. This is a two player picture, a character study of Miss Daisy (Jessica Tandy) an "old, rich Jewish lady," her chauffeur Hoke Colburn (Morgan Freeman), an aging, black, former milkman, and changing times and changing relationships in the recent past in the South.

Miss Daisy lives alone in a large house in the suburbs of Atlanta. The house was found in a small town, Griffith, Georgia, 60 miles distant from Atlanta. The town's main street and a Piggly Wiggly grocery store also figure in the story. Miss Daisy's house appears in the picture from the opening frame; before any of the players appear we see light filtering through a window in an upstairs bedroom. Then we see Miss Daisy adjust her hat in a mirror (the camera lens) to go out. In the soft and warming light of the house's interiors, her smartly dressed figure walks briskly from the upstairs to the downstairs. Oak trimmed arches between the rooms frame her slender moving body.

Miss Daisy's house is comfortable; nothing about it intrudes too much. The interiors are decorated in a traditional American mode of the 1920s, and many of them, Miss Daisy's bedroom for example, were left with the furnishings in them just as they were rented for the production from an elderly Georgia widow. The flowery front room wallpaper in soft colors was faded and had to be copied and returned to a more pristine state by the production designer, Bruno Rubeo. The framed reproductions of Dürer prints were added to walls to reflect writer Alfred Uhry's recollections of his grandmother's home on which the interiors were modeled. Some of the photographs hung on the walls are of Jessica Tandy as a baby and young girl. The furniture is that of period styles replicated, which were drawn from catalogues and magazines of the 1920s.

This is not an ostentatious dwelling, but one that is quietly prosperous. It properly reflects Miss Daisy's conservative approach to money matters and her old-fashioned values. You feel that everything is in its long established place in this house, and indeed over the course of several decades, the movie's time span, relatively little about the house changes, except the kitchen.

There is a sense of orderliness, too, that registers as Miss Daisy departs through the kitchen telling Idela (Esther Rolle), her maid, that she is leaving, a custom to which she always adheres. As she traverses the yard to get into her shiny black Chrysler we are shown the solid reassuring red brick exterior of the house and its white shuttered windows. Miss Daisy then proceeds to put the story in motion by backing her car onto a neighbor's garden wall.

Her cars — they will figure prominently in the film to mark the passage of time — are just about the only physical thing in Daisy's world that changes. The other is the kitchen. A frequent set in the film, its furniture and appliances change over time. A television, which Miss Daisy doesn't like, is even added at one point.

The first major scene in the kitchen involves her son, Boolie (Dan Akroyd) confronting his mother about her driving capabilities. The kitchen's solid wooden cabinets, white tile walls and black and white patterned floor are the scene of several emotional encounters between them.

Some things in the film age perceptively, like Daisy's son Boolie who gets a paunch and loses his hair. Idela also ages, her hair gets grayer, she moves more

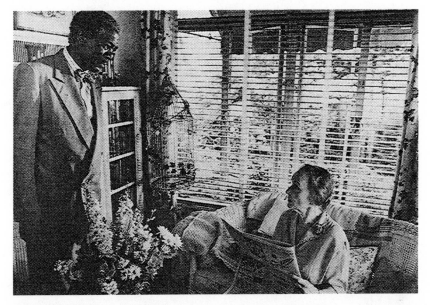

Driving Miss Daisy (1989, director Bruce Beresford, production designer Bruno Rubeo). Hoke (Morgan Freeman) and Miss Daisy (Jessica Tandy), in the traditionally decorated sunroom of her house, spar over whether he'll drive her to the Piggly Wiggly.

slowly and then abruptly dies one day in the kitchen. Hoke, the chauffeur Daisy first rejects and in the end says is her "best friend," ages slowly too.

The only character who seems impervious to time is Miss Daisy. As Boolie says, when first discussing his mother with Hoke, "She's all there, too much there if you know what I mean." Only at the end, when Daisy shows signs of senility, does she seem to have aged. Her thin, wispy hair when it is out of its familiar bun gives her a forlorn look. In the nursing home where she lives at the end of the film, she moves haltingly with a walker.

Hoke, from the beginning, admires Miss Daisy's house, enjoys her photographs, tries to take care of her flowers. Hoke comments at one point when they are arguing in her car, "If I was ever to get my hands on what you got, shoot, I'd be shakin' it around for everyone in the world to see."

The house is seen at all times of the year, with a blaze of color in the spring, in the morning's fog, and even in an ice storm, another element in the film that marks the passage of time in the story.

Another house, Boolie's in 1953 at Christmas, is a source of comic relief. Fifties decor had a full-blown humorous side and production designer Bruno Rubeo exploits it to the maximum here. We first see Boolie examining a Perry Como album with Eartha Kitt singing "Santa Baby" on the soundtrack. There is a cut to Boolie's wife Florine (Patti Lupone) chastising the cook about the

Christmas supper. The kitchen is 1950s modern, the stove is blue, the cabinets blue and yellow, and the linoleum on the floor has diamond shapes in yellow with an abstracted leaf pattern in the center. Florine's outfit, a red sweater and a green circle skirt with crinolines underneath decorated with a pair of giant poinsettias, underscores the frivolity of the decor. This is a fashionable, ephemeral kitchen unlike Miss Daisy's traditional and solid kitchen.

Hoke drives Miss Daisy to Boolie's Christmas festivities, she frets all the way about how Jews have no business celebrating Christmas. As they approach Boolie's house, Hoke comments, "Look what Miss Florine done." She has decorated the entire facade of the big Plantation Revival house including the colonnade with hundreds of Christmas lights. The lawn is decked out with a sled carrying Santa and drawn by a reindeer in multi-colored lights. It is the gaudy exterior equivalent of the gaudy interiors, and a sign of Miss Florine's determination to out-gentile the gentiles.

At the picture's end, a "For Sale" sign appears on the front lawn of Miss Daisy's house. Beresford then takes the camera inside to the silent rooms of the house. They are devoid of people but full of memories of the characters in the story. Again we see close-ups of the black and white photographs on the walls, of a little girl who must be Miss Daisy. It feels like she has died.

But as a car draws up the driveway we again see the "For Sale" sign, but with "sold" plastered over it. Hoke and Boolie meet one last time in the quiet memory-laden house. And now, even the furniture has been removed. Miss Daisy has been in a nursing home for two years. As she had predicted, she has been put in "perpetual care" before she's dead.

Hoke and Daisy have one last moment together over the ritual of eating food in her new "home." That which, by custom, had so long separated them now unites them. He feeds her bites of pumpkin pie.

The subtleties of the production design by Rubeo, and the direction by Beresford, which used it so effectively to forward the story and frame it within the terms of domesticity, resonate in memory.

The Godfather, Part II (1974)

DIRECTOR: Francis Ford Coppola
PRODUCTION DESIGNER: Dean Tavoularis
ART DIRECTOR: Angelo Graham
SET DIRECTOR: George R. Nelson
SCREENPLAY: Mario Puzo from his novel *The Godfather* and Francis Ford Coppola
CINEMATOGRAPHY: Gordon Willis

For more information on the production designer of this film, see Part II.

COSTUMES: Theodora van Runkle
MUSIC COMPOSED BY: Nino Rota

The *Godfather* films, parts I–III, designed by Dean Tavoularis, are all characterized by a gold and sepia tonality that emanates from lamps in the houses of the Corleone family: first in a tenement, then in a large suburban house, and finally in an estate on Lake Tahoe, Nevada. These houses provide much of the context for the film's emotionally charged plot. This tonal quality is changed only when the crime syndicate family leaves the confines of their domestic setting. Since these are films about family and private lives more than about criminal activities per se, the tonal quality seems pervasive.

The warm lighting falls over furniture and objects that are in earth tones. The settings seem tinged by gold, but with much black and deep red added, a palette that is reminiscent of Rembrandt's. Since the family's business is the pursuit of money (gold) at whatever cost, the lighting takes on more than a powerfully suggestive character and seems to be laden with symbolic intent.

The light glows warmly around dining tables, whether the times are good or bad. It looks shadowy and ominous when the Godfather is seeing petitioners or when the family is huddling in conference and is in deep trouble. The lighting casts remarkable patterns of shadow over faces, while parts of the room often slip into total darkness.

This choice of lighting, made by director of photography Gordon Willis with production designer Tavoularis and director Coppola, gives a time worn cast to the film. The images are like those found in old engravings when the paper has yellowed. The epic unfolds like pages in immigrant history, rather than a modern story of criminal activity. That's why the bright light that occurs when the Corleones are not in their own milieu (the Miami and Cuba sequences and in the Senate Caucus Room during the Kefauver investigations in Part II) is so jarring; it brings the real world of everyday life and crime into focus.

The domestic decor in *The Godfather* faultlessly hints at the growing affluence of the Corleone family and then proclaims its wealth in *The Godfather, Part II*. The houses which grow in scale are decorated in unremarkable good taste, with only occasional touches that allude to the Sicilian peasant origin of the family, like fussy hand-blown Venetian glass vases.

The Godfather, Part II opens to the bright sunlight of Sicily, as it retells the story of Vito Corleone's (Robert De Niro) flight to America as a boy, his ocean voyage which landed him beside the Statue of Liberty on Ellis Island. It then cuts to 1958, and a church interior where the first communion of his grandson Anthony, the son of the crime boss and now Godfather Don Michael Corleone (Al Pacino) and Kay (Diane Keaton) is taking place.

This event occasions a big party, a focal point for the unfolding of the film's narrative (as it had been in *The Godfather* and will be in part III). Family parties

are used by screenplay writers Coppola and Mario Puzo, the author of the original novel, to hone the characters, their relationships within the family, and as rites of passage in the life of the family. This one is taking place on a broad lawn on the shore of Lake Tahoe. The family has moved from New York City to better control its gambling interests in Nevada.

The blue of the lake is a backdrop to a large pavilion where entertainment is taking place. Linen covered tables sit in rows before the stage which is first occupied by entertainers and then by an arrogant and corrupt politician. Director Coppola cuts back and forth from the festivities to the criminal dealings of the Godfather in a darkened house interior, which must go on even at a party. The Godfather maintains that all he does is for the family, but it is apparent that the "business" has a life of its own. By the film's end, this factor will finally prove stronger than the intimate bonds of family.

The Godfather conducts his business from the inner sanctum of a den which has a leaded glass window whose pattern looks like a spider's web, an oblique reference to the nefarious web of favors given and redeemed by Don Corleone in the room. The den is dark and "masculine" in mahogany tones and with one wall of rugged natural stone. The family "business" is run by males only.

Michael sits in an oversized armchair, the Godfather's throne, as did his father before him. The camera frequently works in close-ups on the petitioners, including an errant sister, Connie (Talia Shire) who must wait in line to see him.

In the evening after the party, Michael and Kay are in their bedroom, she beneath elegantly monogrammed sheets. The room, like the living room overlooking the lake, has the cozy feel of a mountain lodge. There are flowers on a table. An overly large, 1950s style table lamp sheds light over the Craftsman furnishings, including a wooden spindle bed. Suddenly, bullets rain into this inviting scene, breaking the calm and shattering more than the furnishings. The couple escape, but Kay has been finally and permanently emotionally wounded, and eventually she will leave Michael.

Michael must depart, both to find out who within his family has betrayed him to the bullets and to cement a deal with Jewish crime lord Hyman Roth (Lee Strasberg). He says good-bye to his son Anthony in the child's bedroom, its walls graced with images of knights in armor; the child is the heir apparent to the Corleone kingdom.

At this point, through a double image of Michael and Vito's face, the audience is taken back to New York City and Little Italy in his father's time, 1917. The teeming streets of the old neighborhood express the striving of the community for a mere livelihood and also for a place in the greater scheme of life in America. Flashbacks to the past are an important technical device that Coppola uses to weave the tapestry of the Corleone family throughout *The Godfather, Part II.*

Vito Corleone is a soft-spoken, hard-working grocery clerk striving to make a living for his family. He's drawn into petty crime to provide material things for his family, and then is pressured to pay for protection by the criminal Black Hand society. Vito's initial heist is an Oriental rug from a finely appointed upper middle–class residence. He and a friend cart it on their shoulders to the first Corleone American residence, a sparsely furnished tenement dwelling which is rapidly filling up with the growing family.

The film returns to present time: Michael speeds by train to Florida, to visit the modest home of Hyman Roth, a crime boss with whom he wants to do business in Cuba, thus escaping both the Kefauver Committee and the preying eyes of the FBI. Dean Tavoularis' design of Roth's extremely small and ordinary house seems at absolute odds with the man's power and wealth; like him it is craftily misleading. The two men talk in Hyman's "Florida" room, crammed full of draperies and furniture covered in a bold brown pattern that screams middle-class 1950s popular taste.

Michael is trying to find the traitor within his ranks, who the audience already knows is his brother Fredo. Fredo's corruption is illustrated by more than words; he's got an out-of-control wife. They are seen in the decadent splendor of black satin sheets in a mirrored bedroom which is quite out of character with the comfortable all–American image that Michael Corleone projects as head of the family. Fredo is not keeping up the right front. In Cuba, he frequents pornographic sex shows and it is there that he inadvertently reveals to Michael that he is the inside traitor.

The film action next moves for a prolonged period to location work in Cuba. This includes a marvelous car trip along the shoreline made by Michael as he enters Battista's corrupt pre–Revolutionary Havana. Michael is quick to see the horrific under-belly of the dictator's culture on this ride. The seamier side of Cuban life is contrasted by Coppola in the scenes to follow with the polish of the luxury hotels, the opulence of the government buildings, and the lavish fantasy of the mammoth tourist nightclubs and casinos. Tavoularis dresses the locations in the right period trappings to make this part of the film a document to its times.

As the revolution dawns, Michael and others in his party are at a New Year's Eve party at the President's Palace. In an unforgettable scene, the richly dressed elite of the island scurry out of the Palace and onto its ample flights of stairs upon hearing of Castro's imminent victory. As they depart in disarray, the magnificent palatial architecture is both backdrop and symbol for the waste and corruption of the Battista years.

Michael Corleone escapes to the United States to learn that the Cuban fiasco is not the only crisis to be faced. His wife, Kay, has lost their unborn child. In a flashback, we again see Vito, this time with a sick little son, in the apartment in their tenement days. He's being asked by the leader of the Black Hand to split the profits from his thievery, but instead determines to kill for the

betterment of his own family. This is the real starting point of the Corleone empire.

Vito stalks his victim from the rooftop of the tenements along a street in Little Italy during the religious festival of San Rocco. The street is lined with stalls, there's a puppet show performing a story about warring knights, while overhead colored lights are formed into arches under which a church procession passes.

Vito savagely shoots his victim in a hallway as the fireworks outside explode to cover his deed. He takes the man's money and calmly goes home to sit with his wife and babies on the tenement stoop as though nothing has happened. The baby plays with an American flag.

The action moves back to Michael on his return from Cuba to his estate at Tahoe. We feel that things are wrong, displaced, out of joint. It is winter, Michael must wade through melting snow and ice, past toys he has not chosen for his children's Christmas, and which have been left out in the snow to rust.

Michael senses the great change as he walks through the house and there seems to be no one home. He discovers his wife alone sewing but does not comfort her. He goes instead to see his mother who lives in an adjacent guest house. Michael and Kay's marriage is dead; he just doesn't know it yet. His mother tells him he can "never lose his family," to which he presciently replies, "times are changing."

Coppola now cuts to the Kefauver Investigating Committee in the Senate caucus room on Capitol Hill. The Corleone family is being investigated; Michael has to testify; the government has found a stool pigeon.

Time again reverts to the past, we see Vito slowly emerging as "the Godfather" to his immigrant neighbors. He offers them protection from a society they do not quite understand or trust. The Corleone family are in the same small apartment, but it is much better furnished. They now own an olive oil import company, a front for their criminal activities.

Cuts are more frequently made now between various events and people in the film story. Michael is next seen seated talking to Fredo, almost in the dark, in the terrace room of his Tahoe home in front of broad glass windows overlooking the wintry lake. Fredo is confronted with his treachery, and can only say, "I didn't know it was going to be a hit." We see the snow accumulating on the rim of the window sill; it is like the cold hardening of Michael's heart against his brother, whom he tells, "You're nothing to me now." He means it and will ultimately have weak and jealous Fredo murdered.

While at the Senate hearing, Michael and Kay are staying at the Hotel Washington in D.C. It is there that Kay tells him she is leaving and taking the children with her. She says that she has aborted their child, rather than bring another Corleone into the world.

In the next sequence, Michael remembers the Sicily of his own childhood when his father took the family on a vacation trip to the old country specifically

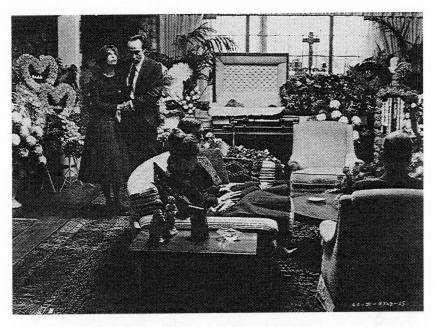

The Godfather, Part II (1974, director Francis Ford Coppola, production designer Dean Tavoularis). Family members grieve over the body of the matriarch of the Corleone family in Michael Corleone's Lake Tahoe home which momentarily resembles a funeral parlor. The rich detail suggests both the authority of the family and their ties to old customs.

to avenge his family's deaths, particularly his mother's at the hands of a powerful Don. Corleones never forget and so Vito slays the now ancient Don on his own terrace overlooking sun bleached gardens and ancestral lands.

A cut again takes the action to the Tahoe living room overlooking the pavilion and lake. Mother Corleone is dead in her coffin with banks of flowers around her making the scene look momentarily like a funeral parlor. The family has gathered for one last time, all except Kay whom Michael will not allow to see her own children.

Fredo is now tolerated, as a kind of foolish uncle to Anthony, Michael's son. One gloomy overcast day, with Michael looking on from an enclosed lakeside terrace, Fredo unknowingly goes fishing with his hired assassin. Michael's glazed room is covered by a black and white striped awning, like prison stripes. As the lethal shots peal out over the water, we realize that Michael is imprisoned by his own warped beliefs and by his now brutal character. In the final moment of the film, Michael is found silently sitting among the fall leaves outside his Tahoe home ... he's all alone.

GoodFellas (1989)

DIRECTOR: Martin Scorsese
PRODUCTION DESIGNER: Kristi Zea
COSTUMES: Richard Bruno
SCREENPLAY: Martin Scorsese, Nicholas Pileggi
CINEMATOGRAPHER: Michael Ballhaus
EDITOR: Thelma Schoonmaker
PRODUCER: Irwin Winkler

The excellent *mise-en-scène* in *GoodFellas* is seen only in passing because Martin Scorsese, the director, cuts so frequently from location to location in the film and because he edits most of it to medium or close-up shots. The dynamic cutting from dramatic moment to moment gives the film its incredible pace, so that it can convincingly move the mob members from a time frame of 1955 to 1980 in what seems an effortless way.

The result is a film that is a perfect balance of screenplay by Scorsese and Nicholas Pileggi, production design by New Yorker Kristi Zea, music (pop tunes of the period that nail the action every time) and costumes by Richard Bruno. This sense of balance is quite different from films like the *Alien* series where settings carry a greater burden for creating the film's mood. In *GoodFellas*, the settings punctuate the story and provide character sketches.

GoodFellas opens on a Pontiac driving down a highway at night. It pulls into a wooded area where a grisly murder is committed by mob pals Jimmy Conway (Robert De Niro), Tommy DeVito (Joe Pesci), and Henry Hill (Ray Liotta). It is 1970. The film then cuts back to 1955 as Henry, the principal character, begins in a voice-over to explain why "as far back as I can remember, I always wanted to be a gangster."

Henry's a kid growing up in a lower-class family in Brooklyn. He first hooks up with a gang by running their errands. The cab stand and pizzeria across the street from his folks' apartment are owned by the gang. Henry's apartment is the first interior setting. It is only glimpsed fragmentarily. The fragments are good enough though to tell us a lot; it is in an older building, has several small cheaply furnished rooms and is dressed out in patterned wallpaper.

These opening frames establish Scorsese's uses of settings throughout the rest of the film: the actors and the action are always paramount. The sets forward the story, but involve the viewer only briefly. This is why in *GoodFellas* details resonate more than usual, things like: tacky barroom Christmas ornaments, hip bead curtains in the 1960s apartment of one of Henry's girlfriends, a wet bar set into a phony rock wall.

For more information on the production designer of this film, see Part II.

The status of the gang members, their success and affluence, can be read in the changing appearance of their residences, especially Henry's and that of mob boss Pauly (Paul Sorvino). In the 1950s, Pauly lives in a vinyl sided row-house. He eventually moves up to a substantial upper middle–class suburban home, nothing really flashy or attention getting from the outside, the flash is saved for the inside.

At the beginning of the film, the gang picnics in Pauly's yard. The gang drink and eat a lot together: they're inseparable, a "second family" to each other. Pauly sits in his yard chair like the American-Sicilian Godfather he is, paunch bellied and lordly in his tiny back yard of packed dirt in front of the chain-link fence. Food sizzles on a grill before him, as Henry's voice explains that all Pauly ever did was "offer protection for people who can't go to the cops."

As Henry's life in the mob unfolds, he acquires a wife, children, and a girl-friend. A subtle point is made in the decor about the relationships Henry has with his first girlfriend and his wife. Henry's first family home, with two babies present, is straight forward middle-class, old-fashioned and boring just like his wife's parents' home where the couple have lived briefly after they got mar-ried.

The girlfriend's apartment, provided by Henry, is glitz and "glamour." The gray and pink living room houses a silk sofa with tropical flowers splashed over a screen behind it. A huge, showy vase filled with feathers stands in the corner. The metal of choice in the apartment is shiny brass; it's seen on the bed, the bar, and on bric-a-brac. This is an apartment taken from the trendiest pop-ular women's magazines.

During Henry's stay in prison in the 1970s, his wife Karen (Lorraine Bracco) and the kids live in a one-room apartment. She has been drawn into his extra-mob drug dealing activities. On his release they get yet another house and Karen, now a changed person, decorates. A more independent, liberated Karen is now into the latest trends and does the place up in a sort of oriental-cum–Hollywood look. An out-of-scale oriental cipher is placed next to the front door. The wallpaper is in a metallic gold on black. A focal point, and one Karen is proud of as she shows people around the room, is the white leather sofa punctuated by black throw pillows and a fake zebra skin. The room has custom touches too, like the large bar set into a wall of fake rock. Recalling the earlier girlfriend's apartment, a vase filled with giant feathers stands in one cor-ner.

The final metamorphosis of Henry's house puts a cap on the whole story; he has ratted on the gang and is in the police witness protection program. The camera tracks across a suburban development of ticky-tacky same-looking houses, as Henry picks up his morning newspaper. He's leading a life without the old action, a life he always hated and joined the gang to avoid. In the last line, a reference to the film's first line, he says, now, "I'm an average nobody."

The grittiest dwelling in the film is the large institutional room the gang members share while they do a stretch in prison. They've filled it with almost all the comforts of home and cook Italian dinners on a hot plate; their fixation on fancy food reaches its zenith. They shuffle around in bathrobes and slippers bribing the guards to do their bidding.

The script deftly alternates the action between interior and exterior settings. This opens the film up to glimpses of the gang's neighborhood. We see its industrial buildings, Idlewild Airport, and, most often, the diners, bars and restaurants where the gang hangs out.

In the 1960s, the gang gathers at the Bamboo Lounge, its fake exotic interior based loosely on South Pacific themes — bamboo and straw walls, strings of colored lights, and carved "Polynesian" heads; the dominant color is red. There are red tablecloths on tables decked out with tiny red fringe lamps. As the owner explains, it's a "class place." You see a little more of it than usual as Scorsese has the camera track through the lounge as the gang members are introduced in Henry's voice-over.

In almost every club or bar the gang frequents, we find them somehow in the kitchen, which underscores Scorsese's point that they are an intimate part of the life of the community. They own or "control" most of the joints or tip so lavishly they can do whatever they want in them. This life is what draws Henry to the mob.

Designer Kristi Zea had to come up with dozens of backdrops in *Good-Fellas,* some of which would appear for only a few seconds. Most of the exteriors are real locations, appropriately dressed for the occasion. The studio-built interiors, like the early girlfriend's apartment, allowed latitude for real invention and character interpretation.

Scorsese's direction makes use of the decor in economical but absolutely meaningful terms. He never has sets built and then ignores them. The beauty of designer Zea's settings is that they move the action effortlessly, but meaningfully, over decades from start to finish of *GoodFellas.*

5. Science Fiction Films and Fantasy Films

Alien (1979)

DIRECTOR: Ridley Scott
PRODUCTION DESIGNER: Michael Seymour
ART DIRECTORS: Les Dilley and Roger Christian
MUSIC: Jerry Goldsmith
SCREENPLAY: Dan O'Bannon; from a story by Dan
 O'Bannon and Ronald Shusett
CINEMATOGRAPHY: Derek Varlint
EDITOR: Terry Rawlings
PRODUCER: Gordon Carroll, David Giler, Walter Hill

Alien is a claustrophobic, basically one-set film, directed by Ridley Scott and starring Sigourney Weaver as third officer Ridley. The spaceship Nostromo is as tightly drawn as is the screenplay, the direction, and the acting. It is a built environment of narrow passages, large open cargo area, and pristine white master computer room. It houses the story of terror on a spacecraft, a common commercial towing vehicle, in some future time. The spacecraft projects a world which is not polished and machine perfected, but is frequently ordinary, grimy, and, in atmosphere, much like older seafaring freighters.

In Alien, as in many other one-set films, the set is like another character in the film. Its multiple interior spaces, defining the work of the crew members and showing their few small communal recreation areas, are on the screen 90 percent of the time.

For more information on the production designer of this film, see Part II.

The craft's mechanistic backgrounds result from the equipment crowded into the spaceship and creating innumerable small spacial pockets which are impenetrable to the naked eye. When the *Nostromo* is invaded by the alien, a malevolent form of life, these spaces provide multiple hiding places from which the beast can menace the crew.

The powerful spacecraft set by production designer Michael Seymour was built with a $1.5 million construction budget. It is abetted by expert special effects associated with the alien — a gigantic murderous creature with multiple rows of fangs that drip an oozy substance over its gaping jaws.

The alien creature was conceived by special effects designer H.R. Giger as a sort of crab-like monster at birth, with its menacing rows of teeth in an embryonic head and with a tail like a reptile. Seymour recalled that, "Early on, the director and I discussed taking on someone like Giger. He had the right sort of curious quality in his work. We got him to do the creature and then he helped later with the alien landscape that included the spacecraft."[1]

At first, Giger's creature is small enough to hide almost anywhere, and its translucent skin blends into the muted walls of the laboratory interiors. As a hideous full-sized creature it remains incredibly difficult to see in the spaceship's interiors quickening its predatory powers.

Various compartments of the spaceship are fitted with computers whose screens blink on and off constantly in data retrieval for the crew. They are omnipresent reminders of the total dependence of the humans on the vast machine in which they are living and flying through space. The crew are prisoners to its advanced technology which has sent them drifting through space toward an SOS that has been answered while they were in a deep hypersleep.

The spacecraft's interiors are lit from dozens of sources by cinematographer Derek Varlint. Light comes from the computer monitors, from behind opaque panels, from sections of the equipment, from keyboards. Seymour remembers, "There was a time when we had about fifty television monitors on at the same time providing different data."

Differing colors distinguish the light in various parts of the ship, and Varlint uses brightness and dimness of light to expand and contract the interiors' spaces. Colored light also intensifies emotional moments — hot reds for panic and terror and blues and whites for rational planning and thinking.

Seymour says, "The lighting is always an integral part of what a film looks like. The set has to be photographed sympathetically or it can lose its drama." That's never the case in *Alien*. The intricacies of lighting fuse with the jets of steam, dripping water and the pulsating sound of machinery in the *Nostromo* to suggest a place that is marginally familiar, sometimes futuristic, and vaguely repelling.

In the setting, without words, we realize from the first that people's basic needs have to be fulfilled even in future time; coffee mugs exist side-by-side with space age technology. The *Nostromo*'s spacecraft and crew are all business,

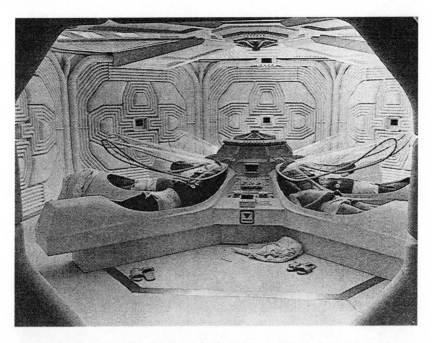

Alien (1979, director Ridley Scott, production director Michael Seymour). The crew
of the space vessel *Nostromo* sleep in separate pods in their high-tech hypersleep
chamber.

so these humanistic touches are kept at a minimum by designer Seymour and
art directors Les Dilley and Roger Christian. The crew's dress is even kept low
key with few personalized touches.

Except for the mechanics, the crew does not operate on levels of intimate
friendship. They are on a towing mission and want to get home and get paid,
and perhaps get away from each other.

The ship's two mechanics, Brett (Henry Dean Stanton) and Parker (Yaphet
Kotto), are working class types, very capable but not in for a big share of the
profits and acting more from mechanical know-how and brawn than from intel-
lectual expertise as are the captain, Dallas (Tom Skerritt), third officer Ridley
(Sigourney Weaver), and android science officer Ash (Ian Holm). For the audi-
ence, the mechanics work in the most familiar surroundings of the *Nostromo*,
what looks like a boiler room. It is in the bowels of the spacecraft.

When asked about his intentions, Seymour explained, "We tried to pro-
duce a sort of intergalactic supertanker or semi, that kind of stepped its way
across the galaxies crewed by a gritty, down-to-earth crew. A collection of
rougher characters worked below decks."

The spacecraft is made out of materials that are uniformly synthetic; no
touch of natural materials appears. The corridors are overpoweringly metallic,

metal floors have long gray tubular forms strung along their walls. At times, plastic takes over as the material preference, particularly in the white hospital lab and the mainframe computer room.

Seymour's explanation for this is that, "The idea was to differentiate between the main spaceship, the *Nostromo*, and the alien landscape which had to be much more organic. It had to be totally the opposite of the hard-edged, utilitarian qualities of the *Nostromo*. The alien landscape had to look as though it had evolved biologically." Much of the detailing of the spaceship is hard-edged in the extreme. The internal doors of the craft are sharply octagonal, for instance, and all slide or snap shut automatically.

Likewise the ship's furnishings look comfortable but ultra-utilitarian; the space crew sleep in individual hypersleep pods around a central mechanical core that regulates their temperatures and other bodily functions. Their beds look eerily like oval coffins covered with Plexiglas.

In the only large space on the spacecraft, the cargo room, a high ceiling adds to the feeling of freedom of spacial movement that is missing in the other cramped parts of the spacecraft. It is here that Brett first encounters an alien on the craft in one of the film's most memorable and humanistic moments. Water from above begins to trickle sensuously onto the workman's face when suddenly, without warning, he is struck down by the creature.

This larger interior allows us to see the huge creature in its full, terrible scale. It also allows for the action scenes where the crew does combat with the creature. Violent action occurs throughout the craft, and, at times, the crew seem at war with the setting. They walk, crawl, and hurtle themselves through the spaceship, alternately loving and hating it. The *Nostromo* is like a living creature to them; they call the main frame computer "Mother."

The film opens on the exterior of the craft as it floats through space. Its mysterious presence in the blue and starry field is background for the information printed on the screen that tells us it is a commercial towing vessel: destination Earth.

The interior focus initially is on the spacecraft devoid of people: an empty corridor, an interior room filled with circuitry seen through transparent panels, another corridor lined with computers, and a close up of a robot in space clothing and helmet. Michael Seymour explained the set and this shot: "The elaborate main set was a huge interconnected maze. Originally Ridley wanted to do a long tracking shot through the empty ship showing no crew at the beginning. He really meant it to go on a long time, through the pre-credits and the credits, for about six minutes. So the way we designed the layout was to allow him to do this long tracking shot. But for various production reasons, the producers were not happy with it being that long, and we had to abbreviate it somewhat.

"We wanted to arrive after this long tracking shot to see the crew awaking from sleep. We introduced the hypersleep rather late in the day. We had in

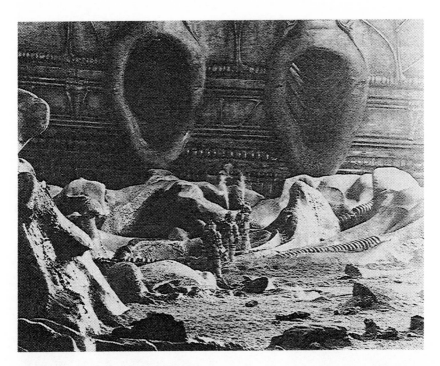

Alien (1979, director Ridley Scott, production director Michael Seymour). The crew of the *Nostromo* are minuscule in the organically imaged landscape of a supposedly unpopulated planet. The planet's topography is suggestive of human and animal skeletons, organs, and orifices.

mind the *Mary Celeste*, and we wanted the *Nostromo* to be a sort of intergalactic *Mary Celeste* that cruises through the galaxies and then all wake up."

The abbreviated opening shot is much like what was intended and does end with the crew arising from their separate sleeping pods and then noisily having breakfast together.

They begin the morning work to discover that their flight course has been altered by "Mother" and they are not headed home to earth, but in the direction of an unpopulated planet which appears to be sending out an SOS.

The *Nostromo* lands on the planet and part of the crew, including the captain and the second officer, Kane (John Hurt) move out to locate and identify the sound and discover if it is, indeed, an emergency signal.

They discover a dark and foreboding alien landscape, its rocky surface a muted gray tonality, streaked with silver. Fog drifts ominously ac:ɾ ɔs its uninviting surface, obscuring the search party's vision. They make out a huge mass and, moving toward it, uncover tubular formations and two enormous oval orifices giving entry to a shadowy interior.

Dallas and Kane and the others proceed cautiously into a towering rib cage

of space that drips from all of its crevices. It resembles the insides of an pre-historic animal made from metal. Perhaps, they reason, it is an alien life form that has fossilized.

Further on, another opening leads them to an environment as hot as the tropics that again resembles a rib cage, but this time it has been inverted. Here they come upon dozens of large eggs incubating in long rows. Kane finds one pulsating as it attempts to hatch. He intently watches a shadowy movement beneath the semi-transparent outer cells of the egg. Opening suddenly and with great force, the creature propels itself from the egg onto Kane's face, its tentacles embracing his head in a death grip.

This alien landscape with its breeding ground is the only other significant setting in the film. Its slimy surfaces, unwelcoming interiors, and horrifying pulsating netherlife rekindle memories of childhood nightmares of something primordial and unknowable.

The captain and crew bring the incapacitated Kane back to the ship, but Ridley, who is now in charge within the craft, tells them they must follow the science department's 24-hour quarantine rule because of the alien life that will be coming aboard. Oblivious to the rule, Ash, the science officer (who is an android programmed to take the alien specimen for investigation to Earth, even if it means sacrificing the crew) lets them back into the ship immediately, the creature still affixed to Kane' face.

One of the most harrowing moments in the action, and one in which the set is indispensable, occurs when they try to cut the tentacles off Kane's face and the alien spills its acidic "blood" onto the spacecraft's floor. The acid eats a hole downward through successive floors of the ship as the audience realizes that if it penetrates the hull, the crew is finished.

The alien disappears from Kane's face and is killed by a fall; Kane awakens, apparently all right, but later succumbs in a pitiful way when an alien egg that has been incubating within his body bursts from his chest.

The real combat with the creature begins now and is carried in frenzied action to all points of the spacecraft until the end. The crew die one by one, and in the final sequences, Ridley, the sole survivor, sets the ship's controls to self-destruct and thus kill the alien who is trapped within it.

To save herself, Ridley enters a satellite shuttle only to find that the alien is inside with her. What follows is in the great tradition of action adventures stories, for she must do one last battle, *mano a mano*, with the malevolent creature. Creeping into a spacesuit, and using it as futuristic armor, she manages to flush him out of the cargo door impaling him with a spear as he begins to fall into an endless oblivion.

Notes

1. Quotations are from an interview with the author.

Raiders of the Lost Ark (1981)

DIRECTOR: Steven Spielberg
PRODUCTION DESIGNER: Norman Reynolds
ART DIRECTOR: Leslie Dilley
SCREENPLAY: Lawrence Kasdan; based on original
 story by George Lucas and Philip Kaufman
CINEMATOGRAPHY: Douglas Slocombe
MUSIC: John Williams
PRODUCERS: George Lucas and Howard Kazanjian (for
 Paramount)

A contemporary fantasy film like *Raiders of the Lost Ark* that has no pretense other than to have fun is wide open to imaginative production values. Director Steven Spielberg and producer George Lucas chose Norman Reynolds and gave him free reign on the project based on his work on *Stars Wars* (1977) and *The Empire Strikes Back* (1980). Reynolds had won an Academy Award for *Star Wars* and was to repeat that accomplishment with *Raiders of the Lost Ark.*

Among Reynolds' difficulties as production designer was the fact that Spielberg shot the movie in 73 days in many locales, including Peru, Hawaii, France and Tunisia. The director used Mickey Moore, a second unit director known for his handling of action sequences, for some of the location work. Spielberg averaged around 40 set-ups per day during shooting.

The opening sequence, with archaeologist Indiana "Indy" Jones (Harrison Ford) narrowly escaping demise, not once, but several times, sets up the old Saturday matinee serial style that is the movie's departure point. In fact, the time in question is 1936 (the heyday of serials), someplace in South America, where, bullwhip in hand, Jones is hacking at underbrush to reveal an ancient carved stone face. Suddenly he is attacked by fierce-looking natives shooting poison darts and arrows. Narrowly escaping them, Jones finds the tunnel he's been searching for only to be told by his guide that no one has ever come out of it alive.

Now the fun begins and so does the production design; the cobwebbed, tarantula infested tunnel is booby-trapped at every juncture and even festooned with the cadaver of an earlier treasure hunter.

The dunnish tunnel interior is spotted with menacing sculpture of a mixed Mayan/Aztec character and with a golden disk that is meant to lure the intruder to destruction. Indy prevails over the tunnel's booby traps and finally exchanges a weighted satchel for the sculpted golden head which is the archaeological treasure he's been seeking.

For more information on the production director of this film, see Part II.

Raiders of the Lost Ark (1981, director Steven Spielberg, production designer Norman Reynolds). "Indy" Jones (Harrison Ford) narrowly escapes annihilation from a monster sphere as he runs out of a tunnel that he has looted.

At this point, the "powers" of the tunnel begin to avenge its desecration; the entire structure quivers and caves in around Indy. Undaunted, he and his guide run for their lives back toward the outer opening. Halfway through, Indy's feckless helper steals the booty as trap doors close upon the adventurer, but he survives to retrieve the prize while the guide is impaled on knives. As a final threat, from out of nowhere, a huge ball hurtles down the tunnel at breakneck speed (a special effect that was back projected and never actually seen by the actor) just behind Jones, who jumps to safety in the nick of time. But his neck is all he saves because Jones is greeted by unfriendly tribesmen and the scheming French archaeologist Belloq (Paul Freeman), who informs him that there is "nothing you can find I can't take away."

In this sequence, many intricacies of set design and much action has flashed by the viewer in a relatively short time. Both are memorable because the elements in the set design are absolutely coincident with the action. Nothing has been wasted. In films that have the kind of breathless pace that *Raiders of the Lost Ark* does, sets take on a special importance. The director needs to know how he is going to get into the action and how he can get out and the production designer must provide the means. There are many more action sequences in a variety of locales in this 115-minute film and they are kept vivid by using the same formula-linking the action to the memorable moments in the settings.

Spielberg slows down the action almost to a stop after the tunnel episode, so that plot exposition can take place. Jones is found lecturing in a university

classroom (a location campus) and afterwards meeting with agents from United States Army Intelligence. The government wants to enlist his help in discovering the lost Ark of the Covenant of Moses which, according to legend, was buried by a pharaoh at the Well of Souls in the lost city of Tanis in Egypt. The Ark must be kept from none other than Hitler, who is "obsessed with the occult." The Ark is believed to have the power to make armies who walk behind it invisible and it levels mountains in its way. Jones' task is merely to save the world from Hitler!

In order to do this, he must find his old professor Abner Ravenwood, who coincidentally has a daughter, Marion, with whom Jones was at one time romantically involved. Ravenwood possesses a crystal from the Pharaoh's staff that is needed to discern the exact location of the Well of Souls and with it the Ark.

Jones returns to his bachelor digs, a house whose interior has Art Deco touches in keeping with the 1930s time frame, to prepare for his departure. It is tastefully decorated with elements that suggest his intellectual pursuits. The living room has walls of bookshelves and display shelves for his collection of antiquities. A fireplace and low-key color and lighting combine to give the interior a strong masculine presence, a reading which corroborates the heroic character of Indiana Jones in the script.

An airplane ride across a superimposed map finds Jones in cold, mountainous Nepal entering a smoky tavern lit by the glow of a roaring fire. This is one of the film's evocative and unforgettable settings. It is first the backdrop for a comedic drinking bout involving the tough Marion Ravenwood (Karen Allen) and then for a sustained action sequence in which almost every inch of the set is destroyed. In the murky golden brown light, you can just about make out a long bar and tables of wood. The light is hidden behind the bar's many bottles and behind wall sconces. Moorish brass lanterns glimmer around the room. The bar's crumbling outer walls reveal brick beneath mortar and the huge fireplace is made of large rough stones. Trouble follows where Indy goes and when he meets up with the hard-drinking Marion, who owns the place, she greets his pleasant "Hi" with a fist to the jaw.

Marion is wearing the crystal (it looks like a medallion) beneath her blouse, but is not about to tell Indy its whereabouts. She tells him her father is dead and during their conversation both are accosted by Toht (Ronald Lacey), a sadistic Nazi agent who's also after the crystal. Toht, a Peter Lorre clone, threatens murder and mayhem and in the ensuing shoot-out, sends Marion's bar up in flames. This, and the fact that she has saved his life, leaves Jones and Marion comrades in arms. They make a get-away to Egypt to find the lost Ark.

The action picks up again on a rooftop overlooking north African white stucco houses; it is Cairo (actually a location in Tunisia) where Indy has come to seek the help of an old buddy, Sallah (John Rhys-Davies), an expert site digger. Sallah is afraid to search for the Ark; "Death has always surrounded it,"

he tells Jones. Indeed, ancient lore confirms that there is a curse on anyone who opens it.

Marion and Indy busy themselves with preparations and explore the city's bazaar, a marvelous location of narrow streets with tiny shops, baskets filled with fruits and vegetables, snake charmers and people in flowing caftans. The Nazis have discovered the pair and a mad chase ensues through the alleys, doorways and stalls of the market quarter, so that many portions of the locale are seen.

Marion, hiding in an enormous basket, is loaded onto a truck of explosives which ignite. Indy believes she is dead. He drowns his sorrow in booze, but is not about to give up the search because he has the crystal in his possession.

Sallah and Jones seek out a soothsayer to decipher the medallion for them. His is a mysterious cavelike dwelling overlooking the night lights of the city beyond. A telescope at a window looks to the light from the stars which the soothsayer can read.

Jones and Sallah now proceed to infiltrate the Nazi dig site, which is on the wrong spot. In the arid desert, Jones, using the knowledge the soothsayer has imparted to him, finds the correct site. He's lowered on a rope into a beehive tomb, like those found in Mycenean Greece. Norman Reynolds, the production designer, in this built set goes through the dictionary of historic ancient architecture to create a complex and visually exciting Egyptian tomb with its Well of Souls.

Like a lot of art directors and production designers before him, he pays scant attention to accuracy in the architecture he is supposedly portraying. Like John Box with the set for Canterbury Cathedral in *Becket*, one architectural style succeeds another at an alarming pace in the same building.

Indiana Jones proceeds from an ancient Greek beehive tomb into one covered with Egyptian frescoes. For unspecified reasons, an architect's model of the great temple complex of Khafre at Gaza sits to one side. Indy dusts off a stone tablet covered with hieroglyphs, checks his data book, holds up a staff with the crystal on it, makes further notations as to where to dig, and then breaks the staff.

As Indy and his friends begin to dig for the Well of Souls, a tremendous storm brews, and lightning strikes; he must enter the tomb to misadventures with dozens of asps. One chamber leads to another one containing colossal ebony and gold statues of the pharaoh. At last, Jones uncovers a casket and within it the golden Ark of the Covenant. Misfortune following him, Indy raises it to find Belloq, the omnipresent bad guy, waiting to snatch it from him and then toss the hapless Marion into the tomb pit, too. For, alas, she is not dead, only strayed and stolen.

The duo can't get out without a rope and it looks like they're goners. But Indy puts up a hard fight with the tomb and with the asps. It is at this point

Raiders of the Lost Ark (1981, director Steven Spielberg, production designer Norman Reynolds). "Indy" Jones (Harrison Ford) struggles to get away from hundreds of snakes among colossal statues of ancient pharoahs of Egypt as he searches for the Well of Souls.

that we learn just how flimsy those Egyptian stone statues really were, as Jones kicks one over with his foot. The colossal statue of the pharaoh falls and a chink in the wall is miraculously found for escape.

The chase for the Ark now begins in earnest, with Indy bringing up the rear and snatching and then losing the Ark. The final action unfolds with Belloq (again he has a captive Marion in tow) trying to open the Ark of the Covenant in the Egyptian desert using the proper Jewish rituals. Jones, in German uniform, is not far behind, but is caught and tied up to await his fate with Marion.

As the Ark is opened, special effects take over and the desert location becomes a built rocky set. Lightning strikes everywhere, vapors arise and rays of light move over the surface and ground like high voltage energy exposed to the naked eye. Wind spirits turn to monsters in the air, flames pierce Belloq's entourage of soldiers and run through the scene melting the flesh of people, leaving only their skeletons. A fire storm breaks loose over everything and only Marion and Jones escape by not opening their eyes. The ark cover is borne heavenward by flames and then returns to cover the Ark.

The last image, an homage to the final sequence in *Citizen Kane,* is one of a huge government warehouse where the Ark in a box labeled "Top Secret" is being stored among thousands of other crates in a vast warehouse. No one will tell Jones where it is.

A fantasy film like *Raiders of the Lost Ark* has profited from the juxtaposition in scene after scene of built settings followed by actual locations that have been reworked to suit the story. This juxtaposition sets up a tension in the visual pattern of the film that is analogous to the tension in the story, blurring the lines between what is real and what is fiction.

II. THE PRODUCTION DESIGNERS (WITH FILMOGRAPHIES)

Mel Bourne

Mel Bourne is one of the most influential production designers of the present day. His feature film design career began with the creation of the urban interiors for Woody Allen's *Annie Hall* in 1977, but before that he had already been working for two decades as a stage and television designer and in commercials, all done in New York City. Because he didn't want to leave Manhattan, Bourne thought his career would end there and that he could, "...forget about any kind of immortality."[1] Since *Annie Hall* he has become one of the best known film production designers and still lives in his preferred hometown.

A native of Chicago, Bourne went first to Purdue University where he got a degree in chemical engineering and then to the Yale School of Drama to put his degree together with theater. While at Yale he studied with famed stage and film designer Robert Edmond Jones.

In the 1950s, Bourne designed many stage productions including *The Male Animal* and *The Millionairess*. He also worked on illustrious television dramatic series like the *Lux Video Theater, Hallmark Hall of Fame*, and more recently he designed the groundbreaking pilot for the *Miami Vice* series.

Of his work on commercials — he's done over 70 — Bourne believes they were a great education for film. The budgets on his commercials were sometimes lavish; his credits include the Alka Seltzer series, "I Can't Believe I Ate the Whole Thing," and the Edie Adams White Owl cigar commercials.

After his first film with Allen they teamed for *Interiors* (1978), a dark drama about the mental dissolution of the mother of a New York family starring Geraldine Fitzgerald. Its monochromatic palette — many of the interiors were done in white and other pale tones with cool accents of gray — matches the intense and cold personality of the main character, who is an intellectualizing perfectionist. The washed pine furniture that Allen preferred in the decor worked well in the minimalist settings. Bourne's production design on the film garnered him an Academy Award nomination.

For details about two of the films for which Mel Bourne was production designer, see the chapters on The Fisher King *(p. 39) and* Reversal of Fortune *(p. 18).*

Bourne has worked with many well-known cinematographers since his earliest days on commercials and considers them, along with the director, his chief collaborators. He knew Gordon Willis, with whom he has shared credits on the Allen films, from those days and later was to work with him as production designer when Willis directed the film *Windows* (1980).

Bourne's design philosophy is simple: "My function is to provide a decent visual atmosphere in which a story can be told, not get my jollies using something if it doesn't carry the picture along."[2] Despite this pragmatic philosophy Bourne wishes American films were more imaginative in their approach to film decor. With Terry Gilliam's film *The Fisher King* (1991, see page 39) his wish for more fantastic and imaginative work was fulfilled. It should be noted that along the way to the work with Gilliam, Bourne had designed complete, authentic and mood evoking 1930s settings for *The Natural* (1984), a baseball picture starring Robert Redford, and taken Allen through several decades, the 1920s through the 1940s, in *Zelig* (1983).

With a great mind for details, Bourne personally designed the many odd props for Zelig including the toys bearing the main character's effigy (now on display at the Museum of the Motion Picture in Astoria, Queens).

Attributing his distrust of set decorators to his time spent in theater, Mel Bourne only allows them to be foot soldiers on his films. His tendency is to oversee all of the details in the sets and the props; he checks out favorite New York stores for period furnishings. Bourne is sure of what he doesn't like in film decor: "I do not like crap all over."[3]

Terry Gilliam, unlike Allen, took a major role in the design of *The Fisher King*, and for specific reasons: "I was trying to keep things grounded in reality, I didn't want to design it to death. I tend to heighten what I shoot, even if it's a piece of litter in the gutter." He wanted Bourne to "drag me back to reality."[4]

The locations for the film were done in New York, but the interiors were constructed on five sound stages in Hollywood. Bourne is used to doing built sets, especially "authentic" New York apartments for Allen's films. Both *Annie Hall* and *Manhattan* were shot mostly on sound stages.

In Gilliam's *The Fisher King* the real scale of the architecture was allowed to come through in this use of locations: beneath the Manhattan Bridge for a homeless squatters' settlement, beside an overpass on the FDR Drive for another, and the Armory on Madison Avenue for a millionaire's house on Park Avenue. As Bourne put it, "You'll know it's a Gilliam movie from the scale of the architecture in relation to the people underneath."[5] The same sorts of ratios of humans to architecture are seen in Gilliam's *The Adventures of Baron Münchausen* and in *Brazil*. The characters in the films are frequently overwhelmed by the settings, in other words by what mankind has built, by civilization itself. This is a major thematic line too in *The Fisher King*, for both Parry and Jack, the main characters, are overwhelmed in some fundamental way

by their surroundings — a world touched by madness, alienation and loneliness.

Mel Bourne Filmography

Annie Hall, 1977
The Greek Tycoon, 1978 (with Michael Stringer, production designer and art directors Gene Gurlitz and Tony Reading)
Interiors, 1978, AAN
Nunzio, 1978
Manhattan, 1979
Stardust Memories, 1980
Windows, 1980
Thief, 1981
A Midsummer Night's Sex Comedy, 1982
Still of the Night, 1982
Zelig, 1983
Broadway Danny Rose, 1984
The Natural, 1984, AAN
F/X, 1986
Manhunter, 1986
Fatal Attraction, 1987
Cocktail, 1988
The Fisher King, 1991
Rude Awakening, 1991
Man Trouble, 1992
Reversal of Fortune, 1992
Indecent Proposal, 1993
Angie, 1994
Kiss of Death, 1995
Something to Talk About, 1995
Striptease, 1996

Notes

1. John Calhoun, "Mel Bourne," *Theatre Crafts*, April 1991, p. 55
2. N.a., "Mel Bourne," *Metropolitan Home*, June 1985, p. 15.
3. Calhoun, p. 43.
4. *Ibid.*
5. *Ibid.*, p. 54.

Albert Brenner

Prolific production designer Albert Brenner has a straightforward definition for his work: "The production designer is in charge of everything that's either out of focus or doesn't move."[1]

Brenner got into the business via theater design. A New Yorker by birth, he went to the New York School of Industrial Arts and, after World War II, did graduate studies at the Yale Drama School. Brenner then taught scenic design, costume design and technical theater at the University of Kansas City.

In the early 1950s Brenner returned to New York to work in the theater. To get into the Scenic Designers Guild (today IATSE Local 876 and New York Local 829) he had to take a two day test, which he remembers vividly: "You had to bring a portfolio of your work and your own tools. First, they gave you drafting to do. Then you were shown pictures of costumes and furniture in various styles to identify. Finally, while you were there, in person, you had to design a set, in color, for a play." The second day was equally arduous: "A large canvas was stretched on the floor, and you took your sketch and painted it full size to prove you could do scenic painting. Today they give applicants six or eight weeks to do the same kind of work *at home*."

"When I got into the movie business there was a sort of reciprocal agreement between California and New York, so if you passed the test the union said you could work on a movie in either place." Commenting on his work in the theater, Brenner says, "The big difference in sets for theater and film is that the theater allows more flamboyance."

Harry Horner, the great independent art director who fashioned many memorable films like *The Heiress* (1949), became Brenner's mentor. The young art director was working in television to make a living when Horner took him on for *The Hustler* (1961), which starred Paul Newman. *The Hustler* ended up earning an Academy Award and Brenner, in the course of it, learned Horner's rules for screen design: "The only thing important is what the camera sees. And

For details about the films for which Albert Brenner was production designer, see the chapters on The Presidio (p. 16) and The Sunshine Boys (p. 36).

you can make a set so the camera sees it." Horner also taught him "that you can make a room as irregular in layout as you like because no one will ever know but you. Camera set-ups can compensate for any abnormality of layout."

Brenner's observation on the history of film design is that "The moving camera was the biggest change from the way the silents saw sets. In silents they were shooting a proscenium arch set. In later films, they could follow Horner's rules because the camera could do just about anything."

Brenner applied Horner's rules in his production design for *The Program* (1993). He crammed numerous sets, placed at every imaginable angle, into an empty warehouse. "You can make the simplest space more interesting if you analyze it from the point of view of the camera and the action." He demonstrated this with the motel room set in *The Program*: "A motel room is a very basic rectangular space with an uninteresting layout of beds. What I did was create a more interesting space by including a shallow foyer with a crooked wall, one on a slight diagonal. So that by placing the camera at the fourth, missing wall, of the room, you see not only the dresser area, but into the bathroom to the mirrored vanity, which then reflects the shower stall and curtain. This made a more visually rich interior, than if you only saw four mostly blank walls."

Brenner analyzes the difference between real architecture and screen architecture, as the difference between wanting to build a client the maximum space on a site (real architecture), to taking a minimum site and doing anything with it (screen architecture). Basically, in film, the site is unimportant. (See illustrations on pages 116, 117, and 118.)

For laying out "what the camera can see," Brenner has invented an instrument that calculates, from the camera set-up, what will be seen, both vertically and horizontally. It can be laid on any drawing and achieve these results.

Building an art department for a film is also a talent he has learned. Basically, Brenner has built up a pool of workers who are needed for the job: "These are people I trust." He hires the same ones for almost every film, depending on their availability.

Brenner knows and trusts draftsman Harold Fuhrmann. He brought him in to do the drafting on *The Program*, and says, "I kept him on location as long as I could." Fuhrmann did the detailed plans for the many separate sets on the movie that deals with college football.

Carol Wood, art director on *The Program*, is another trusted person. She and Brenner have worked on several films together, and he says of her, "She's a production designer herself, now." Wood sees that Brenner's ideas for sets are done correctly. In a way, their partnership has been like that of the old studio apprenticeship system of training. Wood comments, "I've learned from Albert to know all about architecture. How things work in the real world of architecture." Wood has a library of books on architectural detailing and styles.

Carol Wood received an education in cinematography, but found that

The Program (1994, director David Ward, production designer Albert Brenner). *Left:* A preliminary "idea" sketch for a motel room in which Brenner is trying to establish a camera position (x over c and tip of triangle in sketch) into the space that will make this standard motel room more visually interesting. *Right:* Finished plan for the motel room. The entryway has been angled so that the camera can see through the door of the bathroom (top right) to a sink and a mirror which further reflects the shower on the other wall of the room.

Hollywood was not ready to accept a woman as a cinematographer. So she took up an aligned visual area, production design.

How do production designers get jobs? Brenner's reply was direct: "Either I'm asked to do a film or my agent gets me an audition. An agent can't get you a job, but can get you an interview. As for the interview, you are always asked how you 'see a film.' You have already seen a script and then are expected to have some visual ideas to offer the director."

Brenner has worked frequently for a few directors. Of the more than 40 films he has done, roughly half have been done for only three directors: Herbert Ross, Peter Hyams, and Garry Marshall. "Having rapport with a director is one of the most important things for a production designer. You work together even before the cinematographer is brought on the film. Then when the cinematographer comes, the director divorces you and marries the cinematographer."

Asked if he has the itch to direct, Brenner responded, "No, because you must know more than the visual parts to get the best out of a piece." Most

production designers seem to share this point of view, and only a rare one or two have switched over.

Brenner likes to come up with a concept for a film which lends itself to the telling of the story. On *Bullitt* (1968), "One of the concepts was to have no red in it except for blood. So only when there was violence did you ever see red. Even Coca Cola signs were brought down to brown. Those are sort of subliminal things.

"When I did *I Walk the Line* with Gregory Peck. The concept was that as the picture progresses we kept dyeing Peck's clothes darker and darker. I took the picture, a tragedy, from color to black. Again this was subtle, unspoken, subliminal."

Brenner admits that his methods can backfire: "On *Point Blank* [1967], which John Boorman directed, my concept was built around the idea of vengeance. The colors are black and white as he begins to get vengeance. When he meets the girl, colors come back into his life. When the film was edited, they took bits from all over the film into the montage. That didn't let the concept make any sense."

The Program (1994, director David Ward, production designer Albert Brenner). Brenner's plan is built in a model before the set is constructed. Brenner's contention that screen architecture can be infinitely manipulated for the camera's eye and still seem realistic to the viewer is borne out in this model.

Brenner's experience with Garry Marshall, with whom he's done three films, was completely different, "Garry likes to stick to the concept. Input is important to him early on in the film's preparation. You can offer suggestions to him. We got along very well."

The time Brenner spends on a film varies: on *The Program* he was involved for six months, on *Backdraft* eight months, and *2010* a year. "Production design is always unpredictable while you're shooting, so you have to work right through it." Part of the problem is that they scout locations, find them, and then lose them, for any number of reasons. "The location manager makes the deal as to what they'll pay, and so on. But I usually find the locations myself." What does he look for? "Well, there is a practical side to choosing a location. Money and the shooting schedule matter a lot. You are always looking for specifics to fit the plot and the action. But you have to keep an eye on the parking of the trucks too. On *The Program* we had a lot of location problems because

we had actor problems. Their availability for shooting varied, so we had to hurry and do something, and then switch back for another actor.

"Sometimes you have to try to convince directors that bringing things to locations is costly, that the same things can be done in a studio for less money and with less hassle. First of all, locations always need fixing. And then they need fixing back."

The two films analyzed in this volume represent different types of production design. *The Sunshine Boys* is centered around a studio built set, Willie's apartment, with location work dropped in to establish place. On the other hand, *The Presidio* deftly uses San Francisco locations as the primary background, mood evocator, and delineation tool for the main characters of the film.

Albert Brenner Filmography

The Hustler, 1961 (with Harry Horner)
The Pawnbroker, 1965 (with Richard Sylbert)
Point Blank, 1967
Bullitt, 1968
Monte Walsh, 1970
Summer of '42, 1971
The Other, 1972
Scarecrow, 1973
Zandy's Bride, 1974
The Sunshine Boys, 1975, AN
The Missouri Breaks, 1976
Silent Movie, 1976
The Goodbye Girl, 1977
The Turning Point, 1977, AN
California Suite, 1978, AN
Capricorn One, 1978
Coma, 1978
Divine Madness, 1980
Hero at Large, 1980
The Legend of the Lone Ranger, 1981
Only When I Laugh, 1981
I Ought to Be in Pictures, 1982
Max Dugan Returns, 1983

Opposite: *The Program* (1994, director David Ward, production designer Albert Brenner). *Top:* The model seen from the perspective of the camera shows how Brenner's idea of expanding the room into several spaces works to eliminate too much dead blank wall for background. *Bottom:* This model for a house by a mill illustrates how little, just the back porch, needed to be built on location to suggest the entire structure. The house's interior was built together with all of the film's other interiors, back to back, in one large warehouse.

Two of a Kind, 1983
2010, 1984, AN
Unfaithfully Yours, 1984
Sweet Dreams, 1985
The Morning After, 1986
Running Scared, 1986
Monster Squad, 1987
Baja Oklahoma, 1988
Beaches, 1988, AAN
The Presidio, 1988
Pretty Woman, 1990
3000, 1990
Backdraft, 1991
Frankie and Johnny, 1991
Mr. Saturday Night, 1992
The Program, 1993
Under Siege 2, 1995
Dear God, 1996

Notes

1. All quotations by Mr. Brenner and Ms. Wood are from an interview with the author.

Dennis Gassner

The distinct and economic directing style of the Coen brothers, Ethan and Joel, whose *Miller's Crossing* and *Barton Fink*, used the production design skills of Dennis Gassner, depends heavily on the *mise-en-scène* to underscore the themes of their often dark and complicated screenplays (written together). Gassner has also walked on the dark side with Stephen Frears whose *film noir, The Grifters* (1990), benefited from Gassner's understatement of period styles and his ability to work with color to punctuate the emotional content of the screenplay.

Gassner was mentored by the great production designer Dean Tavoularis, whose work on the *Godfather* trilogy (see page 90) constitutes one of the finest chapters in contemporary film design. Tavoularis' rich settings for those films drew gangster films out of smoky back rooms into the upper class living rooms of America, building on the films' theme of crime as a "family" business.

Especially in *The Grifters*, Gassner's debts to Tavoularis are evident. The action is played out in settings that are fairly straightforward and recognizable, but they are frequently drenched in evocative color. "Hot shades go with hot emotions," the art director has noted.[1]

In the Coen films, which embrace a highly stylized version of "reality" there is much explicit subtext in the decor. There is symbolism in the crumbly hotel room of *Barton Fink* and in the apartment of Tom Reagen in *Miller's Crossing*, and it is of an overt type.

Both Coen stories focus on tightly controlled, supposedly unemotional anti-heroes (Barton and Tom). The Coen brothers themselves adopt a very controlled approach to filmmaking. The entire film is storyboarded. The brothers collaborate on every aspect of a film and most especially on its "look." Gassner says that Frears gave him a free hand in his designing of *The Grifters*, while the Coens worked closely with him on the formulation of the visual look of their films. This is certainly what gives the Coen's films, including *Raising*

For details about the films on which Dennis Gassner was production designer, see the chapters on Miller's Crossing *(p. 68) and* Barton Fink *(p. 50).*

Arizona, their recognizable look, which is distinguishable no matter which production designer they choose, and they have used several different individuals. Gassner doesn't mind their tight planning of the films as he is likewise highly organized. He breaks down each scene in a screenplay using index cards and colored chips that signify the emotional content that the sets must enhance.

On both *Miller's Crossing* and *Barton Fink*, the decor is economical in a way seldom seen lately in American films. Every wall surface is not laden with detail, and nowhere is there the overabundance of visual clutter that frequently passes for reality. A certain vacant quality in Barton Fink's room and in Tom's apartment, speaks to the character of the occupants. Such stylization of decor is seldom attempted in American films today, but was more common in the 1920s and 1930s with art directors like Anton Grot at Warner Brothers. To their credit, the Coen brothers, understand the power of the objects in the setting, or their absence, to underscore themes. This is something known to all production designers who often have to sell the concept to their directors.

Dennis Gassner Filmography

Wet Gold, 1984
The Hitcher, 1986
In the Mood, 1987
Like Father, Like Son, 1987
Wisdom, 1987
Earth Girls Are Easy, 1989
Field of Dreams, 1989
Miller's Crossing, 1989
Barton Fink, 1991
Bugsy, 1991
Hero, 1992
The Hudsucker Proxy, 1995

Notes

1. N.a., "On the Shady Side," *Metropolitan Home*, October 1990, p. 50.

John Graysmark

Prominent British born production designer John Graysmark candidly calls himself "a true son of nepotism," as far as entering the film industry is concerned. But his prominence and longevity in the business are due solely to his creativity and work ethic. He explains that as a young boy, "My father had just returned from the Army after World War II, and one Sunday he took me to Denham Studios. No one was there. We looked at the sets for a Paul Robeson picture." Graysmark was enamored by them, even liking the way they smelled "antiseptic and clean, because of the kind of paint they used in those days." He confided to his father, "I want to be a part of this."

Graysmark's father had been a supervising carpenter at the studio before the war and eventually became construction chief for all Metro-Goldwyn-Mayer pictures in the post-war period. He also directed his son's education toward his goal of a career in films. Graysmark took the exam and entered architecture school at the age of 13, leaving to begin his film career in earnest at 21. His first job was on the Ingrid Bergman comeback film *Anastasia* (1956).

Graysmark's father had given him a simple but effective work ethic. If a production begins at 8:30 a.m., be there at 8:00. If you've made a mistake, come forward immediately and admit it. "In an industry that invented the term 'alibi,' this has been very good advice," says Graysmark.

Over the years the observation of others, including performers like Ingrid Bergman, has solidified his sense of professionalism. "On my third film, *Indiscreet* [1958], I recall how during the lunch break she ate with a suitor who brought a picnic hamper to the set. When the break was over she returned to her place and proceeded with the next scene, always knowing her lines and not causing delays. Today, at lunch, the 'star' is surrounded by an entourage somewhere in a trailer nine miles away."

Graysmark's progress in the industry has been marked by his association

For details about one of the films for which John Graysmark was production designer, see the chapter on Ragtime *(p. 74).*

with other fine production designers, in England, and also in America and Italy. "First I worked in the 'John Box family' and then in the 'Don Ashton Family.'" He became an expert draftsman in this capacity as part of an art department team, doing working drawings, overseeing the building of sets and assisting Box and Ashton in all other aspects of their films' designs. The techniques of sketching and storyboarding were used then as they are now. For Graysmark one of the principal things to be learned as a production designer, "and it takes *years and years*," he says, is who the best crafts people in the industry are, "who are the best model makers, scenic artists, seamstresses and so on."

"The only totally designed film I ever worked on was *2001*. I was a draftsman. I worked on it for two years and we weren't even at the model stage. I got bored with it and left."

When Dino De Laurentiis sent Graysmark the script for *Ragtime* the title at first led him to think it was a musical, which he had no desire to do. "Musicals are a pain [for art departments]," he says. Many changes are made throughout the production of musicals because of the staging of choreography or other factors. "I was tired, just having come off a couple of other films." But then he read the script of the drama, changed his mind about the film, and eventually earned an Academy Award nomination for it.

"De Laurentiis asked for the sketches a couple of days into the film. I was surprised and thrilled that he wanted more than my drafting skills. I went home that night, and remembering a drawing technique that Ted Haworth had used, a tracing method on tissue thin paper with color added that ended up looking like a color lithograph, I got to work." Graysmark used the method only making the sketches much larger in scale. "De Laurentiis loved them! I did the same thing on other films. The only drawback was that on a picture like *The Bounty* [1984], the humidity made the thin paper wrinkly and the drawings looked like old crocodile hide." He later found a material suitable in all climates for his sketching method. Although sketches usually belong, by contract, to the film's producers, Graysmark has managed to keep a few of them, mostly on films that never got made.

"De Laurentiis hired me on a handshake. The motion picture business is not usually run that way, especially now when every film, like *Courage Under Fire* [1996], seems to have nine or ten producers," according to Graysmark. "This makes the job of production designer more politic than it used to be. There are a lot more people interested in giving the designer their opinions on the sets. When I worked with John Box, the producer only spoke with him around once a week, if that. They trusted him to do the job."

Commenting on other changes in production design over the 40 years he has been in the business, Graysmark continues, "The system is also a lot different today because so much money is committed above the line, especially for actors' salaries." In the 1950s the art department got around 10 percent of the budget below the line. "It's nothing like that now. Two and a half percent

is average now. Sets are way down there in producers' considerations. And they all like location shooting. But I never saw a location you didn't have to fix."

Computer generated imagery, although not cheap, has also captured the center stage from other more traditional means of generating effects. "Even," Graysmark says, "when the same thing can be done in a traditional way. The optical houses tend to want to grab all the money for effects. Usually a house wants to be the exclusive contractor on a film too. They're grabby."

Although now and then he has worked with Don Ashton, production designer for *The Bridge on the River Kwai* (1957), on architectural interior design for hotels, Graysmark much prefers film design, despite "the amount of effort being so much greater in movie design. I like the speed with which things are done from start to finish, often in two weeks. You make the sketch, draftsmen take over, then the carpenters. You get to see what you've designed almost immediately."

John Graysmark Filmography

Young Winston, 1972, AAN
The Big Sleep, 1977, AD
Escape to Athens, 1979, AD
Flash Gordon, 1980, AD
Firefox, 1981 (with Elayne Ceder), AD
Ragtime, 1981, AAN
Lords of Discipline, 1983
The Bounty, 1984
Club Paradise, 1985
Lifeforce, 1985
Duet for One, 1987
Superman IV: The Quest for Peace, 1987
Gorillas in the Mist, 1988
Honor Bound, 1989
White Hunter, Black Heart, 1990
Robin Hood: Prince of Thieves, 1991
White Sands, 1992
So I Married an Axe Murderer, 1993
Blown Away, 1994
Courage Under Fire, 1996

Notes

1. All biographical material and quotations are from an interview with John Graysmark.

Douglas Kraner

Production designer Douglas Kraner came to film design via work in the theater. Now living in California after 15 years of activity in New York City he works exclusively in film "because I can't seem to find the time for anything else."[1] Kraner holds a M.F.A. degree in scene design (University of Massachusetts). After graduation he went on to work as the resident scene designer at the State University of New York (Stony Brook) and then taught and lectured at other universities. Aside from his theater credits he did a lot of film and television work in the 1970s, primarily as a set decorator.

Kraner's mentor was well-known production designer Patrizia von Brandenstein, with whom he began as a set decorator on *Touched* in 1981. He was subsequently to work on five other features with von Brandenstein including *The Untouchables*, *No Mercy*, and *The Money Pit*. "She helped me form my design philosophy," says Kraner. "I had a great relationship with her." He subsequently worked as a draftsman, and then an art director, and then co-designer on *State of Grace*.

Kraner says he begins with "a specific concept. Often this can be a single visual reference (or group of them)." He never makes things up as he goes along, rather, in the course of the production, weighs all of his design decisions against the "concept" reference.

On *Sleeping with the Enemy* there was no lengthy description in the script of the married couple's beach house. "In fact it was called 'a Cape Cod cottage.' Well, that would be a house with shingles and other place references to me. Joe Ruben (the director) and I decided that instead the house had to fit the husband's personality and be alienating to the wife. Yet at the same time we wanted to incorporate the idea that, at least at some point, something about him had been attractive to her." The beautiful modernist house which is geometric, formal and filled with exquisite objects represents a sort of aestheticism that dominates his personality to the point of obliterating its humanity.

For details about one of the films for which Douglas Kraner was production designer, see the chapter on Sleeping with the Enemy *(p. 126).*

Kraner searched up and down the South and North Carolina coasts for a location house he could use, but found none that was absolutely right. He ended up building the house in North Carolina, with the second portion of the picture being filmed on location in the South Carolina town of Abbeville.

Kraner explains, "I wanted a sense of instability in the beach house. The glass walls, together with the reflective quality of its granite floor, gave it this unstable feeling, like being at sea. There is no way to know when the floor stops and the walls begin."

Kraner confirms what a close look at the *mise-en-scène* of *Sleeping with the Enemy* reveals: "not a single piece in that house was there by happenstance." Among the art objects in the living room is a female statuette that was acquired by the couple during their brief interlude of honeymoon happiness. "That was the most difficult decision in the interior. The director and I wanted the piece to be the one that reflected a bit of both of them." Kraner had several sculptors working on the project and says about the one finally chosen, "We liked it for its sense of history (Egyptian), and femininity, and a reserve that the husband had." The care taken with telling specific details in the decor fits the characters absolutely, and adds subliminal tension to this film.

Douglas Kraner Filmography

No Mercy, 1986, AD
Home at Last, 1987
The Untouchables, 1987, AD
Arthur II: On the Rocks, 1988, AD
Dominick and Eugene, 1988
Working Girl, 1988, AD
Homeless, 1989
Lean on Me, 1989
State of Grace, 1989
Uncle Buck, 1989 (visual consultant)
Curly Sue, 1991
Sleeping with the Enemy, 1991
Raising Cain, 1992
Mr. Wonderful, 1993
Baby's Day Out, 1994
Miracle on 34th Street, 1994
Extreme Measures, 1996
Mr. Wrong, 1996

Notes

1. All biographical material and quotations are from an interview with Douglas Kraner.

Norman Reynolds

Norman Reynolds entered the world of art production design via the circuitous route of commercial art and then television. Born in London, his name is closely linked with that of George Lucas and Steven Spielberg, from his work as art director on the film *Star Wars* (1977, with Les Dilley and John Barry), and production designer on *The Empire Strikes Back* (1980), and one of the films analyzed here, *Raiders of the Lost Ark* (1983), and others.

After attending art college and working as an artist in advertising, he recalls: "I went to Shepperton Studios one day, and I had always been interested in films — from the days of going to movies twice a week.... I started in the drawing office, in the art department, and plodded on. It's a matter of learning as you go— drawing, assisting, art directing, set dressing and all those things."[1]

Working as an art director on several films before becoming a production designer, Reynolds found it to be a difficult job, and has noted, "It's the difference between being the captain on a ship and the second mate. The designers would design the set, and we would talk about it, and he would come and visit. And as art director, you're thinking about that *one* section of the film, getting that one set ready."[2] But, Reynolds says, the production designer must think of every set, and expect the brunt of any criticism on the picture's decor. Of his own work, Reynolds says, "If it doesn't work, or they can't shoot on it, then that's a fortune wasted, and I just have to go and kill myself!"[3]

A tough part of production design Reynolds contends is thinking so far in advance of so many different elements that will need to be brought together to create the film's "look." He says, "I have to ensure that a set is designed, and working drawings are done early enough, to allow for the thing to be built — and for any delays — by a date which may be three months away. Now, if you multiply that by all the sets and all the locations ... it's that, and it's budgeting."[4]

For details about two of the films for which Norman Reynolds was production designer, see the chapters on Avalon *(p. 82) and* Raiders of the Lost Ark *(p. 105).*

The search for locations constituted a substantial part of the work on *Raiders of the Lost Ark* (see page 105). The production designer and his colleagues traveled around the world in under two weeks seeking locations in places as far apart as Hawaii and France.

Norman Reynolds says that both Spielberg and Lucas are interested in the way the film will look. "Some directors are more concerned about the sets; others are more concerned about the actors, which in a visual medium, I find strange. I wouldn't say that the sets are *as* important as the actors, but if the set is wrong, then the scene is wrong."[5]

Reynolds had worked with director Barry Levinson on a recreation of Victorian England for *Young Sherlock Holmes* (1985) before recreating Baltimore, through several decades of the 20th century, for him on *Avalon*. The tasks seem to have been equally challenging, but more of Baltimore could still be found extant and able to be transformed for the latter picture. Reynolds' well known ability to handle fantasy may have attracted Levinson, for there are several scenes that call upon it in *Avalon*, like the entry of the main protagonist, Sam Krichinsky, into Baltimore on the 4th of July.

Both films have nostalgic biases that are carefully handled, and especially in *Avalon*, never allowed to become mawkish. The production designer, who has worked so ably on both big budget and big box office movies and smaller films, has wanted to try his hand at directing. Steven Spielberg gave him that chance on his television series *Amazing Stories*, and now Norman Reynolds has a hand in two areas of film production.

Norman Reynolds Filmography

The Little Prince, 1974
Mr. Quilp, 1975
The Incredible Sarah, 1976, AAN, AD
Star Wars, 1977 (with Les Dilley, John Barry), AA
The Empire Strikes Back, 1980, AAN
Raiders of the Lost Ark, 1981, AAN
Return of the Jedi, 1983, AAN
Return to Oz, 1985
Young Sherlock Holmes, 1985
Empire of the Sun, 1987, AAN
Avalon, 1990
Mountains of the Moon, 1990
Alien³, 1992
Alive, 1993
Clean Slate, 1994
Mission: Impossible, 1996

Notes

1. Adam Pirani, "Production Designer Norman Reynolds," *Starlog*, February 1986, p. 31.
 2. *Ibid.*, p. 31.
 3. *Ibid.*
 4. *Ibid.*, p. 30.
 5. *Ibid.*, p. 31.

Bruno Rubeo

Italian born and educated Bruno Rubeo attended a high school in Rome devoted to training young people in filmmaking. While there he had the opportunity to listen to lectures from Italian film royalty: Vittorio De Sica, Roberto Rossellini, Federico Fellini and others. Rubeo decided right away to major in art direction, drawn to it by a love of architecture.[1] This training brought him a passing knowledge of everything from editing a film to animation, which came in handy on his first job in the industry — working for a special effects expert in Rome.

After moving back and forth in the movie industry between America and Europe, his break as a production designer came with a job from Oliver Stone on *Salvador* (1986). The production filmed on location in Mexico in only six weeks' time. The preparation of its 90-plus sets proved easier than recreating Vietnam in the torrid countryside of the Philippines for *Platoon* (1986) which Rubeo made immediately afterwards for Stone.

In comparison, the production design for *Driving Miss Daisy* was, at least, physically less draining. The problem on this poetic film, directed by Bruce Beresford, was lack of funds. Rubeo explains, "It's the least amount of money I've ever had to make a movie. Bruce [Beresford] said exactly what he wanted ... and he stuck to it to the letter."[2]

Rubeo scouted the locations for the house and then redecorated and refined it. The harmonies of its interiors evidence Miss Daisy's taste and character. They ring true to her values, which are basically traditional.

Bruno Rubeo Filmography

Spring Fever, 1983 (art director with Carmi Gallo)
Platoon, 1986

For details about one of the films for which Bruno Rubeo was production designer, see the chapter on Driving Miss Daisy *(p. 86).*

Salvador, 1986
Walker, 1987
Blood Red, 1988
Talk Radio, 1988
Born on the Fourth of July, 1989
Driving Miss Daisy, 1989, AAN
Old Gringo, 1989 (with Stuart Wurtzel)
Kindergarten Cop, 1990
Blood In, Blood Out, 1992
Sommersby, 1992
The Client, 1994
Dolores Claiborne, 1994
The Evening Star, 1996

Notes

1. Vincent Lobrutto, *By Design*, (Westport, CT: Praeger, 1992) 256ff.
2. *Ibid.*, p. 262.

Michael Seymour

Production designer Michael Seymour's career has been one which, like others in the field today, has taken him to many parts of the world on assignments in feature films, commercials and television. His home is now in Los Angeles, because as he says simply, "That's where the work is,"[1] but he still keeps a residence in London where he was educated at the Royal College of Art, after attending Bournemouth College of Arts, where he received a National Diploma in Art.

Seymour and Ridley Scott, the director of *Alien*, met at the Royal College of Art. "I was doing fine art. I was a painter. He came into the College in my last year. Around 1971 we first worked together on commercials and other projects. I worked with him and his brother Tony Scott for at least five or six years and with other directors in his company on a lot of commercials."

Ridley Scott and Seymour started to work on *Alien* in 1978. "He hadn't worked on any feature films before *Alien*," Seymour remarked. "I had worked on several in Britain, France and Israel."

When asked for his definition of a production designer, Seymour remarked that the designer "...has overall responsibility for what goes behind the actors. You must have an overview of all the visuals. The production designer is very influential in devising the look of the film and is in control of it."

The ideal working conditions for Seymour are "...when the director, director of photography, and production designer work intimately together on a film. But that's hard because the photographer usually comes in last, while I ordinarily start four to five months prior to filming. On *Alien*, I started four months prior to filming, which was not a lot of time, because we had to get the designs out and start construction. I had about one hundred fifteen members of the construction crew working for six months on the settings (three months before and three months into the shooting). It was about a sixteen-week shooting schedule."

For details about one of the films for which Michael Seymour was production designer, see the chapter on Alien *(p. 99).*

Seymour has described his mental method as "deep focus ... you do need to think, not only about what's happening this afternoon or tomorrow morning, but also at the same time you must be devoting as much concentration on what's going to be happening in six to seven weeks' time, because there are things which have to be started now for that period, which if you don't start them now will not be ready in time. So you develop a 'deep focus' attitude where you have things which are right here and things which are much farther away and you're giving them the same amount of concentration, but you're spacing them out in your mind."

The screenplay by Dan O'Bannon did not suggest specifics of the set; these he worked out with Ridley Scott, whom Seymour calls "a very visually oriented director." Four complete stages at Shepperton Studios were used for the several levels of the spacecraft. Everything seen was built, according to Seymour, "except for the miniature of the shuttle craft seen at the film's end. Even the underside of the *Nostromo* was constructed on one of the stages, then suspended from a ceiling grid, then shot from underneath."

When asked about the art director, he commented, "The art director carries out the sketches, then working drawings are produced by the draftsmen. Details are worked out in evolution.

"The art director sees that the sets are carried out and built as I want them built. The art director tries to get the sets at the design level the production designer wants them at."

When asked about Les Dilley's work on *Alien*, Seymour continued, "Les is a friend. At that time he was a technical art director. [Among] the first assistants to the production designer are the art directors and the set dressers.

"Dilley had worked on a number of science fiction pictures; he's done *Star Wars* [1977] as art director and later did *Raiders of the Lost Ark* [1981] and he continued to do this right up until *An American Werewolf in London* [1981], I think. Then he came to L.A. and began to do movies himself.

"I always get to choose my own assistants, unless they ask for too much money, which would be rare, then production might step in and say 'no.' I always have it in my contract that I have control over the art department."

Seymour has enjoyed working on a lot of films. "*Theatre of Blood* became a cult film," he recalled, "and when it was reviewed my work was mentioned by *Variety*, which I thought was nice as it was a British film." Some of his films, although not as successful as *Alien*, were more complex and elaborate films to design.

"*The Bride* was not very successful, but it had locations and built sets, and I did a nineteenth century circus that was supposed to be outside Budapest, but I built it in France. I built huge baronial halls on a stage in Britain whose exteriors were towers on the end of chateaux in France. Often, it was more complicated to execute those sets because I was working in so many different countries and their studios and locations."

Seymour finished a movie in Mexico, a western. "I was down there three and a half months; it's called *Gunmen* … it's not a film that's designed on a big scale, but I'm a professional production designer and I go from one medium to another; if something interests me, I take it."

Michael Seymour Filmography

Gumshoe, 1971
Theatre of Blood, 1973
Rosebud, 1975
Alien, 1979, AAN
Eureka, 1984
The Bride, 1985
Mr. Destiny, 1990
Revenge, 1990
The Thing Called Love, 1993
Beverly Hills Cop III, 1994
Gunmen, 1994

Notes

1. All factual information and quotations are from an interview with the author.

William Stout

Production designers and art directors have come to their field through a variety of art disciplines and educational routes. The Chinouard Art Institute (now California Institute of the Arts) has produced more than its fair share, including William Stout. Born in Salt Lake City (1949) and raised in Los Angeles, he was a scholarship student at Chinouard.

Stout's first fame in the 1960s began as a comic book illustrator, magazine cover artist, conceptual artist on films, and eventually he received a production designer credit in 1985 on *Return of the Living Dead*.

The wild, weird and color-filled comic strips he liked as a boy and later as an artist pop up as inspiration for designs on mythic, fantasy films like *Conan the Barbarian* (1980), *Conan the Destroyer* (1983), and *Clan of the Cave Bear* (1984) to which he contributed. He enjoys working on movies where he can create highly imaginative surroundings for the actors.

In the 1970s Stout assisted Russ Manning on the syndicated *Tarzan* comic strip, did work on the "Little Annie Fanny" strip in *Playboy* magazine, and designed over 35 "bootleg" record album covers which won him international celebrity, including a retrospective in the French magazine *Metal Hurlant*.

The album covers led to similar work on a larger scale, in the 1970s, as he began doing movie posters, his first for *Wizards* was followed by scores more, including: *Monty Python's Life of Brian, More American Graffiti, Allegro Non Troppo*, and *Rock 'n' Roll High School*.

Stout's enthusiasm for prehistoric creatures has led to several illustrated books, including *The Dinosaurs, A Fantastic View of a Lost Era* (1981), and *Ray Bradbury's Dinosaur Tales* (1984), which have increased his reputation as a purveyor of science, science-fiction, and fantasy imagery.

"I got into films by sheer chance, standing in line at an art store I heard two guys discussing doing *Buck Rogers in the 25th Century* [1978]. And I said, 'I know who should design it. Me.' They said, 'Let's see your portfolio.' I took

For details about one of the films for which William Stout was production designer, see the chapter on Return of the Living Dead *(p. 44)*.

it over the next day, and they hired me."[1] Stout did concept art and design on the picture which Daniel Haller directed for Universal.

"On *Conan the Barbarian* [1980], John Milius [the director] did not want people who had been in films before working on the settings. He hired me to do storyboards, but I asked to do other things. I learned by watching the production designer [Ron Cobb] on that film. He and I were the entire art department for about a year, and then when we moved to Europe they hired art directors. Ron Cobb is one of the few geniuses working in this field. Creative ideas just pour out of his head.

"I'm usually offered five to seven films in January and February. Hollywood is an extremely conservative, traditional work place, and they [production types] like to be finished with the film before the Christmas holiday, so they can spend time off. They gear up again after the first of the year. I'll start at any stage of production, as long as they pay me."

Stout, an astute businessman, keeps and copyrights his own art work and designs for pictures. He has also negotiated a percentage of merchandising profits for the art department on recent films.

"Between films I fill in with work illustrating or on other projects, like the *Conan* stage set for the Universal Tour in Florida [1987].

"I like to develop concepts, to work as a production designer. My job is to help the director with the visualization of the film. I'm not really qualified to be an art director, because I don't have any architectural design experience. I farm that work out to assistants with the background. I come from illustration — comic books and books on fantastic creatures.

"On *Godzilla, King of the Monsters,* I was hired by Steve Miner as the production designer a year prior to trying to sell the picture. In that case, my art work was part of the selling process. Unfortunately *Godzilla* never got released."

According to Stout, the preproduction phase can vary a lot: "If the preproduction phase is long, I don't need anyone to help me, I like to do everything myself. But if there is little preproduction time, then I need others to turn out the work. On *Masters of the Universe* [1986], the preproduction time was so short that my first or second drawing was used. The original production designer quit two months prior to shooting. He'd only made one drawing. I was designing all the way through shooting, just keeping a jump ahead of the schedule. I was on good terms and understanding with the director, Gary Goddard, on this one. So it wasn't hard to produce what he wanted."

Stout's view of production design is totally inclusive: "I consider my job to be in charge of everything seen on the screen, except the actors. This includes costumes. I like to hire the people I want in those areas, so that we'll see eye to eye. I like to hire the construction coordinator, who will build the sets."

Stout sees all the areas of building the visual imagery as closely connected and liable to be fouled up if there is not a consensus among the crew about what is being done overall.

"Many times on films there's a kind of war between the production people and the art department. They like to control things. At Cannon [*Masters of the Universe*] they made me feed things, sets and props, out all around town, because they didn't like to give one person too much money. I had a guy who could have done everything, but I had to run all over town checking on things being built and made for the film. They also cut the art department's budget from ten percent [of the total film budget] to five percent when they saw that I was saving money. This on a twenty-five million dollar film. I'll never let that happen to me again. You learn on every film, what to do and what not to do."

The sentiment that production design is learned on the job is universal among designers. Although a few schools now include courses on production design, since the beginning of art direction in films "on the job" training has been the principal learning method for the craft.

Stout recalled, "On *Masters of the Universe* I did storyboards as well as the overall concept. I've had a lot of experience doing storyboards.

"While a picture is shooting, I check the cameraman every day, so he doesn't screw up my sets. On *Masters of the Universe*, the cameraman screwed up the lighting and I had to go around pulling out plugs from the wall, literally. I had to make him take color gels off the lights that were ruining the color of the sets, which I had designed and had painted a certain way.

"I like to be there during filming, especially the entries of characters, which I think should tell you a lot about them, are they good or bad guys and so on. I try to be there when entrances are shot to see if my designs are followed.

"I learned a lot from comic strips like *Steve Canyon*. In the first presentation strip, you don't see the main character until the last picture. You see other people's backs as they react to him, you find out if he likes children, is kind, so that by the time he appears you are ready to go anywhere with him and know his whole character."

When queried about production design styles, Stout replied, "With me the job dictates the solution. I'm not out to impose a style on it, but let it define the style. I don't see art directors as having styles."

What kind of work will he not accept? "I turn down scripts for various reasons. One is budget, if they come in showing a budget of 1.4 million on a picture that will cost five million, I can't work with them if they're that unrealistic from the beginning.

"Also, I turned one down because of the subject — pit bulls. They were going to shoot down in Texas, and I know that would get into a real pit bull fight, and I'd be calling the SPCA or someone. So I just wouldn't go with the picture.

"Monetary. I get a flat fee. Which I keep raising each picture. My fee does not depend on the budget of the film. Producers always can find out how much you made on a picture, so you never can take less than your last picture, or they will start trying to get your fee down every time."

Research, which used to be done by a special department in the days of the in-house Hollywood studios, is done principally by the designers and their staff today. Stout explains, "I have a library of books that I use for research. I prefer to do all the research myself, and never field it out. That's one of the fun parts of the job, poking around in bookstores and reading on things." Since most designers only do one picture a year, it gives most of them time to do the research. There are still a couple of independent researchers in Hollywood, but their numbers are truly small.

Stout is sometimes asked to help with the trailer and advertising after the picture is shot. "This is easy for me," he maintains. "I've done fifty ad campaigns by myself. But on my films as production designer, I am seldom asked to do the ads. That's because Hollywood sees everyone as being very compartmentalized. You can only do one thing."

William Stout Filmography

The Return of the Living Dead, 1985
Masters of the Universe, 1987

Notes

1. All quotations are from an interview with the author.

Paul Sylbert

Brooklyn born Paul Sylbert has been working in film since the mid–1950s. Among other directors he worked with early on was Alfred Hitchcock, himself a former art director. Sylbert's work on Hitchcock's *The Wrong Man* (1957, with William L. Kuehl) was followed by assignments with less illustrious directors. It was not until later with films like *The Drowning Pool* (1975) and *One Flew Over the Cuckoo's Nest* (1975) that his name went to the forefront of American film designers where it has remained.

Paul Sylbert, whose identical twin Richard is also a preeminent production designer (see page 143), studied at Temple University's Tyler School of Fine Arts. During those days he hoped to make a career as a representational painter. He painted scenery at the Metropolitan Opera and then began his professional life as a designer in television at NBC in New York City. While married to the Greek actress Irene Papas, he designed for the Greek theater in Athens. A flawed attempt to become a motion picture director is chronicled by Paul Sylbert in a book about his experience, *Final Cut: The Making and Breaking of a Film* (1974).

Paul Sylbert, in an interview in the *Los Angeles Times* (March 18, 1975), explained that when he first came into films he had to invent his own techniques, as there was nothing to draw upon. This is a sentiment that is commonly expressed by art directors who came to film through television. They missed out completely on that wonderful training ground for art directors that was provided by the old movie studio system. In that period (the 1920s through the 1950s) young designers were brought into art departments in all of the Hollywood studios and put along side seasoned art directors to apprentice in their craft.

Paul Sylbert, like his brother Richard, has worked with producer Robert Evans on more than one occasion. Evans really favors the Sylbert family. Many of the producer's most important pictures have been designed by one or the

For details about one of the films for which Paul Sylbert was production designer, see the chapter on Sliver (p. 34).

other of the brothers. *Sliver*, discussed in this volume, is an Evans-produced vehicle as was the Mike Nichols directed *Biloxi Blues* (1988).

Paul Sylbert's design of *Biloxi Blues*, a nostalgic period film set in the war days of the 1940s, was somewhat of an exception for the designer who seems to have done mostly films with contemporary settings. For *Biloxi Blues* Sylbert came up with realistic sets that were tinged with a patina of time. In the opening frames of the movie, we see soldiers on a train. There is a gold and brown tonal quality to the images coming from their uniforms, the brown river over which the train crosses, and other sources. This tonality continues in many parts of the film so that those colors become synonymous with memory.

Sliver is entirely different. Most of its tonalities are chilling, as the title itself suggests they might be. The film is set in the world of business and professionals living in the 1990s in New York City. And rather than a multitude of settings, as he had done for *Biloxi Blues*, here the production designer had to contain his ideas within the framework of a single modern apartment building. There are no important exterior scenes in *Sliver*, which gives the film its vaguely claustrophobic character that suits the plot so well.

Paul Sylbert successfully sets out the individual characters of the main protagonists in their apartment furnishings. The apartments, themselves, all have roughly the same amount of space and the same layout. A similar challenge was faced by Sylbert on the well-known film *One Flew Over the Cuckoo's Nest* (1975). In that movie, most of the action takes place inside a mental institution, in particular, inside a ward dayroom. The dynamics of the story are reflected in just that one room. The inmates are more or less imprisoned for the entire day in the sanitized whiteness of the room. The only area sectioned off is the nurses' station which overlooks the dayroom, but is cut off from it by glass and low barrier walls. Psychologically and physically it is a world apart. To underscore this, the nurses' station is harshly lit with white light that is as bright and cold as the stiffly starched white uniform worn by the tyrannical Nurse Ratchet (Louise Fletcher). In *One Flew Over the Cuckoo's Nest* and in *Sliver* the *mise-en-scène* meshes so well with the drama that the audience hardly realizes how much it contributes to the story as it develops.

Paul Sylbert Filmography

A Face in the Crowd, 1957 (with Richard Sylbert)
The Wrong Man, 1957 (with William L. Kuehl)
Teenage Millionaire, 1961
The Tiger Makes Out, 1967
Riot, 1969
Bad Company, 1972
The Drowning Pool, 1975
One Flew Over the Cuckoo's Nest, 1975

Mikey and Nicky, 1976
Heaven Can Wait, 1978, AA
Hardcore, 1979
Kramer vs. Kramer, 1979
Resurrection, 1980
Blow Out, 1981
Wolfen, 1981
Gorky Park, 1983
Without a Trace, 1983
Firstborn, 1984
The Pope of Greenwich Village, 1984
The Journey of Natty Gann, 1985
Ishtar, 1987
Nadine, 1987
The Pick-Up Artist, 1987
Biloxi Blues, 1988
Fresh Horses, 1988
Career Opportunities, 1991
The Prince of Tides, 1991, AAN
Rush, 1991
Sliver, 1992
Milk Money (1994)

Richard Sylbert

Richard Sylbert is one of the very top production designers working today, and one who has worked successfully in nearly every film genre. He is also a designer with a distinct and well-articulated theory of design: "I take care of how the picture looks. The cameramen take care of the lighting. And the director takes care of the emotions."[1]

Sylbert maintains that on reading a script, he first tries to find the "structure":

> I rewrite [the] story — that structural whole — in terms of color, line, pattern, repetition, contrast, architectural spaces, and a number of other things. And I do it in a rather simple way. You can always find the one line that describes a movie. For instance, the basic action of *48 Hours* is "find the killer."[2]

One of Sylbert's early memorable films was Elia Kazan's *Baby Doll*, a film that took him out of the ranks of television designers. He had worked for CBS and NBC after attending the Tyler School of Design of Temple University, along with his twin brother production designer Paul Sylbert (see page 140). Among their friends were directors they would later make films with, including John Frankenheimer, Sidney Lumet, Robert Mulligan, Arthur Penn and George Roy Hill.

Richard Sylbert, like his brother, had planned to become a painter and credits American tonal painting as a major source of inspiration for his design work. Tonal painters tend to stay within a narrow range of colors with an occasional contrasting color. Some of Sylbert's period pictures, like *The Cotton Club* (see page 64), evidence this influence. He says:

> My idea of color now, especially for period films, is to get a sense of tonality out of it. I think color can be very disturbing for an audience, meaning

For details about two of the films for which Richard Sylbert was production designer, see the chapters on Chinatown *(p. 58) and* The Cotton Club *(p. 64).*

that it gets in the way of the actors. Because acting is the only real architecture in a movie; that's what you're protecting all the time. You're making sure that nothing, absolutely nothing, is interfering with the scene.[3]

Kazan gave Sylbert the script to read and then asked him to draw a few sketches. He drew a still-life with a column, got the job, and subsequently others from him. His impressions of that time are vivid: "Kazan was a director interested in the emotional dynamic of a scene. We had only metaphorical discussions. When we began *Splendor in the Grass*, Kazan and I were talking about the Loomis family, and he said to me, 'You know what the Loomis family is like? It's homey stew, but you can see a little orange carrot now and then.'"[4] Kazan's attitude suited Sylbert perfectly, and he says, "I never discuss my designs for a film with the director. All the pictures I have ever designed are my vision, my version of the world."[5] This is a position that few other designers can take with directors, and is a tribute to his status in the industry.

While Sylbert learned a lot of his early design techniques through on-the-job problem solving in television, he did have the opportunity to work with and have as his mentor, William Cameron Menzies. Menzies is the man whom most art directors consider the greatest designer in American film history. David O. Selznick invented the term production designer for Menzies' work on *Gone with the Wind*. That film saw five directors come and go. It was Menzies' sketches and complete storyboard for each frame that created the basic imagery of the picture.[6]

Of his own works' relationship to Menzies, Sylbert has said:

> What I am doing is what Menzies did, only I'm doing it in an entirely different way, and with an entirely different set of people. But Menzies taught me about getting hold of the whole thing, about making the connections and keeping control of it and making rules.[7]

At age 22 Sylbert had the opportunity to spend several months working with Menzies on two black and white Fu Manchu pilots. When they had finished, Menzies exhorted him to go to Hollywood and revive the business of art direction.

Richard Sylbert explains the structural rules for what has become a classic private eye picture, *Chinatown*:

> It takes place in 1937 in a drought. First rule: No clouds in the sky, or as few as possible. The sky should be white, except once when it's going to be very blue, but that's a specific choice. Second rule: Every building in the picture, every single thing you see exterior, is white, Spanish, and you have to look up to see it. To get to it, you have to walk up or ride up. The reason for that is that uphill is harder than downhill for a detective.[8]

Sylbert's brief analysis of the rules for *Chinatown* incorporates the theme itself (drought and the theft of the precious water), California and 1937 generally (absence of clouds and Spanish revival architecture), and what it is like to be a detective. Jake Gittes (Jack Nicholson), the private eye, has an uphill battle to obtain every bit of information he accumulates.

Sylbert explains further why white is so important to the overall look of the film: "We used it in this picture in two ways, a cool white and a warm white. The warm white is to keep telling you how hot it is. All the colors of this picture start with the color of burnt grass.... But those are the only colors in the whole movie, the colors of a drought."[9] Sylbert's control of color and then his insertion of it, as in Evelyn Mulwray's (Faye Dunaway) hot red lipstick and the flaming red booth in which she and Gittes sit in a restaurant, let us know that they will develop a hot sexual relationship in the course of things.

About the settings for *The Cotton Club*, Sylbert says, "[I] never had one conversation with Francis Coppola about the sets. First of all, I was there for six months before he was, and I'd already designed the picture. Second of all, he had enough problems."[10]

More recently Richard Sylbert's work on Warren Beatty's stylized version of the cartoon *Dick Tracy* (1990), has been widely discussed. Many critics saw the settings as at least one of the characters in the picture.

The production designer's goal was to create a separate reality for the comic strip detective's exploits: "Warren decided years ago that *Dick Tracy* had to break all the rules, that we were going to have to throw away everything we knew to make it work.... He knew there was no way in the world you could take this man with a yellow hat and coat who's followed by a guy with a flat head and walk him around Chicago. We had to create a parallel world."[11]

The rules for *Dick Tracy* may seem relatively easy, but were deceptively difficult to make work. They are that the film should be created using only the seven colors that Chester Gould, the cartoonist who created *Dick Tracy*, had used in the original strip. Also, rather than using a lot of miniatures, such as had been used in *Batman* (1989), another cartoon based film, matte paintings (60 of them) and the Universal back lot were used in *Dick Tracy*. Sylbert was enthusiastic about using the back lot streets for Chicago, because everything in it could be repainted to his specifications.

Scene by scene, Sylbert, along with costume designer Milena Canonero and the special effects artists Michael Lloyd and Harrison Ellenshaw, worked so that, besides the architecture, every object in every scene is done in one of the seven colors: red, blue, yellow, green, orange, black and purple. And not only are the colors limited, but they also are intensely saturated.

Sylbert decided that the usual set decorating items would be eliminated, so there are "no paintings on the walls, no textures, no fine details."[12] In other words, the sort of things that most renowned art direction flourishes upon were abandoned to create *Dick Tracy*'s reality.

Sylbert was also told by Beatty to do work that stood out, and has commented, "Doing work to be noticed goes against the grain of your work and it makes you very nervous."[13] Sylbert's ideal is to have the settings compliment and not overwhelm the actors. In *Dick Tracy* the balance is tenuous, but it does hold.

Richard Sylbert's brilliance as a production designer stems from an ability to analyze a script and articulate its main themes in visual terms. He has an unfailing grasp of the film's core, which is especially important to pictures with complicated plots, like *Chinatown*. Sylbert has, in his production design, done just what his mentor William Cameron Menzies hoped he would do, "put a little dignity back into the business."[14]

Richard Sylbert Filmography

Baby Doll, 1956
Crowded Paradise, 1956
Edge of the City, 1957
A Face in the Crowd, 1957
Wind Across the Everglades, 1958
The Fugitive Kind, 1960
Murder, Inc., 1960
Mad Dog Coll, 1961
Splendor in the Grass, 1961
The Young Doctors, 1961
The Connection, 1962
Long Day's Journey Into Night, 1962
The Manchurian Candidate, 1962
A Walk on the Wild Side, 1962
All the Way Home, 1963
Lilith, 1964
How to Murder Your Wife, 1965
The Pawnbroker, 1965
What's New, Pussycat? 1965 (as associate producer)
Grand Prix, 1966
Who's Afraid of Virginia Woolf?, 1966, AA
The Graduate, 1967
Rosemary's Baby, 1968
The April Fools, 1969
The Illustrated Man, 1969
Catch-22, 1970
Carnal Knowledge, 1971
Fat City, 1972
The Heartbreak Kid, 1972
The Day of the Dolphin, 1973
Chinatown, 1974, AAN

The Fortune, 1975
Shampoo, 1975, AAN
Players, 1979
Reds, 1981, AAN
Frances, 1982
Partners, 1982
Breathless, 1983
The Cotton Club, 1984, AAN
Under the Cherry Moon, 1986
Shoot to Kill, 1988
Tequila Sunrise, 1988
Dick Tracy, 1990, AA
Bonfire of the Vanities, 1991
Mobsters, 1991
Ruby Cairo, 1992
Carlito's Way, 1993
Mulholland Falls, 1996

Notes

1. "Dialogue on Film: Richard Sylbert," *American Film*, December 1985, p. 16.
2. *Ibid.*, p. 12.
3. *Ibid.*, p. 16.
4. "Dialogue on Film: Richard Sylbert," *American Film*, December 1989, p. 24.
5. *American Film*, 1985, p. 12.
6. Beverly Heisner, *Hollywood Art: Art Direction in the Days of the Great Studios* (Chicago and London: St. James Press, 1990) 41ff.
7. *American Film*, 1985, p. 16.
8. *Ibid.*, p. 14.
9. *Ibid.*
10. *Ibid.*
11. Jack Mathews, "The Look of 'Tracy,'" *Los Angeles Times*, Calendar Section, June 10, 1990, p. 3.
12. *Ibid.*, p. 22.
13. *Ibid.*
14. *American Film*, 1985, p. 16.

Dean Tavoularis

Dean Tavoularis is one of the most respected and articulate production designers of the past several decades. His work is admired by those in the field and he is credited with helping director Francis Ford Coppola construct many of his masterful films, from *Apocalypse Now* to *The Godfather*.

After finishing art school training he took a job in the art department at Disney Studios, which he remembers fondly, "When I worked at Disney Studios, my film school, Walt wanted every script storyboarded on a scene-by-scene basis so he could control what was developed in live-action filming, just as he did in animation."[1] The experience he had at Disney gave him the meticulous training which he has carried over into his later work.

Tavoularis contends that for the production designer the main challenge is to solve the most difficult aesthetic problem of the film first, "...and then apply that solution to all the other problems."[2] But the next greatest challenge lies in another direction: "At least ninety percent of being a production designer is organizing and creating your art department and your crew, the machinery that makes one's ideas take form in reality. The creative part is about ten percent of the total effort."[3] This statement is a bit overly modest from the designer of the numerous memorable sets seen in just the *The Godfather, Part II* alone.

According to Tavoularis, budgeting is also a headache for the production designer because producers generally want a detailed budget before the sets are very far along: "The more I can delay, within reason, the more accurate I can be in submitting the budget. The set designs must be finished before I can make an intelligent estimate of the costs of settings for a given film."[4]

Tavoularis says that the most important relationship for a production designer is with the director, and he likes to work with those who give a great deal of thought to the "look" of the film. Francis Ford Coppola, a director with whom he has had great rapport, is one who is very interested in the visual side of the craft of filmmaking.

For details about one of the films for which Dean Tavoularis was production designer, see the chapter on The Godfather, Part II (p. 90).

Few production designers have commented on the role of the writer, but Tavoularis says he sometimes consults them, especially when his designs stray from the background indicated in the script or when the writer has been overly detailed in trying to direct the film in his screenplay. The production designer insists, "The writer cannot say, 'This is my script and that's the way it will be shot.'"

Another spin has been given to the writer and production designer roles by Coppola and Tavoularis on *The Godfather, Part II*. The director was also the writer and had not finished the script when Tavoularis started work on the settings. "As we worked on the design of the film, it influenced the writing, and in fact the script was completed after the designs for the film were done."[5] This certainly shows Coppola's trust in his production designer. But the sets coming before the script is certainly a rarity in filmmaking.

Tavoularis says that the locations, when finally chosen, frequently cause alterations in the conceptions for settings. What he may have thought possible in an early drawing for a film may prove impractical at the site.

One of the elements that Tavoularis strives for in his design is a feeling of continuity throughout the film. Transitions from scene to scene are not to be overly abrupt. He works especially hard to achieve this through the use of color and color harmonies. His mastery of continuity can be seen in the many scene changes in the *The Godfather* and *The Godfather, Part II*.

Tavoularis has done numerous period films, from his very first solo production design job on *Bonnie and Clyde* (1967) which Arthur Penn directed. On a $55,000 budget, he carefully chose locations in Texas to give the film its air of 1930s authenticity.

The production designer begins every period film by immersing himself in research materials, from old photographs to paintings of the period. He especially wants his settings to have the emotional feel of the period, for as he puts it, in what seems a summary of his design philosophy, "*Emotional* is the operant word here because the production designer must create settings with overtones more felt than seen."[6]

Dean Tavoularis Filmography

Bonnie and Clyde, 1967
Little Big Man, 1970
Zabriskie Point, 1970
The Godfather, 1972
The Conversation, 1974
The Godfather, Part II, 1974, AA
The Brink's Job, 1978, AN
Apocalypse Now, 1979, AN
The Escape Artist, 1982

Hammett, 1982
One from the Heart, 1982
The Outsiders, 1983
Rumble Fish, 1983
Peggy Sue Got Married, 1986
Gardens of Stone, 1987
A Man in Love, 1987
Tucker: The Man and His Dream, 1988, AN
New York Stories ("Life Without Zoe" segment), 1989
The Godfather, Part III, 1990
Hearts of Darkness: A Filmmaker's Apocalypse, 1991
Final Analysis, 1992
The Opposite Sex and How to Live with Them, 1993
Rising Sun, 1993
Shelf Life, 1993
I Love Trouble, 1994
Jack, 1996

Notes

1. Roy Paul Madsen, *Working Cinema* (Belmont, CA: Wadsworth Co., 1990), p. 87.
2. *Ibid.*, pp. 107, 109.
3. *Ibid.*, p. 83.
4. *Ibid.*, p. 82.
5. *Ibid.*, p. 86.
6. *Ibid.*

Wynn Thomas

Wynn Thomas was already an art director, working on the Stan Lathan film *Beat Street* (Patrizia von Brandenstein was the production designer) in 1984 when he met Spike Lee by chance. Lee was trying to get a job as the director's personal assistant. Thomas recalls, "Spike had come in to interview for the coffee-fetching position of assistant to the director.... He stopped by the art department.... He saw me there, and said, 'I didn't know there were any black people doing art direction.' I said, 'You didn't know that because there aren't very many.'"[1]

Thomas studied theater design at Boston University and then worked in that field in New York City. For a while he was the set designer for the Negro Ensemble Company. He wanted to get into films and first approached it through television. A chance meeting with Richard Sylbert led to a job in the art department of the film *The Cotton Club*.

Spike Lee and Thomas began working together on a project that was never produced and then in the summer of 1985 Lee got financing for his first film. Wynn Thomas has worked as production designer on every one of Lee's films since that first one, *She's Gotta Have It* (1986).

On *She's Gotta Have It* Lee brought Thomas and the cinematographer Ernest Dickerson together to form the nucleus of his filmmaking team, a team that has been the backbone of Lee's company on his subsequent and increasingly successful films. Thomas takes on other work between Lee's films, like Robert Townsend's *The Five Heartbeats* (1991), but stays committed to Lee's films which appear at the rate of about one a year.

On *She's Gotta Have It*, with a budget of only $800, Thomas created Nola Darling's spacious apartment in a loft above the Ferry Bank Restaurant beneath the Brooklyn Bridge. Shooting in only 12 days and in black and white was a challenge, because Thomas says, "Color creates a certain mood.... With black and white films, you have to use texture to create moods and areas of contrast."[2]

For details about two of the films for which Wynn Thomas was production designer, see the chapters on She's Gotta Have It *(p. 21) and* Jungle Fever *(p. 11).*

As Lee's films grew in complexity and he gained mainstream financing, Thomas has been called on to do ever more demanding and imaginative work. Lee's films, now with big art department budgets, are shot in studios in New York City and on locations around the city and the world, as in *Malcolm X*.

On *School Daze* (1986) Thomas had mainly to devise college settings, but for Lee's next film, *Do the Right Thing*, there were more interesting challenges. The production designer had to find a whole block for the setting of the film, with a place for a pizzeria and the Korean market vis-à-vis one another. He turned up a street in the Bedford-Stuyvesant section of Brooklyn, where the film is laid. It had two vacant lots ample enough for the building of the pizzeria and market. Since the pizzeria gets burned down at the film's end, Thomas knew from the beginning that he would have to build it and he adds, "There are no Korean markets in Bed-Stuy, there are only bodegas...," so he had to build that too.[3]

Because the street figures almost constantly in the two hour film, he looked for one that had some interesting architectural detailing and then added solid bright colors on walls and a mural. This detailing sometimes over brightens a basically realistic film, giving it an surreal design quality like that found in earlier movies like the urban musical *West Side Story*.

Thomas says the hot temperature written into the plot was matched on the set in the summer of 1988. "It was a grueling experience for the art department, because we had to build two buildings plus rehab a whole street in six weeks."[4] The entire film was shot on the street in Bedford-Stuyvesant.

Later films like *Mo' Better Blues*, *Jungle Fever* and *Malcolm X* contained a mixture of built sets and locations. On *Mo' Better Blues* a major portion of the film was studio built, but once again Thomas had to find an important street location, this time for the exterior of the jazz nightclub, Beneath the Underdog. Greenwich Village yielded the Cherry Lane Theater exterior and its block on Commerce Street that takes a sharp 90 degree turn. Its brick facades with their multi-paned sash windows were glitzed up with entrance canopies, neon signs and standing sandwich boards.

The block unfortunately turned out to have a historic designation, so that Thomas could attach nothing to the facades. He had to devise ways to fix the scenery to the buildings by extended poles at either the top or bottom. The added effort paid off, he believes. "I don't think we ever would have found a block that had that feeling, or that mix of buildings, anywhere else in the city. What happens is that you find what is ideal, and you deal with the specific problems of that location."[5]

Working together with Lee has become almost intuitive. Thomas understands, without a lot of conversation, what the director wants to do in a film. Thomas says, "I think one of the strengths in my relationship with him is that I am able to respond to what he's written. On most films the director has not written the script. But when you work with Spike, you are working with

someone who has written the script, and as a result, is giving you all the information."[6]

Of the nightclub set for *Mo' Better Blues* Thomas commented, "Spike never came to me and said, 'I want high-angle shots in the club' ... I just knew that he would want them.'" Lee's only instructions to him were: "I don't want it [the nightclub] to look like a typical jazz club, and I want to be able to use the Steadicam to go from one room to the next."[7]

One of the strengths of Thomas as a designer is his ability to take a location and give it more character, particularly through the use of walls of color. He has brought this technique to several films and to specific purpose. His block in Bedford-Stuyvesant has vivid colored walls along it and the architectural details of the buildings have been emphasized through color, so that the street is constantly interesting to the viewer as the characters move up and down its treeless sidewalks in a summer heat wave.

In his work Wynn Thomas has also shown an enormous understanding of period styles and their translation and transmutation. This is clear, for example, in *Mo' Better Blues*, but is especially evident in the Spike Lee translation of Malcolm X's *Autobiography* into *Malcolm X*. The action moves chronologically, with some flashbacks, through decades in several areas of the country, and from a burning farmhouse, to a barbershop where Malcolm X, then known as "Detroit Red" (Denzel Washington), is having his hair conked, to a hilarious street scene with Spike Lee and Washington as Zoot-suiters, to the grim ballroom where Malcolm X was murdered. Although Lee does not have time in the lengthy film to linger on any setting, the ambiance provided by Thomas etches out the changes in Malcolm's life as he progresses from street loser to national leader.

Likewise, Thomas' work on *The Five Heartbeats* (1991) is right on target for the periods through which he follows the lives of five singers in a pop group. Robert Townsend's directorial style allowed the settings to frequently become comic foils for the actions of the singers. Overall the settings are nostalgic in keeping with the nostalgic content of the film, which has a melancholy underside.

Only in the business of film production design for about a decade, Wynn Thomas has made a formidable mark on contemporary American film through his association with director Spike Lee. By associating himself primarily with one director, the production designer is following in the footsteps of great art directors from the studio days. In those times, the 1920s through the 1950s, the ties between art director and director were mostly forged through a common contractual arrangement with the same studio. Today directors and production designers come together continually when they are temperamentally and artistically suited to one another.

Wynn Thomas Filmography

Beat Street, 1984 (art director with production designer Patrizia von Brandenstein)
She's Gotta Have It, 1986
Brighton Beach Memoirs, 1987 (art director with production designer Stuart Wurtzel)
Eddie Murphy Raw, 1987
School Daze, 1988
Do the Right Thing, 1989
Homeboy, 1989 (art director with production designer Brian Morris)
The Package, 1989 (art director with production designer Michael Levesque)
Mo' Better Blues, 1990
The Five Heartbeats, 1991
Jungle Fever, 1991
Malcolm X, 1992
A Bronx Tale, 1993
Crooklyn, 1994
To Wong Foo, Thanks for Everything! Julie Newmar, 1995

Notes

1. J. Calhoun, "A New Spike Lee Joint," *Theatre Crafts*, 1990, p. 65.
2. *Ibid.*
3. *Ibid.*
4. *Ibid.*
5. *Theatre Crafts*, p. 66.
6. *Theatre Crafts*, p. 65.
7. *Ibid.*

Patrizia von Brandenstein

For about a decade Patrizia von Brandenstein has been one of America's top production designers. She works on one major feature film after another and they all have substantial budgets. Her design philosophy, often repeated, and honed over years as first a scenic artist, a costume designer and then an art director and production designer, is that the design process is much the same on all pictures, but that each one prompts its own unique design solution.

Like others in the field, she doesn't think that designers should have styles, but she warns, "It's just as easy for an art director to get typed as it is for an actor. You get into things, and then you realize you're working in a certain color range."[1] For that reason she likes to choose films that are radically different in concept, like the dramatic period film *Ragtime* and *The Money Pit*. The latter is a contemporary comedy directed by Richard Benjamin in which a couple's newly purchased house collapses around them as it is being renovated.

Patrizia von Brandenstein, who is married to prominent production designer Stuart Wurtzel, was born in Phoenix and as a young girl and teenager lived with her parents in Paris. She apprenticed in the French National Theater and then studied in New York at the Art Students' League and Studio and the Forum of Stage Design.

Von Brandenstein began her career as a costume designer Off Off Broadway and then got a job in San Francisco at the American Conservatory Theater where for five years she was the staff costume designer. Her start in films was as a costume designer, for *Saturday Night Fever* (1977). She created John Travolta's memorable white disco dancing suit, a defining icon of the decade.

Today she lives and works out of New York. Her first assistant art director credit came on Herbert Ross' film *Play It Again, Sam* (1972). With Joan Micklin Silver's *Hester Street* (1975) she garnered more experience and recognition for her craft. She was the art director to Stuart Wurtzel's production

For details about two of the films for which Patrizia von Brandenstein was production designer, see the chapters on Amadeus *(p. 46) and* The Untouchables *(p. 77).*

designer role on that film, but explains, "The fact is ... we were both production designer. I had transferred into the East Coast union as a scenic artist, so I got fined for art-directing without a license. The film, though, did us both an immense amount of good. It was made for very little money, but it had a very rich, full look, and in black and white."[2]

Now the Academy Award–winning (for *Amadeus*) production designer is among the first brought on a film, usually four to six months prior to production. The usual working day for von Brandenstein during a film's preproduction phase is 12 hours. This goes up to 15 hours a day when the film is in production. First von Brandenstein estimates the costs for the settings and then, she comments: "You need to help [the director] find his vision of the film."[3]

Directors have the final say on the visual components of the film, and they can be very exacting; director Mike Nichols had the Ford Mustang of the main character of his *Postcards from the Edge* repainted six times to get the right shade of blue. In the months before the film was shot von Brandenstein watched movies with Nichols of films that took a satiric look at Hollywood. They also viewed the opening shot of *Touch of Evil* six times analyzing Orson Welles' tracking technique.

On Brian De Palma's *The Untouchables*, the director planned the action and the camera set-ups and movement in preproduction. Von Brandenstein worked with De Palma on the director's specific image of Al Capone (Robert De Niro), and says: "De Palma knew precisely how he wanted to express Capone's place in the world. He wanted to express the idea of power, a man of complex personality in absolute control. I thought of Capone as a man of great dignity, somber, sartorially very splendid.... I thought of him as a great prince, in the colors Di Lampedusa described in *The Leopard*—the book, not the movie—like a gangland Sun King. The world revolved around him."[4]

Von Brandenstein does not maintain an established art department, but uses different associates on individual types of pictures depending on their expertise. She forms her art department so that the film can be brought in with its physical look intact at the agreed upon budget. Working closely with the production manager helps to keep things on course, she says.

Von Brandenstein likes to keep cordial and close relationships with her art directors, set dressers, and the other designers on any film, like, the costume designer, hair and makeup artists. She is clear, though, about the fact that "a production designer has more responsibility over the whole picture" than does any other designer.[5]

Director Forman has commented on von Brandenstein's handling of her co-workers: "At the beginning ... the Czechs were very suspicious of her on *Amadeus*. Here's this American lady with, for them, a very pretentious name, a phony name. And she's deceitful. She's very soft-spoken, but then you discover she's a real tough lady. By the end, she was best friends with all of them."[6]

Patrizia von Brandenstein has worked with Milos Forman on two big-budgeted pictures with historic themes: the earlier *Ragtime* (1982) where she was an art director in the art department along with Anthony Reading (UK) while John Graysmark was the production designer, and on *Amadeus* (1984) for which she won the Academy Award for production design.

Ragtime uses wonderful location settings: the family home in New Rochelle and big built sets, like the J. P. Morgan Library in New York City. Among von Brandenstein's assignments on that film was the supervision of the construction of the nickelodeon set.

Amadeus uses well-researched locations, palaces and churches in Prague and the rest of Czechoslovakia, and some 20 major built sets. *Amadeus'* story, a fictionalized drama about the composer Wolfgang Amadeus Mozart and the Italian composer Antonio Solieri, was a time consuming and heavily researched film (she employs a research person), on which von Brandenstein worked for about a year. After the research she found one of the greatest challenges to be finding materials not easily acquired in Eastern Europe:

> I needed London for wigs, Rome for costumes and fabric, Paris for ribbons. I needed acres of materials: hair spray, riplox, boxes of hairpins and hairnets, paper and ink to write music on. In the Rome flea market I just got suitcases full of things, to make eighteenth-century powder puffs, silver knife handles.[7]

For von Brandenstein the collaboration between the director cinematographer, and production designer are crucial to a good looking and well designed film. Milos Forman agrees and describes her method of working: "She serves the project ... and doesn't try to second-guess the director. I argue with everyone. That's how you start a mutual adrenaline flow. And there are *always* frictions there. They can be resolved in a damaging ego fight. Or the excitement can show up on the screen. I welcomed the clashes very much because [the creative solutions] were always more proper and appropriate for the film."[8]

Patrizia von Brandenstein's film designs are in agreement with her dictum that each film prompts its own unique visual treatment. She cannot be typecast as a production designer except in the meticulous care given to every detail of her films. Her popularity as a production designer would seem to be tied to the pinpoint accuracy of her definition of characters through their surroundings and her ability to emotionally charge the film's action with sets that are able to comment on and enhance it. The adaptability of von Brandenstein's work to various directors' visions in setting a "look" for each individual picture is evidence of the scope necessary to a production designer in collaborating on this important aspect of film production.

Patrizia von Brandenstein Filmography

The Gardener's Son, 1977
Girlfriends, 1978 (art director)
The Last Tenant, 1978
Summer of My German Soldier, 1978
Breaking Away, 1979 (art director)
Heartland, 1979
My Old Man, 1979
Hardhat and Legs, 1980
Tell Me a Riddle, 1980
Ragtime, 1981 (art director with production designer John Graysmark and art director Anthony Reading), AAN
Silkwood, 1983
Touched, 1983
Amadeus, 1984, AA
Beat Street, 1984
A Chorus Line, 1985
The Money Pit, 1986
No Mercy, 1987
The Untouchables, 1987, AAN
Betrayed, 1988
Working Girl, 1988
The Lemon Sisters, 1990
Postcards from the Edge, 1990
State of Grace, 1990 (with Doug Kraner)
Billy Bathgate, 1991
Leap of Faith, 1992
Sneakers, 1992
Six Degrees of Separation, 1993
Just Cause, 1995
The Quick and the Dead, 1995

Notes

1. Carlos Clarens and Mary Corliss, "'The Pit,' and the Production Designer," *Film Comment*, April 1986, p. 72.
2. *Ibid.*, p. 4.
3. David Chell, *Moviemakers at Work* (Redmond, WA: Microsoft Press, 1987), p. 154.
4. Carol Troy, "Architects of Illusions," *American Film*, August 1990, p. 37.
5. Chell, p. 154.
6. Troy, p. 35.
7. Clarens and Corliss, p. 4.
8. Troy, p. 36.

Kristi Zea

New York production designer Kristi Zea has worked on a series of distinguished motion pictures with well-known directors from Martin Scorsese to Jonathan Demme. She was attending Columbia University when she got a job in commercial advertising with a still photography studio. This experience led her into doing television commercials. She explains, "Commercials are baby films. You have the same kind of crew, the same kind of needs.... Mel Bourne, who is a fantastic production designer, was hired a lot by these commercial production companies. He'd be doing the set design. I always admired him enormously, and one day he called me up and said, 'I'm doing a Woody Allen movie, *Interiors*, and I need somebody who has access to interior decoration and design showrooms....' Assisting Mel was an incredible experience; I'll never forget. It taught me an enormous amount."[1]

Zea's best known work was on the Academy Award–winning *The Silence of the Lambs*. She had worked previously with that film's director Jonathan Demme on *Married to the Mob* (1988).

According to Demme they worked very closely to come up with visual concepts that articulated the script. Demme admits that neither the novel nor the screenplay gave a great many specifics to be followed in creating the film's look: "One of the big challenges for this movie was, how do you depict some of the shocking scenes described in the screenplay? Like when the police officers burst into the room in Memphis to discover their fallen partners. Ted (Talley, the screenplay writer) wrote, 'What greets them is a snapshot from hell.' Thanks, Ted. But it's okay, we got that."[2]

Demme describes his working method as getting together with Zea and the other production principals, cinematographer Tak Fujimoto and sound manager, Chris Newman, to get an image for the film. Demme did not come to *The Silence of the Lambs* with a set notion. He relates how: "We sit down, Tak, Kristi and Chris Newman ... and we swap views and impressions. The

For details about two of the films for which Kristi Zea was production designer, see the chapters on GoodFellas (p. 96) and The Silence of the Lambs *(p. 23).*

thing is, we were all responding to the book and the screenplay. You read that book and you're going to come away with an impression of what that stuff looks like."[3] The director's description of the process once again underscores how difficult it is to persuasively credit any one person with the distinct visual look of any film.

One of the screen images that Demme and Zea put a tremendous amount of time and energy into was the bars on Lecter's cell. "We were never happy with the different looks we were experimenting with. And finally we went to glass. The looks of Lecter's environments are sort of one step beyond, one step into active imagination in the presence of a lot of ultra-realism elsewhere in the picture."[4] The repeated attempts to come up with satisfactory solutions to a single problem is typical of art direction in films. Ideas are constantly reworked from the beginning of production preparation and then sometimes throughout the filming period.

The strange cell block that Lecter inhabited was a result of Demme's not wanting this movie to resemble the many prison films audiences have seen previously. Elements of a strange habitation are hinted at in the book, but again specifics were lacking there. Demme goes on, "I didn't want to settle into a someone-visiting-a-prisoner scene. We aspired to create a setting for these encounters (between Lecter and Clarice) that would not evoke any other films, that would have a freshness and a scariness all their own."[5] In these scenes, as in others, he used a subjective camera. Zea's dungeon setting of rusticated stone walls evokes the artistic scariness of the great 18th century Roman engraver Piranesi's *Prisons* series, with their sense of fantasy and dread.

When talking about the "look" of the film Demme commented on the lighting, "I didn't want the film to look like another modish, stylish, moody broody long-shadow catch-the-killer movie." He trusted this matter to Tak Fujimoto. The rest he trusted to Kristi Zea.

Kristi Zea Filmography

Lucas, 1986 (art director)
Angel Heart, 1987 (art director with Armin Ganz)
Married to the Mob, 1988
Miss Firecracker, 1989
New York Stories ("Life Lessons" segment), 1989
GoodFellas, 1990
The Silence of the Lambs, 1991
The Super, 1991
Lorenzo's Oil, 1992
Philadelphia, 1993
The War, 1994
Sleepers, 1996

Notes

1. Vincent Lobrutto, *By Design* (Westport, CT: Praeger, 1992), pp. 242–243.
2. Gavin Smith, "Jonathan Demme, Interviewed," *Film Comment*, January-February 1991, p. 33.
3. *Ibid.*, p. 34.
4. *Ibid.*, pp. 32–33.
5. *Ibid.*

Bibliography

Albrecht, Donald. *Designing Dreams*. New York: Harper & Row, 1986.

Avallone, Susan, ed. *Cinematographers, Production Designers, Costume Designers, and Film Editors Guide*. Beverly Hills, CA: Lone Eagle Press, 1990. Published annually, lists credits.

Barsacq, Leon. *Caligari's Cabinet and Other Grand Illusions*. Rev. and Ed. by Elliott Stein. Boston: New York Graphic Society, 1976.

Brouwer, Alexandra, and Thomas Lee Wright. *Working in Hollywood*. New York: Crown, 1990.

Calhoun, John. "Mel Bourne," *Theatre Crafts*. April 1991: 40ff.

_____. "A New Spike Lee Joint," *Theatre Crafts*, vol. 24, no. 7. 1990: 65.

Chell, David. *Moviemakers at Work*. Redmond, WA: Microsoft Press, 1987.

Corliss, Mary, and Carlo Clarens. "Art Direction," *Film Comment*. May-June 1978: 25ff.

_____. "'The Pit' and the Production Designer," *Film Comment*. April 1986: 4ff.

Coppola, Francis Ford, and James V. Hart. *Bram Stoker's Dracula*. New York: Newmarket Press, 1992.

Davis, Alicia. "Alienation Process, Michael Seymour," *Creative Review*. June 1982: 11ff.

"Dialogue on Film, Richard Sylbert." *American Film*. Dec. 1985: 12ff.

"Dialogue on Film, Richard Sylbert." *American Film*. Dec. 1989: 21–26.

Hamley, John, and Patrick Downing. *The Art of Hollywood: A Thames Television Exhibition at the Victoria and Albert Museum*. Thames Television. London. 1979.

Haskins, Jim. *The Cotton Club*. New York: Random House, 1977.

Haworth, Ted. "Production Designer vs. Art Director," *Film Comment*. May-June 1978: 36.

Heisner, Beverly. *Hollywood Art: Art Direction in the Days of the Great Studios*. Chicago and London: St. James Press, 1991.

Hollander, Anne. *Moving Pictures*. Cambridge, MA: Harvard University Press, 1991.

Horowitz, Mark. "Coen Brothers A–Z: The Big Two-Headed Picture," *Film Comment*. Sept.-Oct. 1991: 28–29.

Jameson, Richard T. "What's in the Box," *Film Comment*. Sept.-Oct. 1991: 26ff.

Lobrutto, Vincent. *By Design*. Westport, CT: Praeger, 1992.

Madsen, Roy Paul. *Working Cinema*. Belmont, CA: Wadsworth Co., 1990.

Mathews, Jack. "The Look of 'Tracy.'" *Los Angeles Times*, Calendar Section, 10 June 1990: 3ff.

"Mel Bourne," *Metropolitan Home*. June 1985: 15.

Michaud, Christopher. "Richard Sylbert Works His Magic," *New York Times*, Arts and Leisure Section, 23 Sept. 1990: 13ff.

"On the Shady Side, Dennis Gassner's Two New Movies," *Metropolitan Home*. Oct. 1990: 50.

Perry, L. A. "One-Sheet Shuffle," *American Film*. July 1991: 11.

Pirani, Adam. "Production Designer Norman Reynolds, Visualizing Victorian England," *Starlog*. Feb. 1986: 29ff.

Riley, Michael M., and James W. Palmer. "An Extension of Reality: Setting in *The Servant*," *Mise-en-Scène*. 2 (Spring 1980): 44–48.

Salamon, Julie. *The Devil's Candy*. Boston: Houghton Mifflin, 1991.

Smith, Gavin. "Jonathan Demme Interviewed," *Film Comment*. Jan.-Feb. 1991: 28ff.

Smith, Tom. *Industrial Light and Magic: The First Ten Years*. New York: Ballantine Books, 1986.

Spence, Betty. "Dean Tavoularis: Art Director as Architect," *Los Angeles Times*, Calendar Section, 5 Oct. 1980: 6.

Stauth, Cameron. "Instant Ambience," *American Film*. June 1991: 9.

Troy, Carol. "Architects of Illusions," *American Film*. August 1990: 32ff.

Yagoda, Ben. "Baltimore, My Baltimore," *American Film*. Nov. 1990: 35–38.

Index

Numbers in boldface refer to pages with photographs.

165